THE PACKAGING AND DESIGN
TEMPLATES
SOURCEBOOK

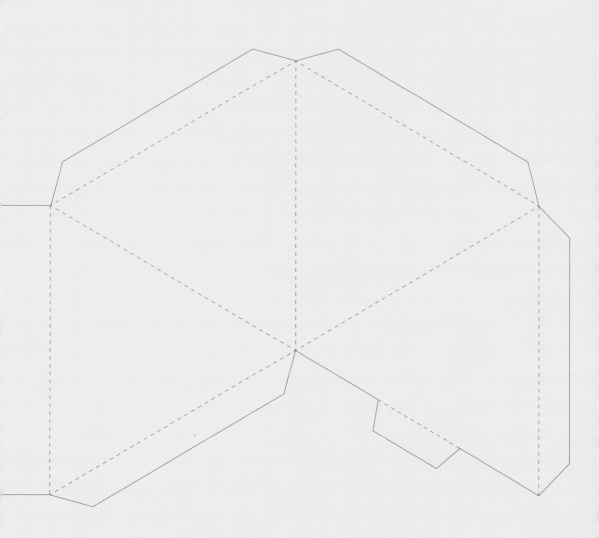

RotoVision

A RotoVision Book

Published and distributed by RotoVision SA
Route Suisse 9
CH-1295 Mies
Switzerland

RotoVision SA
Sales and Editorial Office
Sheridan House, 114 Western Road
Hove BN3 1DD, UK

Tel: +44 (0)1273 72 72 68
Fax: +44 (0)1273 72 72 69
www.rotovision.com

10 9

ISBN: 978-2-940361-73-1

Art Director Tony Seddon
Design by Studio Ink
Diagrams by Jane Waterhouse

Reprographics in Singapore by ProVision Pte.
Tel: +65 6334 7720
Fax: +65 6334 7721

Printing and binding in Singapore by Craft Print International Limited

THE PACKAGING AND DESIGN
TEMPLATES
SOURCEBOOK

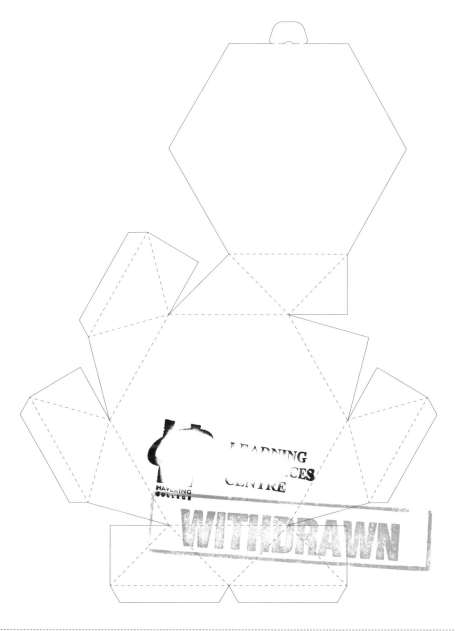

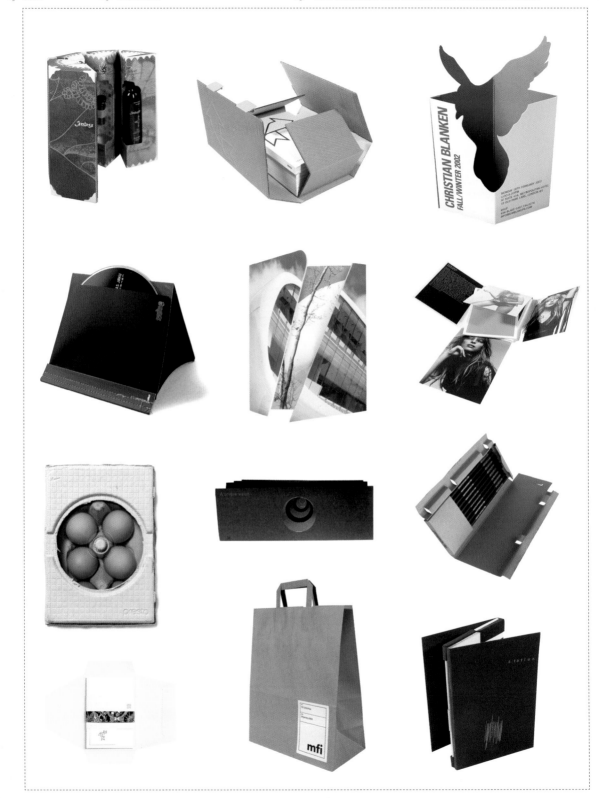

CONTENTS

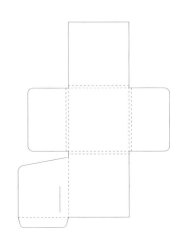

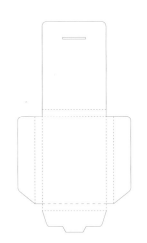

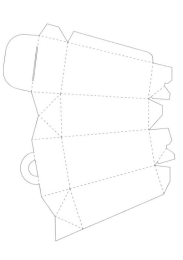

INTRODUCTION

Graphic design is usually thought of as a two-dimensional activity. However, anything more complex than a single poster or letterhead functions in three dimensions.

Most of the work featured in this book is three-dimensional and involves an element of reader participation. Many of the featured designers believe that design involving reader interactivity tends to be more memorable and the information conveyed more easily absorbed than work that is simply looked at on flat sheets.

This book is a stunning showcase of new, innovative, and classic packaging and paper engineering ideas. The new concepts cover a variety of design fields, including detailed templates showing how to copy, fold, construct, and complete them.

It looks at the work of successful international designers and design groups who have come up with creative packaging and paper engineering solutions for a multitude of inspiring projects, and shows the templates for these designs.

It includes various experimental formats, cuts, shapes, and folds created in a variety of materials, that will not only enthuse designers, but inspire them to expand their creative spheres.

The packaging ideas featured can be created by a designer independently, without recourse to complex manufacturing or engineering processes and materials. The illustrations deconstruct and reveal the structure of the featured projects, and can be copied, adapted, and developed to be applied to new designs.

There are many ways to do something and many ways to interpret a brief. These templates will act as a vehicle to be adapted and developed, taking graphic ideas down new avenues and in alternative and original directions.

BOOKS AND
MAGAZINES

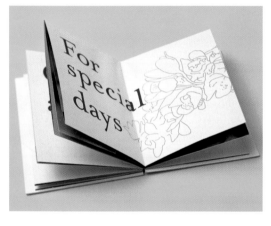

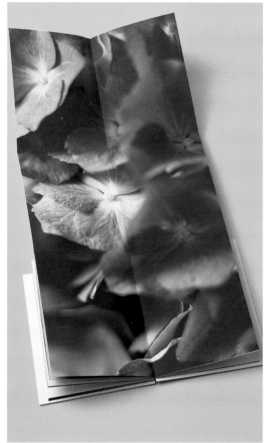

DESIGN	→	Iris Associates
PROJECT	→	Promotional book
DESCRIPTION	→	Each three-paneled page is folded down to the size of one page and attached to the other pages with glue. The spine of the book is uncovered so that the neatly gathered folds are exposed and together look like a folded concertina. Two white pieces of board are used for the front and back cover.

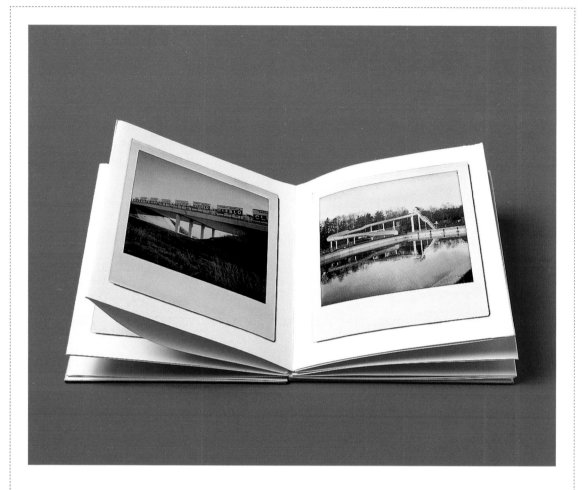

DESIGN	→	KesselsKramer
PROJECT	→	Self-initiated book
DESCRIPTION	→	*Missing Links* is a miniature book in concertina format with cardboard covers. It features a collection of polaroid photos taken by Eric Kessels over a 10 year period.

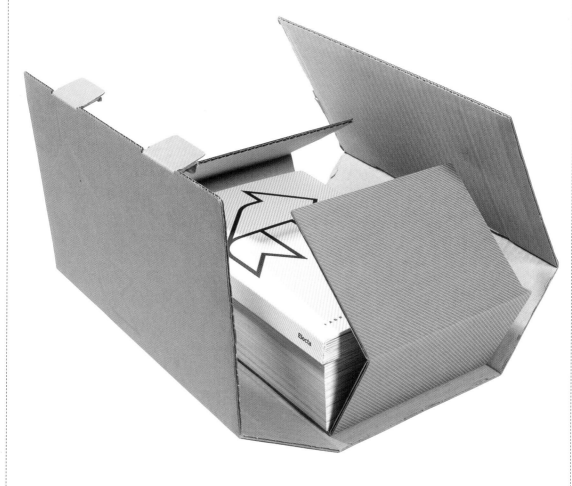

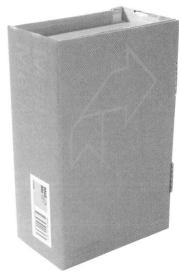

DESIGN	→	Fabrica
PROJECT	→	*Mail-me* book packaging
DESCRIPTION	→	Two books beautifully contained within a custom-made, thick cardboard box.

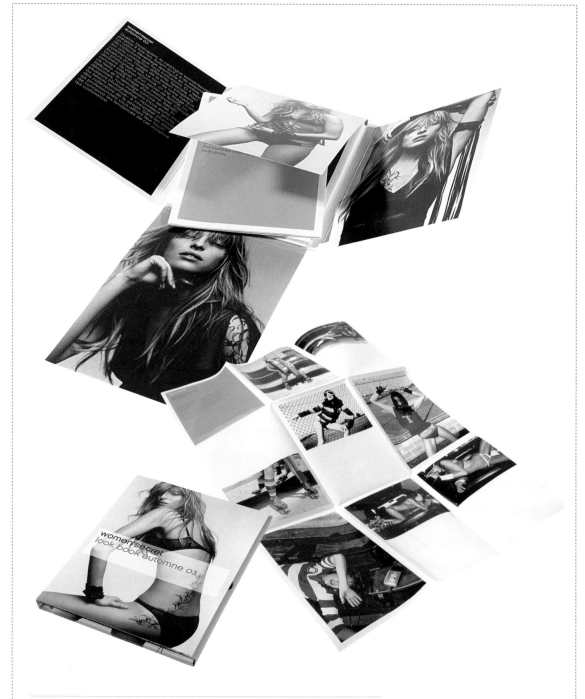

DESIGN	→	Base Design
PROJECT	→	*Women'secret look book*
DESCRIPTION	→	Four-leafed folder that opens to reveal a series of six separate folded sheets.

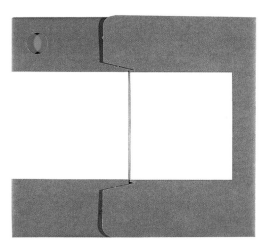

DESIGN	→	Union Design
PROJECT	→	Book packaging
DESCRIPTION	→	This card book envelope has a die-cut circle that reveals a flash of the front cover. This is a simple and stylish way to give a book or magazine a greater perceived value and interest.

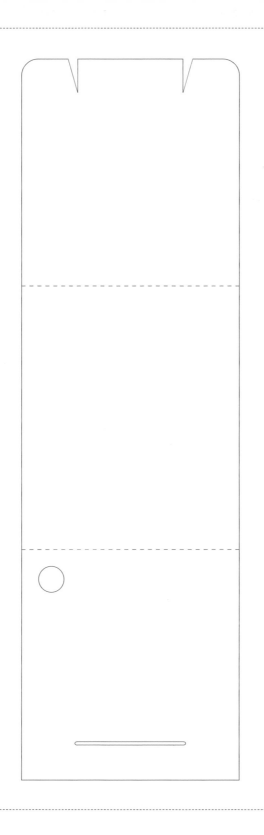

 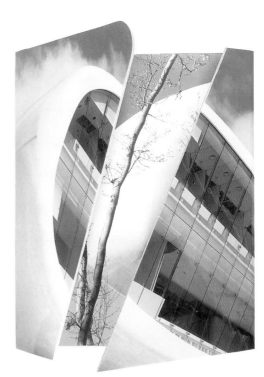

DESIGN	→	Cartlidge Levene
PROJECT	→	Commemoration book
DESCRIPTION	→	This book has been designed in two sections which are loosely contained within a 3mm thick board cover with a diagonally sliced opening. In this case, the angle of the cut is along the same axis as the glass panels on the cover photograph.

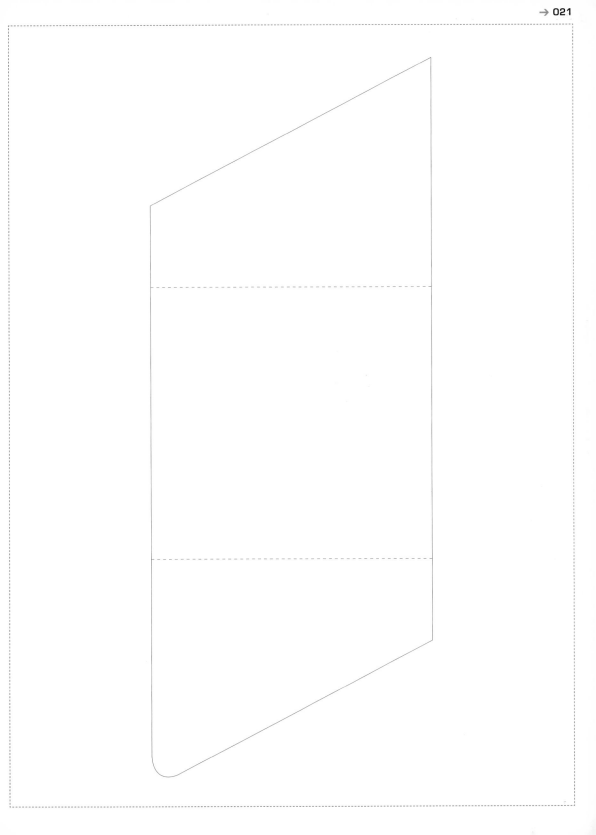

DESIGN	→	Paul Farrington
PROJECT	→	Artist's book
DESCRIPTION	→	This book is formed of five sheets of A4 (8¹/⁸ x 11⁵/⁸ in) paper printed both sides, then folded down to A6 (4¹/⁸ x 5³/⁴ in). These sheets are then bound with a white elastic band, and the result is a book that has "hidden" pages inside the folds.

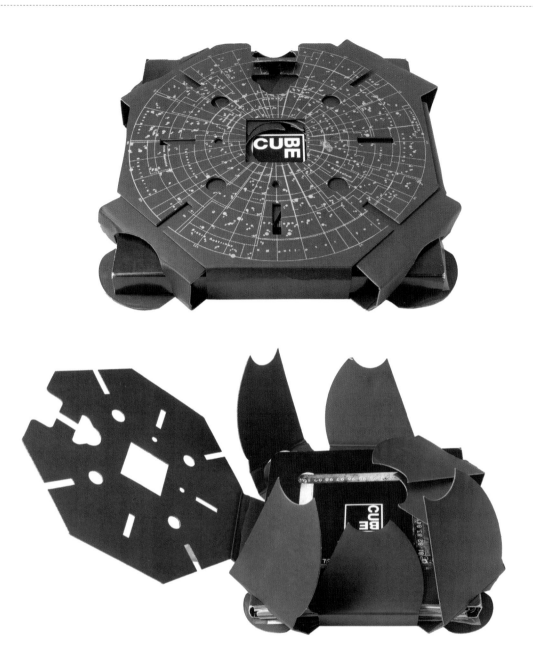

DESIGN	→	Giorgio De Mitri/Patrici Di Gioia
PROJECT	→	*CUBE* magazine
DESCRIPTION	→	Die-cut, multifaceted magazine packaging. This card package, designed to hold a limited edition magazine, shows how, by pushing the conventions of packaging design, we can produce something that is absolutely unique.

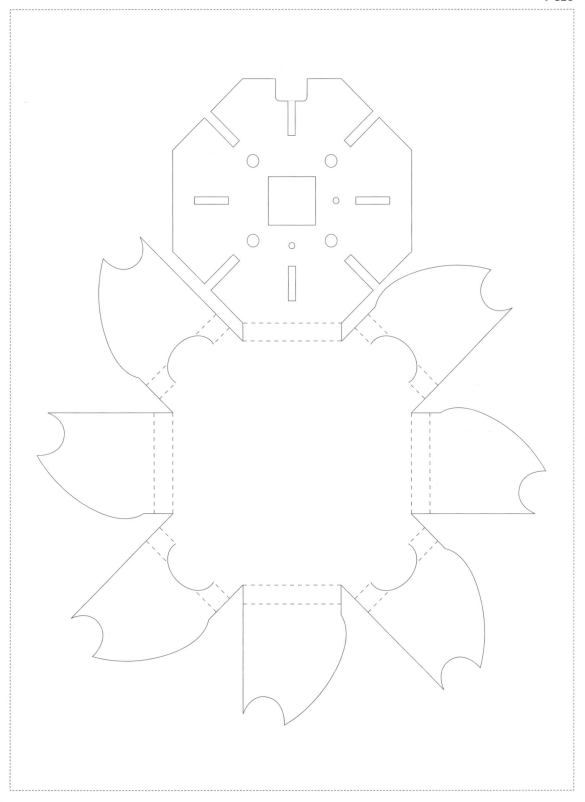

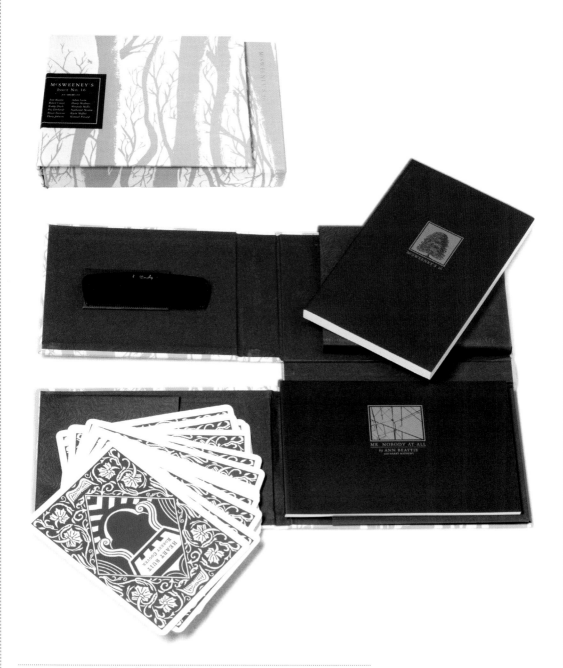

DESIGN	→	Dave Eggers/Eli Horowitz
PROJECT	→	*McSweeney's* magazine
DESCRIPTION	→	Shown here is a great example of this "journal's" design. For Issue 16, they wanted to create something that looked like a book, but unfolded unexpectedly. The idea has been successfully executed to a very high and considered finish.

DESIGN → FL@33

PROJECT → A collection of poetry

DESCRIPTION → Here, two separate poetry collections sit as loose leaves
 inside two pockets created by paper that has been folded
 round and pasted to form pockets at the bottom of the
 alternate (and opposite) sides. This complicated cover
 concept was produced using just a single piece of paper.

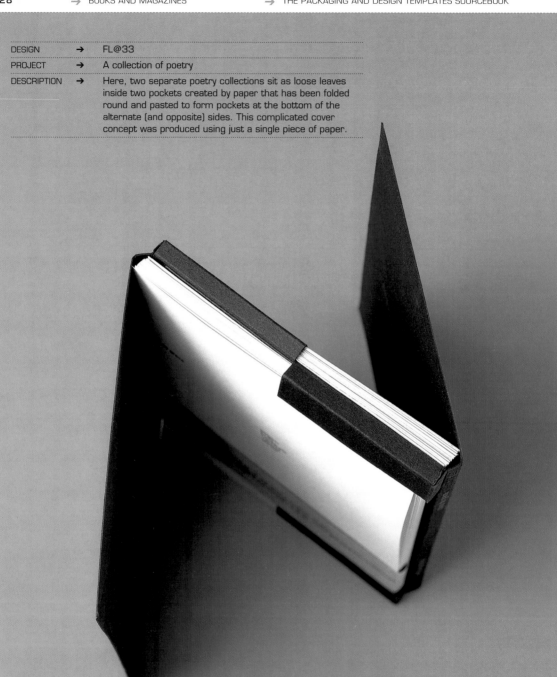

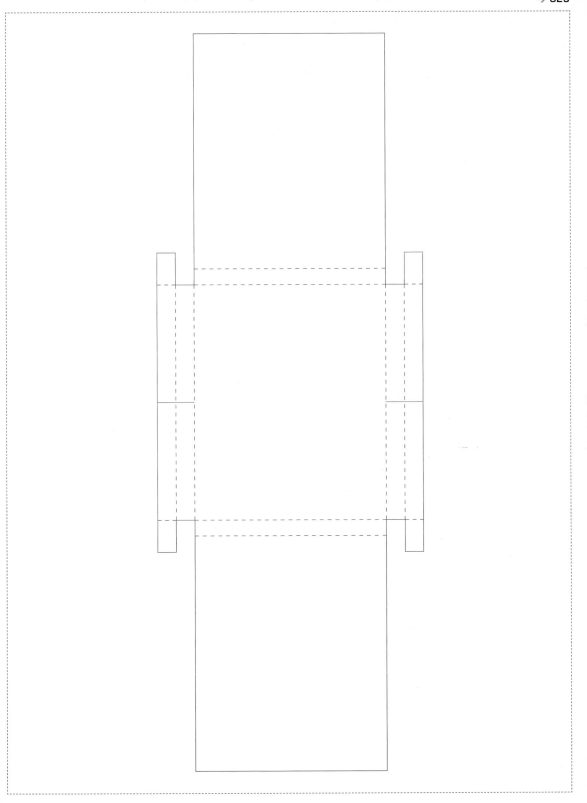

BROCHURES AND CATALOGS

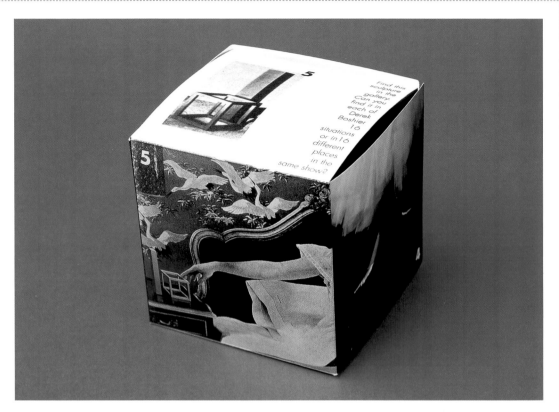

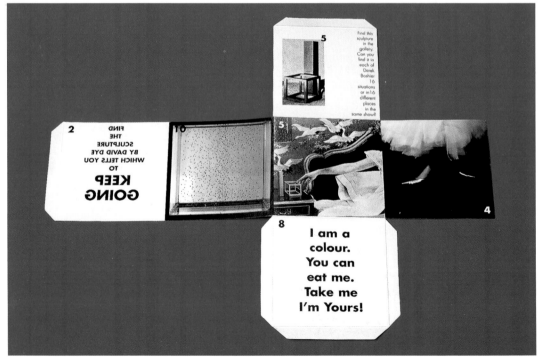

DESIGN	→	Joanne Stockham
PROJECT	→	Children's exhibition brochure
DESCRIPTION	→	To engage the interest and gain the understanding of children visiting a conceptual art exhibition, artist Joanne Stockham created this card puzzle-cube that guides them around the gallery and encourages them to look at, and ask questions about, the various pieces of work.

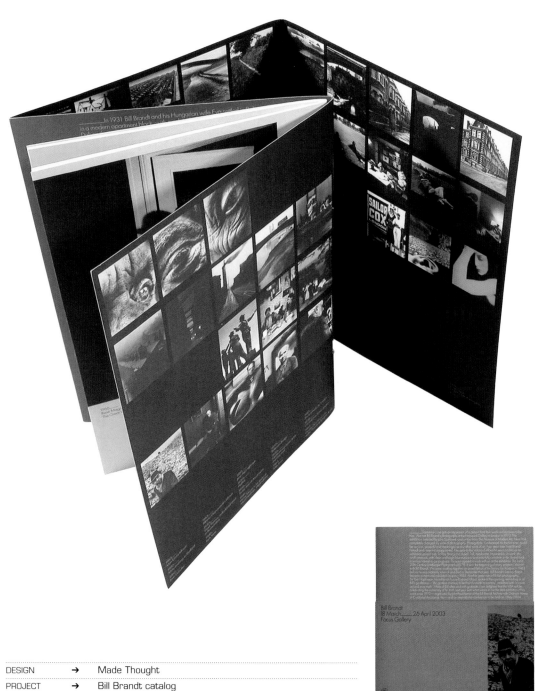

DESIGN	→	Made Thought
PROJECT	→	Bill Brandt catalog
DESCRIPTION	→	This saddle-stitched catalog incorporates an extended cover section that wraps back around itself to form eight internal panels, on which small reproductions of Brandt's images appear.

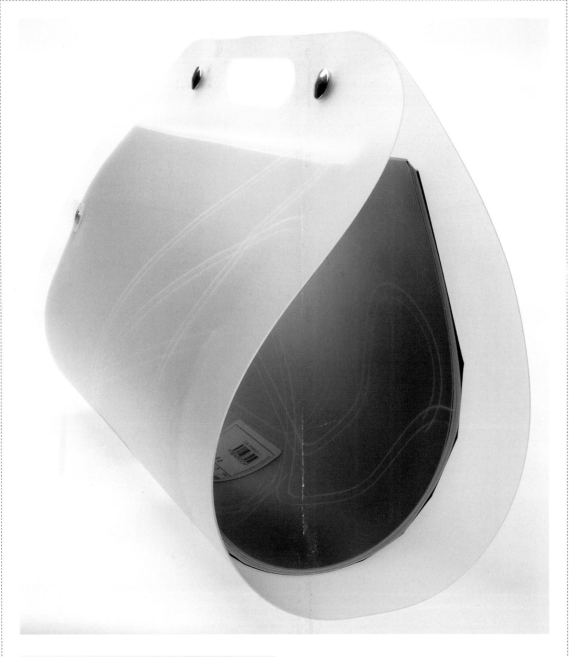

DESIGN	→	Area
PROJECT	→	Large-format exhibition catalog
DESCRIPTION	→	This catalog has a polypropylene cover which allows it to be folded in half and clipped together with press studs to form a "handbag," making it more manageable to carry around.

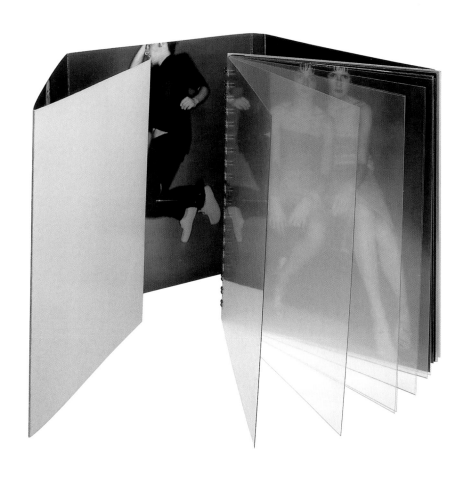

DESIGN	→	Area
PROJECT	→	Fashion catalog
DESCRIPTION	→	This luxurious catalog consists of roll-folded front and back covers and contains a series of acetate sheets that slowly reveal the photographic images within as they are turned.

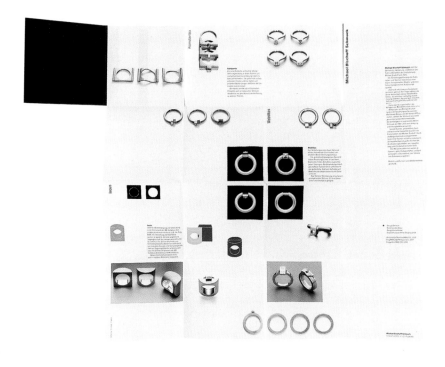

DESIGN	→	HDR Design
PROJECT	→	Brochure
DESCRIPTION	→	This pocketbook-format brochure folds out to 395mm x 395mm. It has a plain black card cover that uses a black elastic band to seal it.

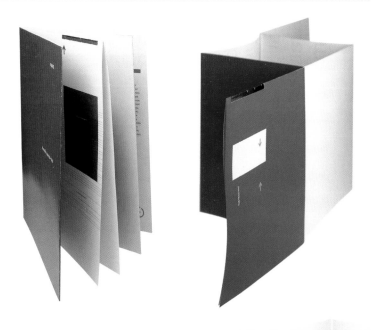

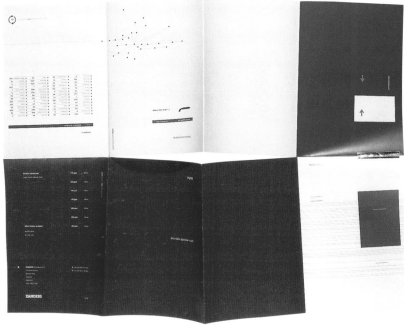

DESIGN	→	Roundel
PROJECT	→	Brochure for Zanders FinePapers
DESCRIPTION	→	This brochure works initially as a conventional document with eight double-section pages. However, it is possible to unfold the brochure into a flat sheet, and once this is done, the method that makes the brochure possible is revealed. The flat sheet is cut along the central fold, which allows the folding to be made.

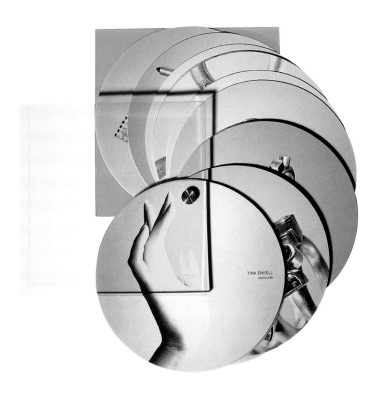

DESIGN	→	Area
PROJECT	→	Jewelry catalog
DESCRIPTION	→	An original format and binding system is used for this jewelry designer's promotional brochure. The pages are circular in form and the outer covers are made from two different colored sheets of perspex, cut into a square format. The binding is one brass binding screw, which allows the brochure to be fanned out.

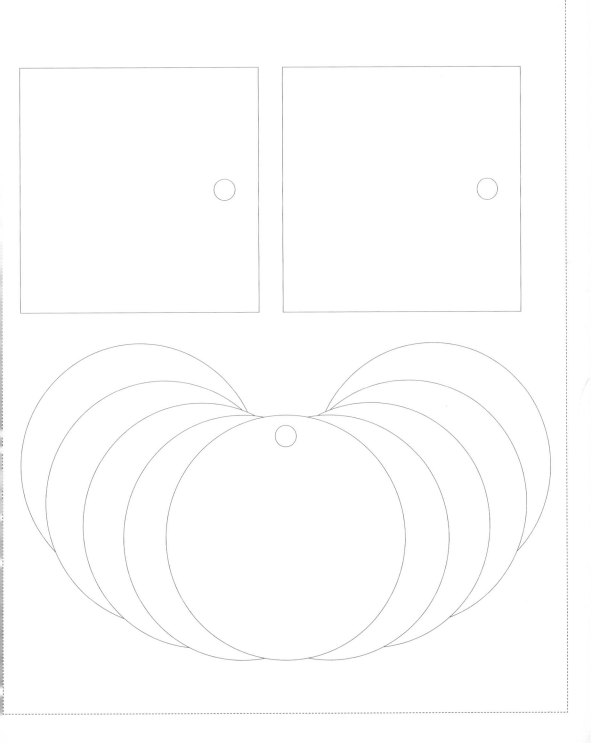

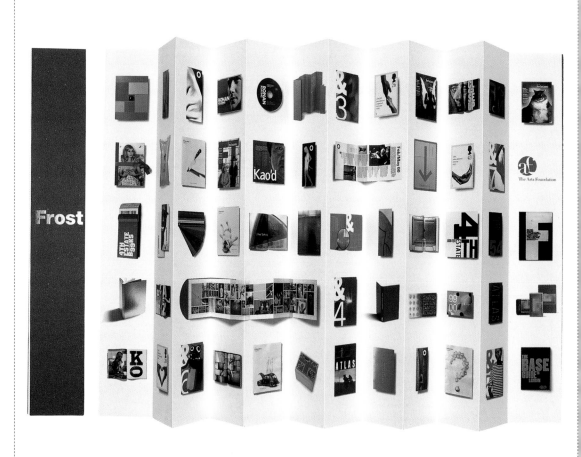

DESIGN	→	Vince Frost
PROJECT	→	Portfolio brochure
DESCRIPTION	→	This large-format concertina portfolio can be read through each opening or by laying the whole work out. There is no explanatory text; the work for often well-known clients and Frost's layout are enough to tell the story.

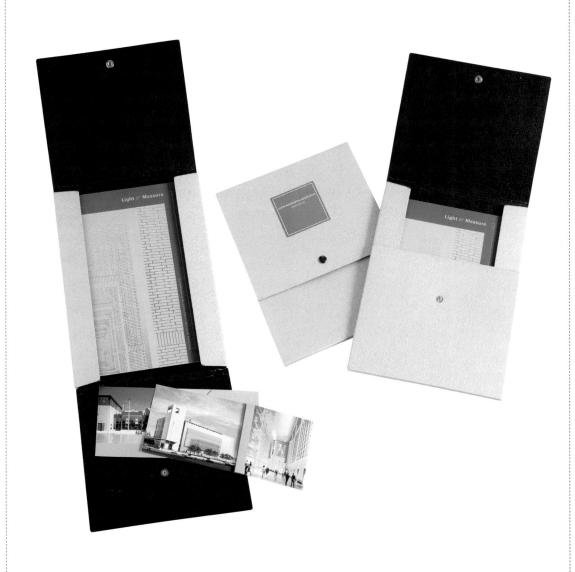

DESIGN	→	Nassar Design
PROJECT	→	Brochure for architecture firm
DESCRIPTION	→	Simple but lavishly produced card folder. This heavyweight, metallic card stock has been die-cut with subtle radius corners and then fixed with a metal snap closure. The cover is finished with a shiny square label.

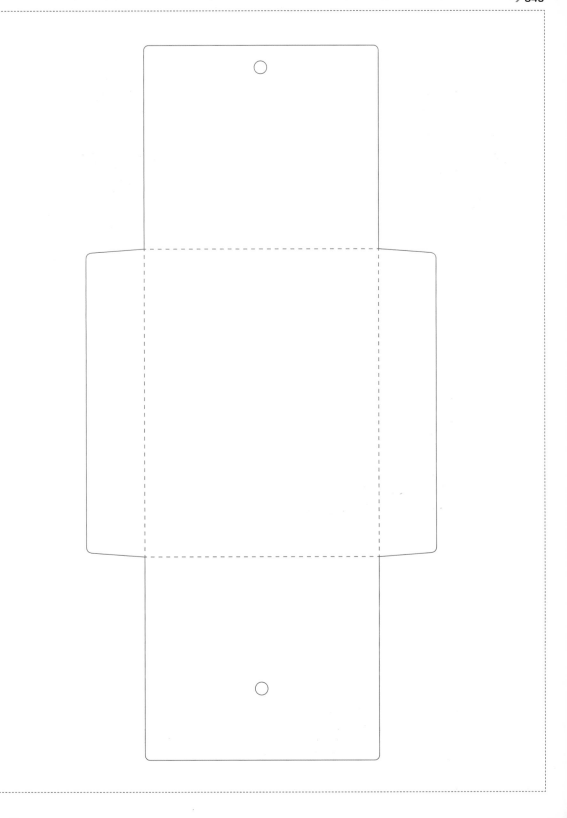

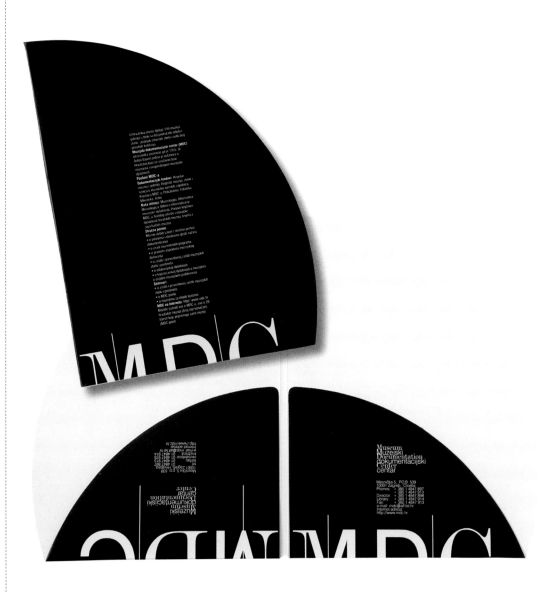

DESIGN	→	Studio International
PROJECT	→	Circular folder brochure
DESCRIPTION	→	This museum brochure has a bowed edge which allows the rectangular inserts to protrude, prompting a dialogue between a curve and a straight line. In flat form, the folder template is a circle with a skinny wedge of pie missing at six o'clock. The sliced bottom of the sphere folds up to form pocket flaps.

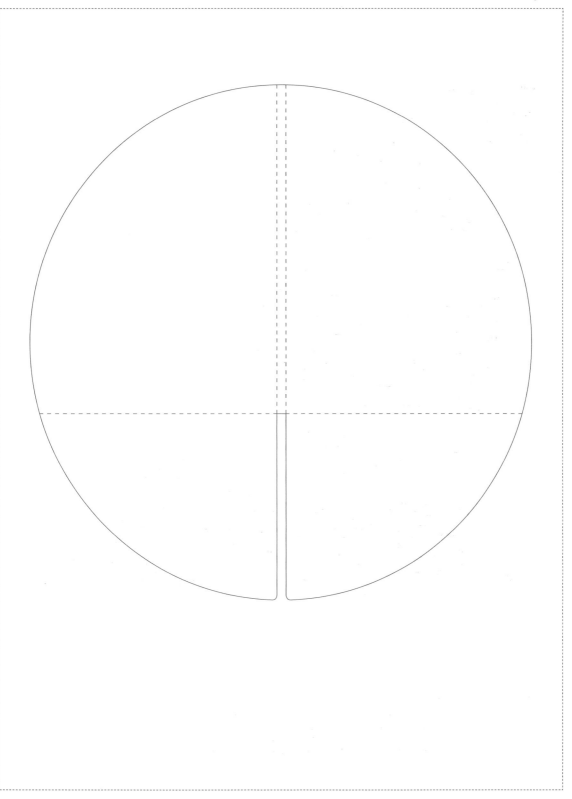

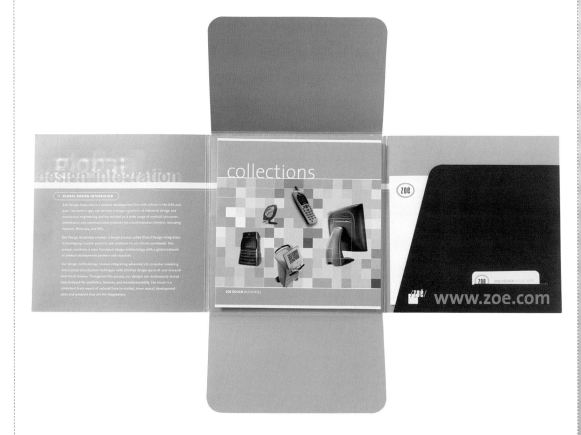

DESIGN	→	Blue Lounge Design
PROJECT	→	Promotional brochure
DESCRIPTION	→	This multi-fold brochure consists of a number of flaps that, when opened, reveal the company's brochure, business card, and covering letter.

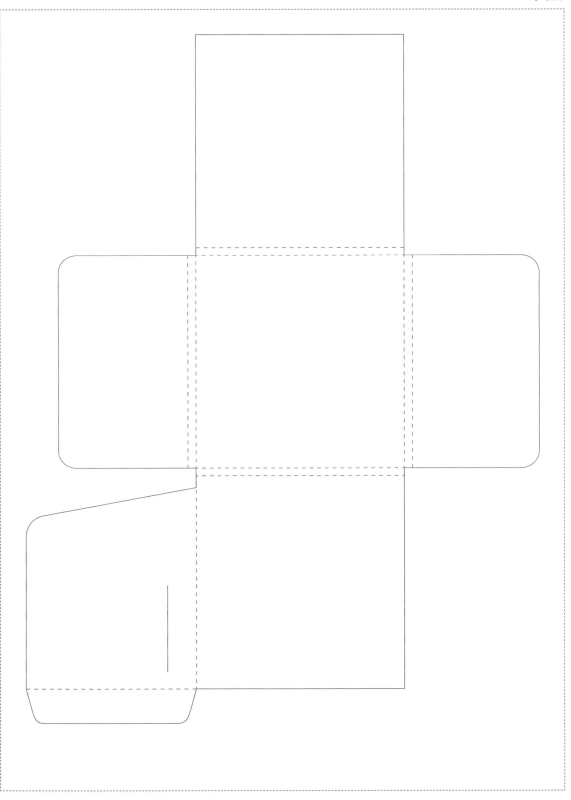

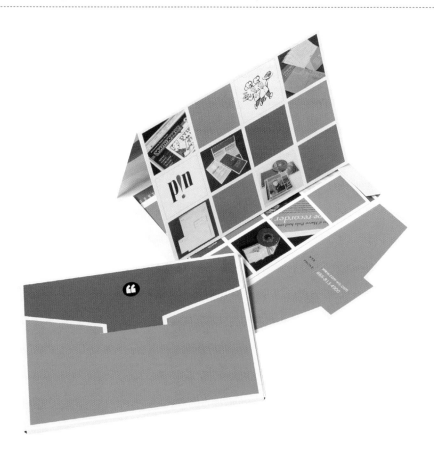

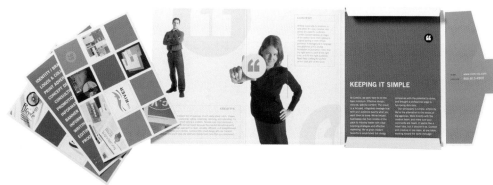

DESIGN	→	Communication Visual
PROJECT	→	Promotional brochure
DESCRIPTION	→	Part brochure, part folder, and part envelope, this hybrid piece features folded tabs that cradle interchangeable postcard inserts. The package closes with a tab/slot system.

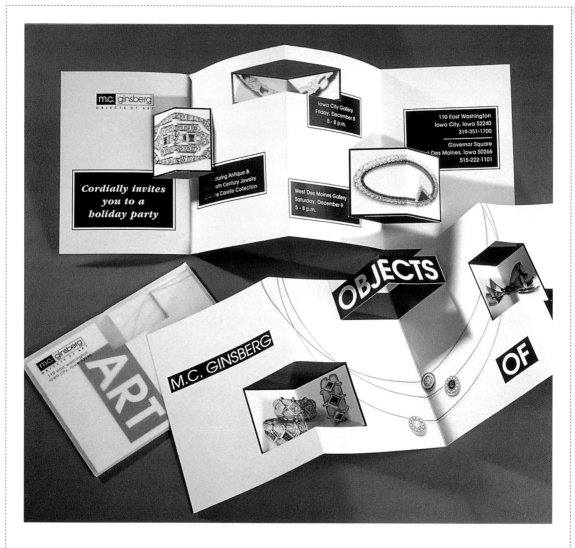

DESIGN	→	Sayles Graphic Design
PROJECT	→	Gallery brochure
DESCRIPTION	→	Several carefully placed die-cuts and strikes on this card brochure help to create what almost look like shelves or showcase space for this jewelry client. The effect is easily achieved and very striking.

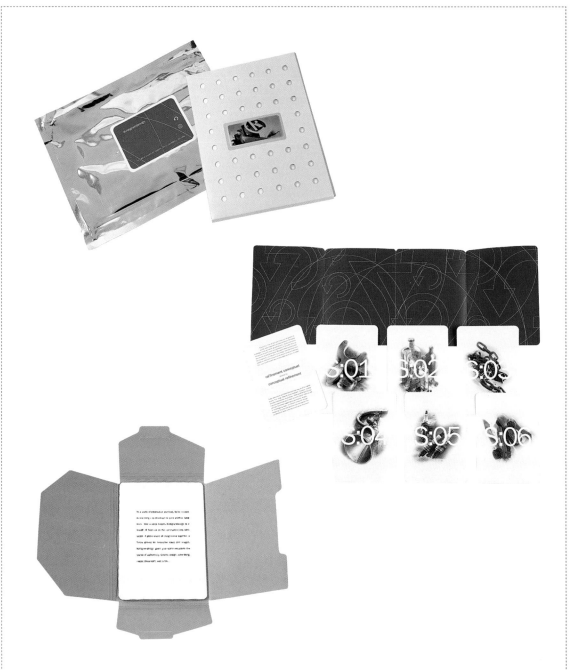

DESIGN	→	Kolégram Design
PROJECT	→	Brochure folder
DESCRIPTION	→	Custom-made card brochure folder, designed to hold a series of postcards. This one has die-cut slots on the back that hold business cards.

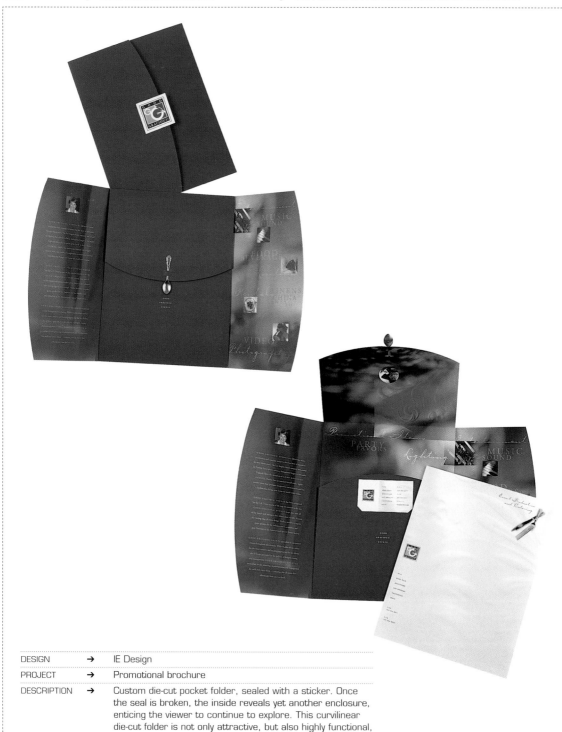

DESIGN	→	IE Design
PROJECT	→	Promotional brochure
DESCRIPTION	→	Custom die-cut pocket folder, sealed with a sticker. Once the seal is broken, the inside reveals yet another enclosure, enticing the viewer to continue to explore. This curvilinear die-cut folder is not only attractive, but also highly functional, housing business cards, letters, and other promotional material within.

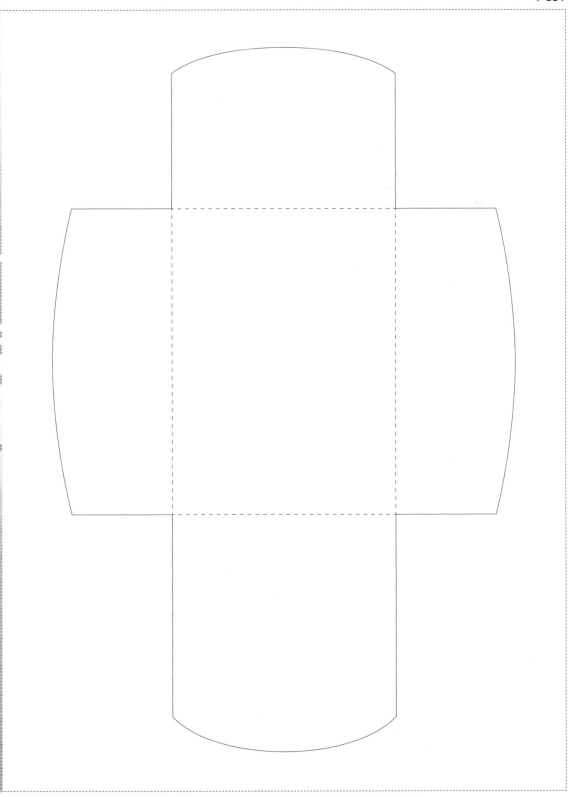

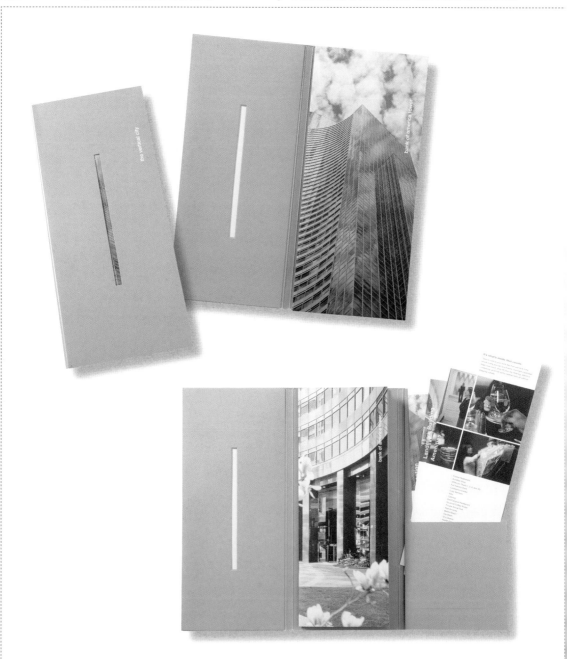

DESIGN	→	Methodologie
PROJECT	→	Brochure
DESCRIPTION	→	This unusually tall and slim folder is accentuated by an elegant decorative die-cut slot in the cover. The back pocket is constructed of a flap that folds from the right and glues along the top and bottom edges. A die-cut in the flap creates a slot for inserts.

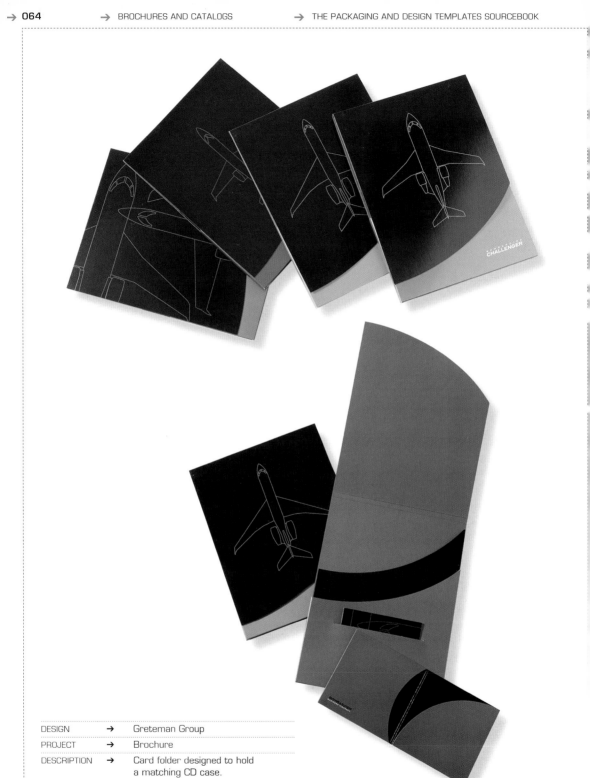

DESIGN	→	Greteman Group
PROJECT	→	Brochure
DESCRIPTION	→	Card folder designed to hold a matching CD case.

03

GREETINGS AND INVITATIONS

Artomatic, in association with Royal Mail host OPEN UP their first exhibition showcasing the best in concept, design and production in Direct Mail from across the globe ⇨

ARTOMATIC Royal Mail

DESIGN	→	B+B
PROJECT	→	Exhibition call for entries and invitation
DESCRIPTION	→	Flat-pack printed box. The box not only acts as an invitation to the exhibition, but can also be constructed and used to submit work.

You are invited to attend one of three special evenings at Artomatic

Wednesday 25 April to Friday 27 April Open until 9.00pm

The show will continue until Thursday 3 May 10.00 – 5.00pm

⇧ OPEN HERE

OPEN HERE ⇩

In association with Royal Mail, Artomatic hosts OPEN UP their first exhibition of Direct Mail celebrating the best in concepts, design and production from across the globe

Admits one

OPEN UP
Tuesday
24 April 2001
6.30 – 10.00pm
at Artomatic

Artomatic
13/14 Great
Sutton Street
London, EC1

RSVP
Artomatic
T 020 7566 0171
E OpenUp@artomatic.co.uk

⇧ OPEN HERE

OPEN HERE ⇩

In association with Royal Mail, Artomatic hosts OPEN UP their first exhibition of Direct Mail celebrating the best in concepts design and production from across the globe

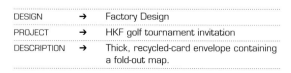

DESIGN	→	Factory Design
PROJECT	→	HKF golf tournament invitation
DESCRIPTION	→	Thick, recycled-card envelope containing a fold-out map.

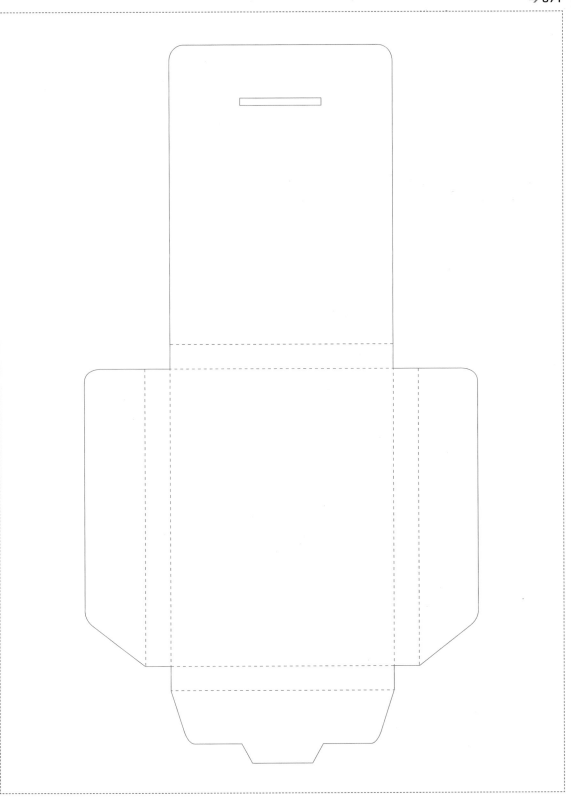

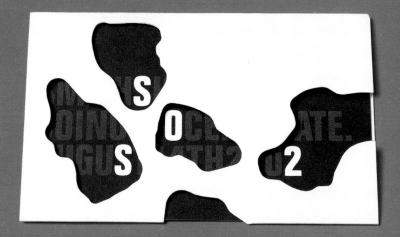

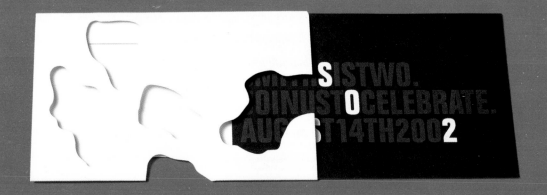

DESIGN	→	Rodney Fitch
PROJECT	→	Invitation for Smiths of Smithfield
DESCRIPTION	→	This second anniversary invitation to the restaurant Smiths of Smithfield, uses a die-cut cowhide device to reveal the "SOS 2" information. The inner invitation then slides out to formally invite you to the party. The cowhide design references the restaurant's location in the Smithfield meat market.

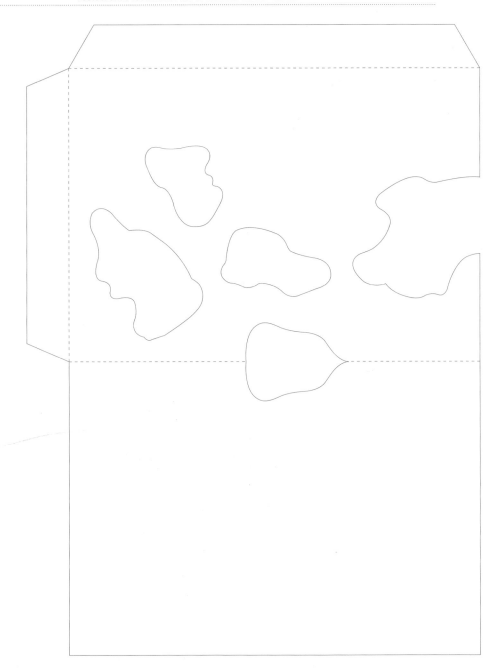

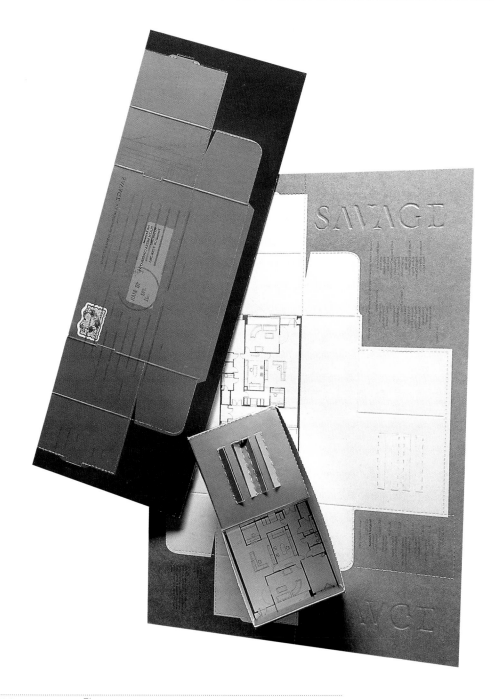

DESIGN	→	Plazm
PROJECT	→	Invitation to the opening of Savage Open House art gallery
DESCRIPTION	→	Die-cut and perforated invitation/mailer that can be assembled into a diagrammatic replica of the gallery space.

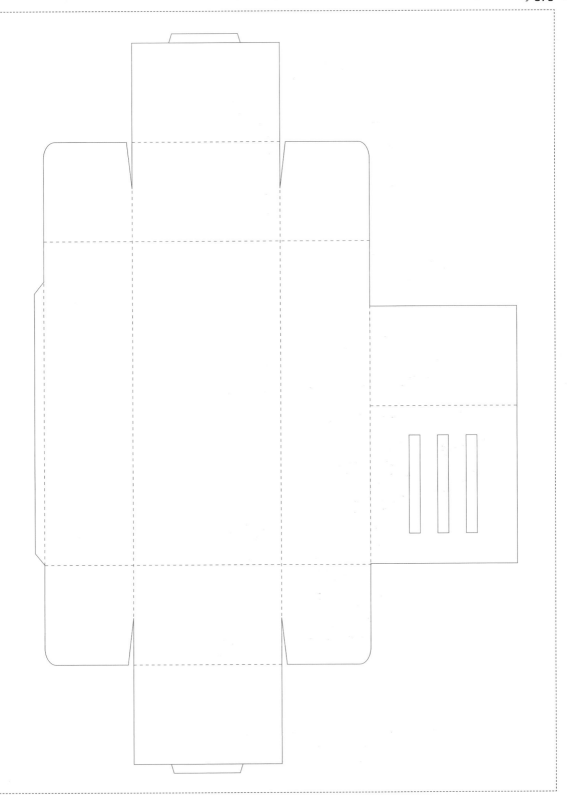

DESIGN	→	sans+baum
PROJECT	→	*Future Map* invitation/catalog
DESCRIPTION	→	*Future Map* is an annual show celebrating the best work of graduates from The London Institute. For the exhibition, sans+baum created uncoated paper bag invitations which were sent out shrink-wrapped. Information sheets placed next to the works could be torn off by the visitors and collected into the bag, thereby turning it into a low-tech, handmade catalog of the show.

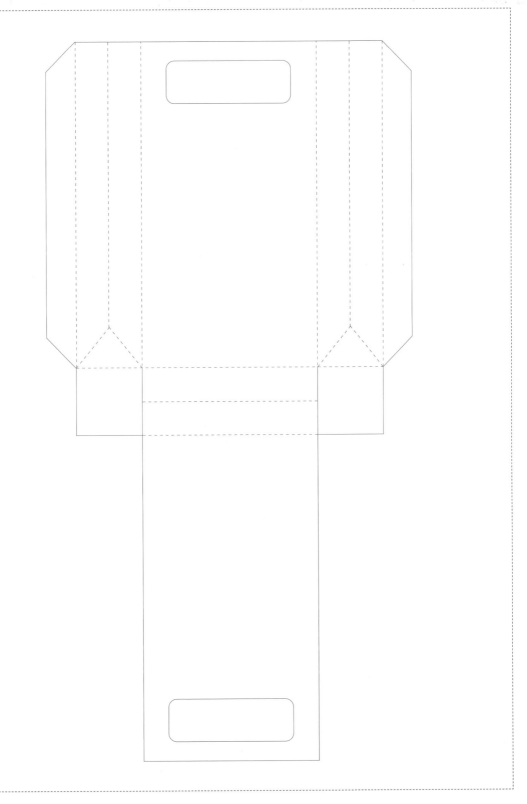

DESIGN → Agitprop

PROJECT → Invitation to a fashion show

DESCRIPTION → Printed single color, die-cut, and folded to make a free-standing desk card.

CHRISTIAN BLANKEN
FALL/WINTER 2002

MONDAY 18TH FEBRUARY 2002
4.00-8.00PM
AT SUITE 416, METROPOLITAN HOTEL
19 OLD PARK LANE, LONDON W1

RSVP
KIM BLAKE 0207.234.0276
INFO@KIMBLAKEPR.COM

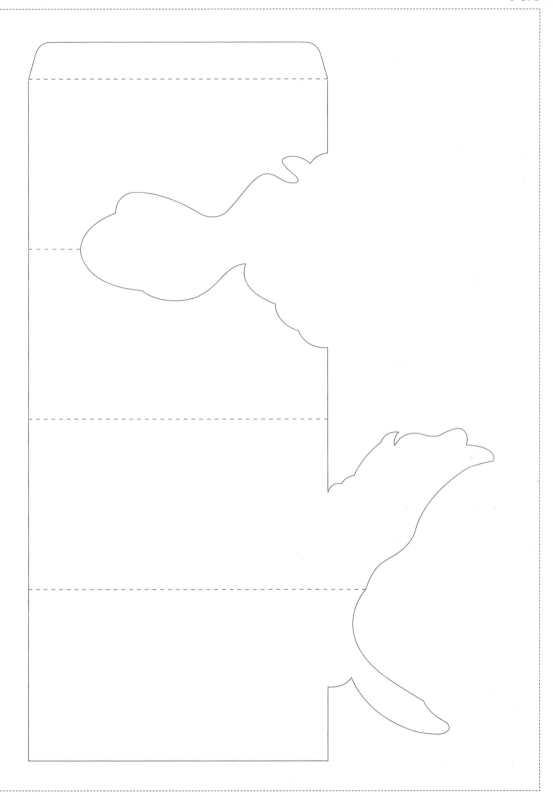

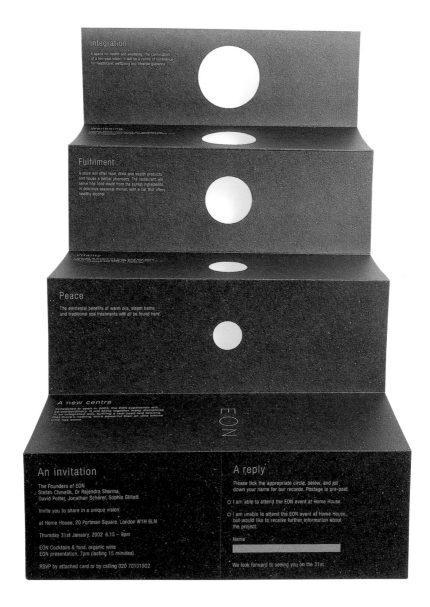

DESIGN	→	Vince Frost
PROJECT	→	Party invitation for The EON Centre for Health and Wellbeing
DESCRIPTION	→	This invitation has a multiple concertina fold with a set of ever-decreasing concentric circles die-cut into the center of each one. The last concentric circle is printed and reveals itself to be the "O" in EON. The last concertina fold is perforated into two halves which can be torn off and used. One is the invitation card and the other an RSVP form.

DESIGN	→	Imagination
PROJECT	→	Invitation for Mulligan Womenswear catwalk show at London Fashion Week
DESCRIPTION	→	Designer Brian Griver chose to experiment with printing typographic patterns over closed pleats for this invitation. When the card breaks open over the pleats, it reveals information about the show and contact details. The invitation is printed on Ikono silk matte 200gsm paper, scored, and then individually hand-folded.

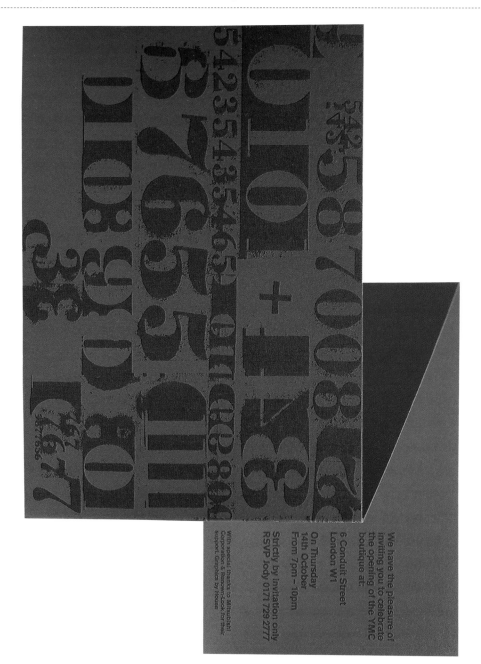

We have the pleasure of
inviting you to celebrate
the opening of the YMC
boutique at:

6 Conduit Street
London W1

On Thursday
14th October
From 7pm – 10pm

Strictly by invitation only
RSVP Jody 0171 729 2777

With special thanks to Mitsubishi
Corporation & Reacore-Look for their
support. Graphics by House

DESIGN	→	Julian House
PROJECT	→	Invitation for the opening of a YMC shop
DESCRIPTION	→	The invitation is silkscreen-printed single color on eyeball-jarring blue-plan card in a concertina format. Bright pink text is printed in a very thick silkscreen ink to allow maximum opacity of the discordant colors.

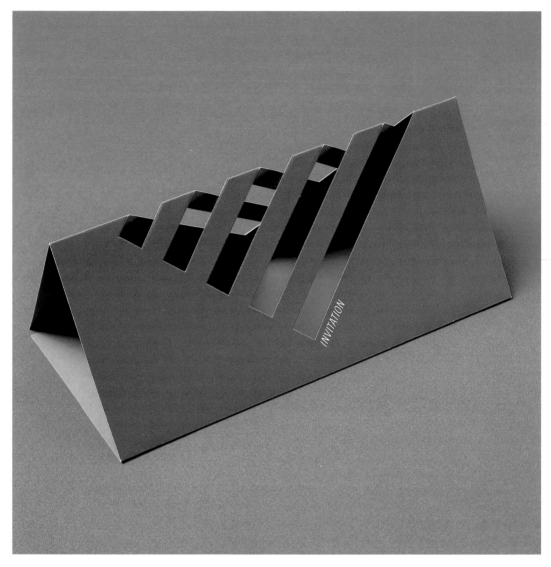

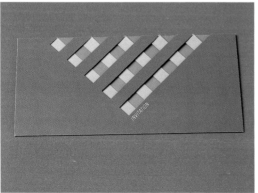

DESIGN	→	Zuan Club
PROJECT	→	Fashion show invitation
DESCRIPTION	→	Opened out flat, this invitation is simply five cut-out strips lined to create a square. It is angled on the page like a diamond and creased through the middle. When this is folded, the die-cut spaces and the strips between them overlap to create the lace-like pattern and effect.

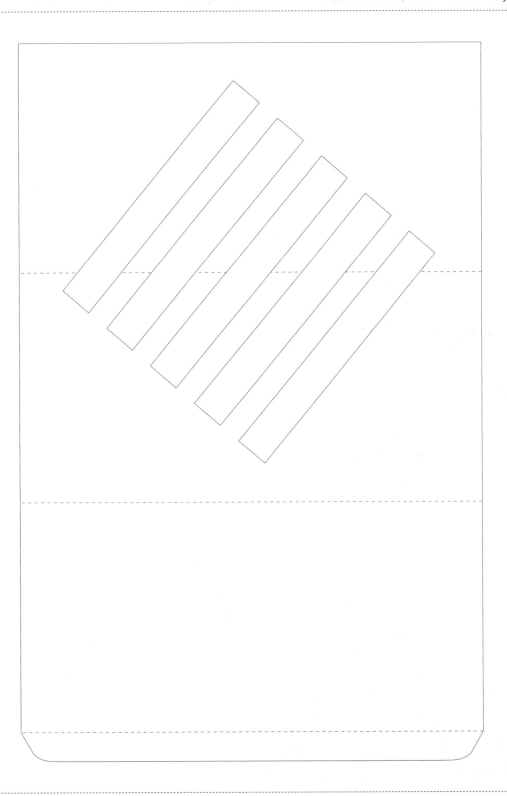

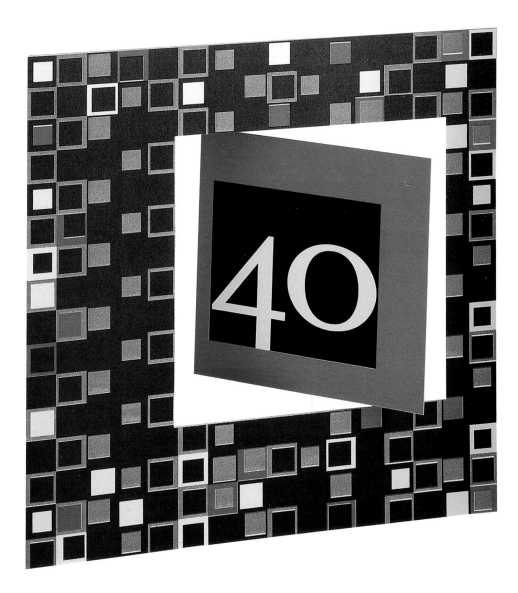

DESIGN	→	Margot Madison
PROJECT	→	Birthday card
DESCRIPTION	→	This invitation is a play on "turning" 40 years old. The birthday card plays with 1950s-style wallpaper and material pattern effects printed in gold, brown, and strong pink. A small square of stiff card is set inside a square cut-out in the invitation, which twirls around when it is removed from the envelope. It is held together by a delicate thread of gold that allows the square to rotate freely.

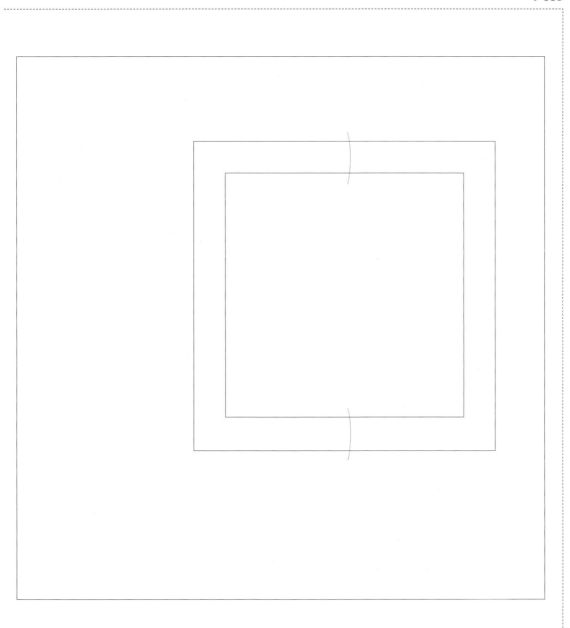

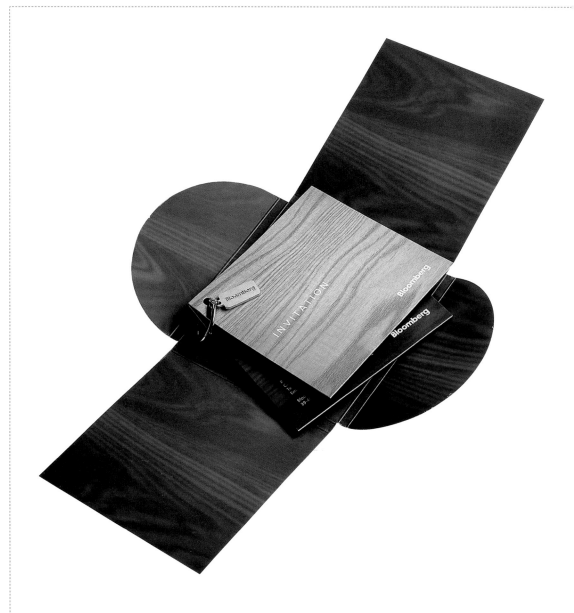

DESIGN	→	Bloomberg
PROJECT	→	Invitation
DESCRIPTION	→	Card folder containing two card inserts printed in various wood veneer textures.

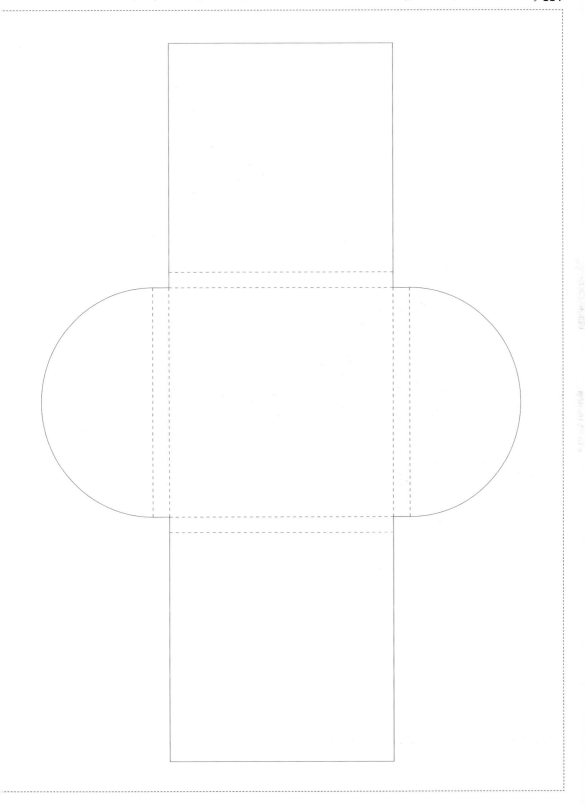

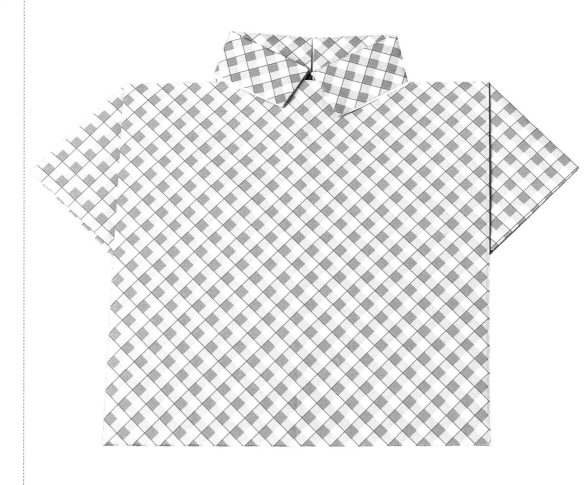

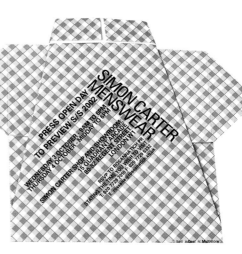

DESIGN	→	Multistorey
PROJECT	→	Press day invitation for menswear designer Simon Carter
DESCRIPTION	→	Shirt-shaped invitation constructed from one sheet of paper, printed with purple gingham.

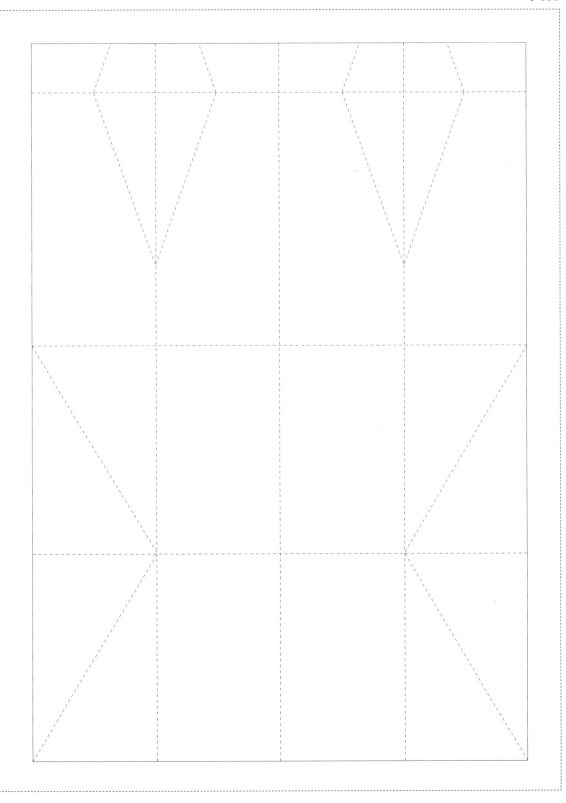

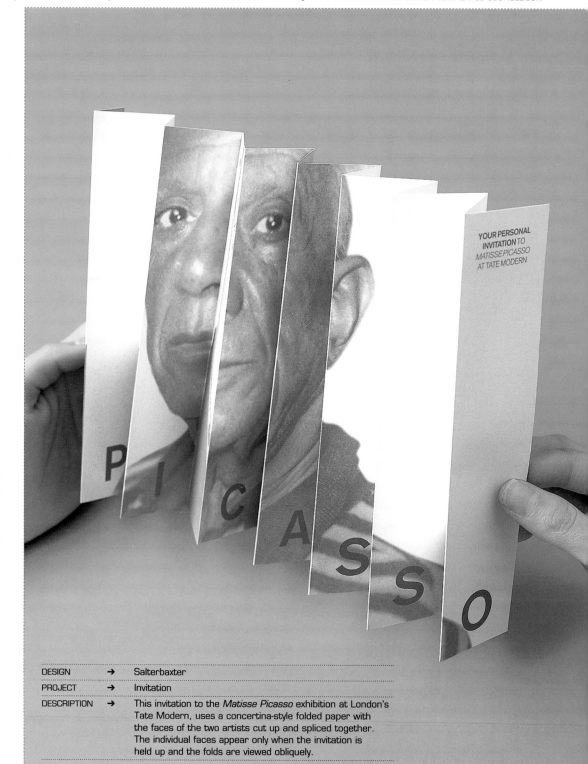

DESIGN	→	Salterbaxter
PROJECT	→	Invitation
DESCRIPTION	→	This invitation to the *Matisse Picasso* exhibition at London's Tate Modern, uses a concertina-style folded paper with the faces of the two artists cut up and spliced together. The individual faces appear only when the invitation is held up and the folds are viewed obliquely.

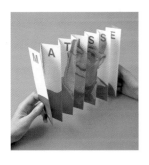

MATISSE

PICASSO

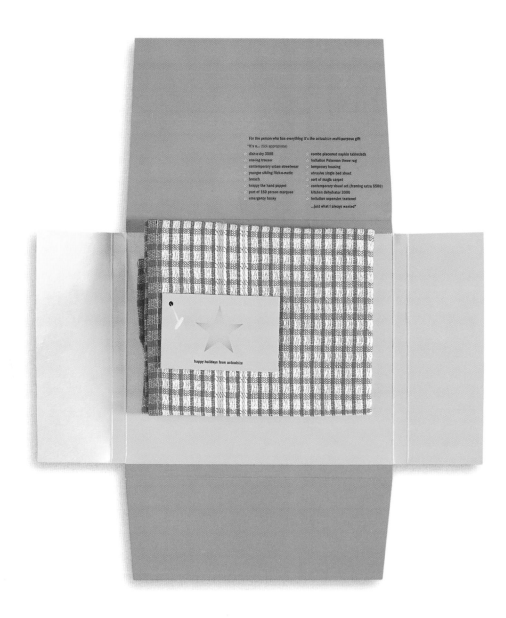

DESIGN	→	Actual Size
PROJECT	→	Greetings card
DESCRIPTION	→	Cardboard packaging for a festive greeting, based on the idea of receiving boring and diabolically inappropriate and/or ill-fitting gifts from elderly relatives. This simple card folder could easily be adapted to hold a number of different items.

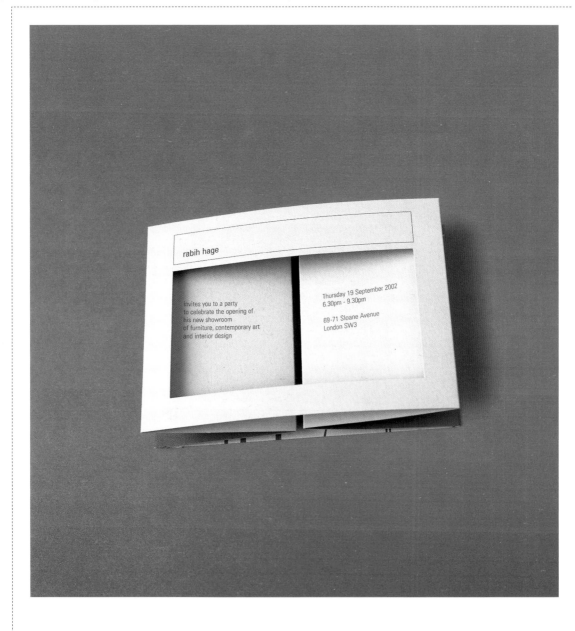

DESIGN	→	Hat-trick
PROJECT	→	Invitation
DESCRIPTION	→	This invitation to the opening of the interior design company Rabih Hage, uses folds and die-cuts to open into a shop window format. Looking through the die-cut rectangle, you can see examples of products available through silhouetted illustrations.

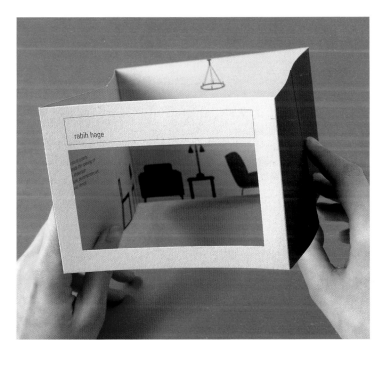

DESIGN	→	Chen Design Associates
PROJECT	→	Wedding invitation
DESCRIPTION	→	The small folder contains a collection of wraps and cards made from such materials as handmade and Japanese paper. It also utilizes the craft-like quality of letterpress printing and metallic silver hand-stamps.

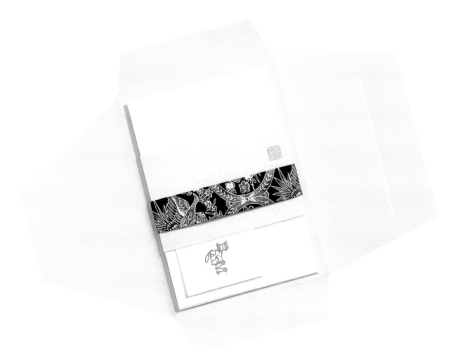

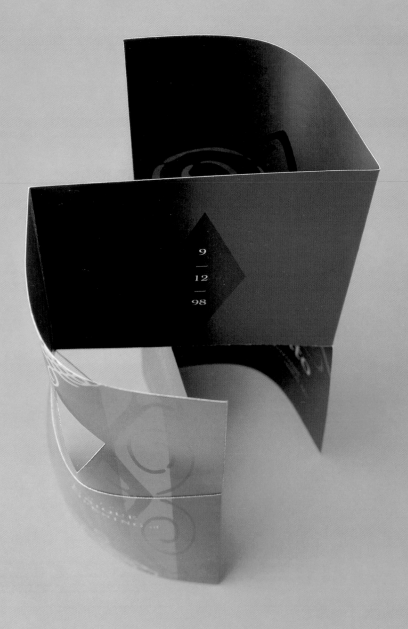

DESIGN	→	Vrontikis Design
PROJECT	→	Invitation
DESCRIPTION	→	This unusual piece is constructed from a single piece of card cut into an "n" shape with a "tail," the bridge of the "n" and the tail each forming half the size of the uprights. When the card is folded up, concertina-style, the tail on the right folds inward through the center to tuck and glue round the upright on the left, transforming into the clever hinged invitation that opens both ways.

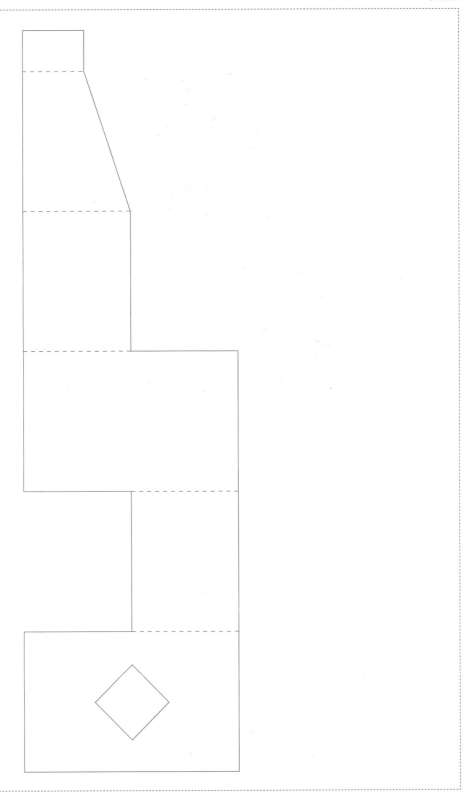

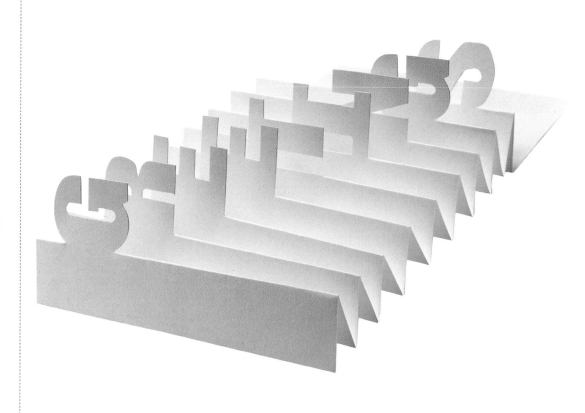

DESIGN	→	Octavius Murray
PROJECT	→	Greetings card
DESCRIPTION	→	Concertina paper-sculpture card. Letters have been carefully cut from the reverse of each fold to create this stunning effect.

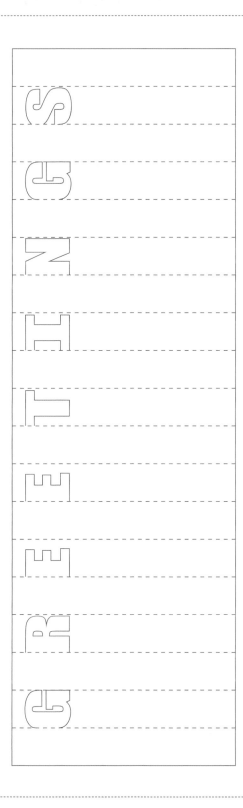

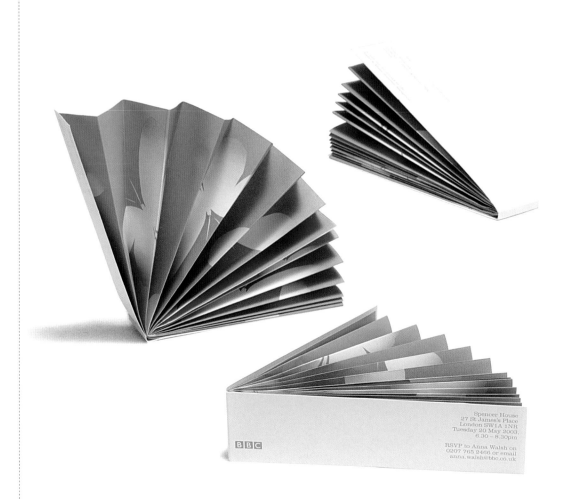

Spencer House
27 St James's Place
London SW1A 1NR
Tuesday 20 May 2003,
6.30 – 8.30pm

RSVP to Anna Walsh on
0207 765 2466 or email
anna.walsh@bbc.co.uk

DESIGN	→	NB: Studio
PROJECT	→	Invitation
DESCRIPTION	→	Concertina-folded card invitations for the BBC's summer party. These fans have a dual function. Not only are they invitations, they are also usable fans.

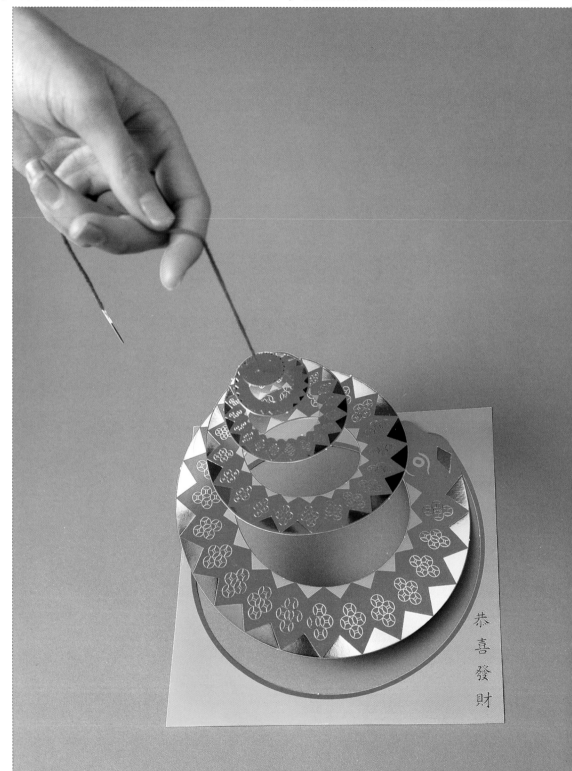

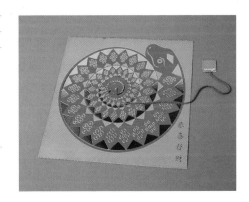

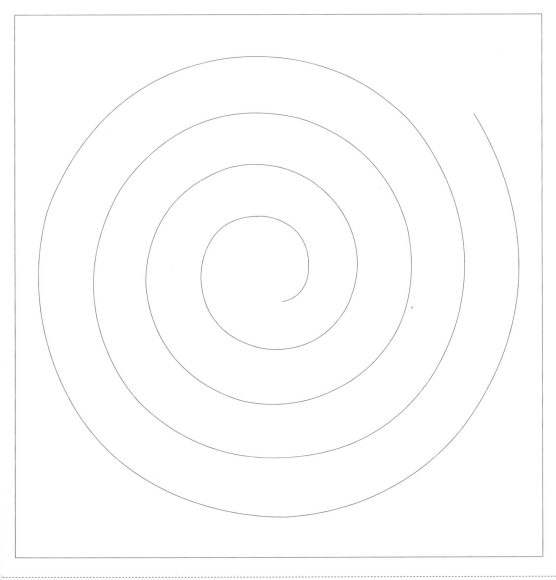

DESIGN	→	Carter Wong Tomlin
PROJECT	→	Chinese New Year card for Orange
DESCRIPTION	→	A circular rendition of a Chinese snake, designed as an ever-decreasing spiral, punched out of a square-format card. The cotton thread secured to the snake's head enabled the cut-out to be hung up. Its slow spiral movement, coupled with the obligatory printed Chinese colors of red, orange, and gold blocking, proved to be very eye-catching.

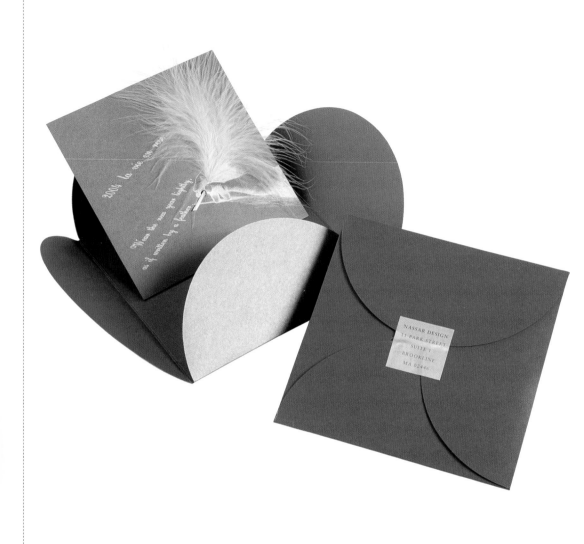

DESIGN	→	Nassar Design
PROJECT	→	Greetings card
DESCRIPTION	→	Crimson metallic envelope custom die-cut in the shape of an open flower. The envelope is flat on one side and pops up into a dimensional object on the other. The envelope flaps are letterpress scored, folded, and held closed with foil stickers.

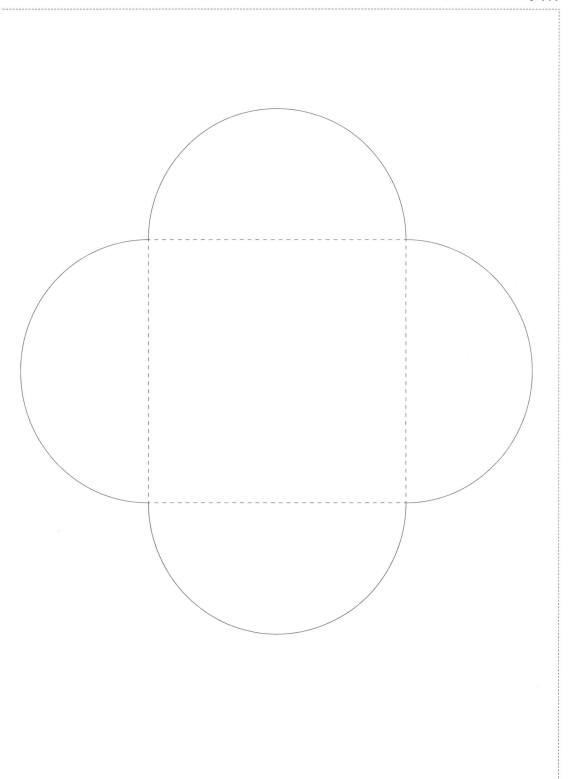

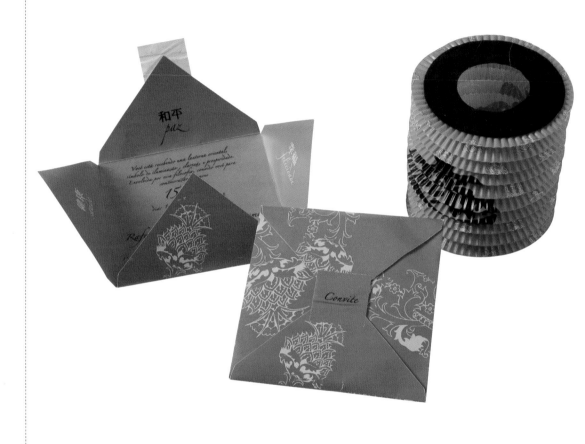

DESIGN	→	Márcia Albuquerque & Carolina Terra
PROJECT	→	Birthday party invite
DESCRIPTION	→	Duplex paper multifold envelope that holds a Chinese lantern.

Katy Parkinson
Project & Conference Manager
t +44 (0)20 8487 2211
f +44 (0)20 8487 2311
kparkinson@richmondevents.com

On Monday 12 June, from 18:45hrs for lite bites and drinks,
in the Library at The London Marriott, County Hall,
followed by a spin on the London Eye at 21:00hrs

DESIGN	→	Bull Rodger
PROJECT	→	Invitation
DESCRIPTION	→	Identity for a travel conference held on a boat. Simple paper boat made from the page of a travel brochure.

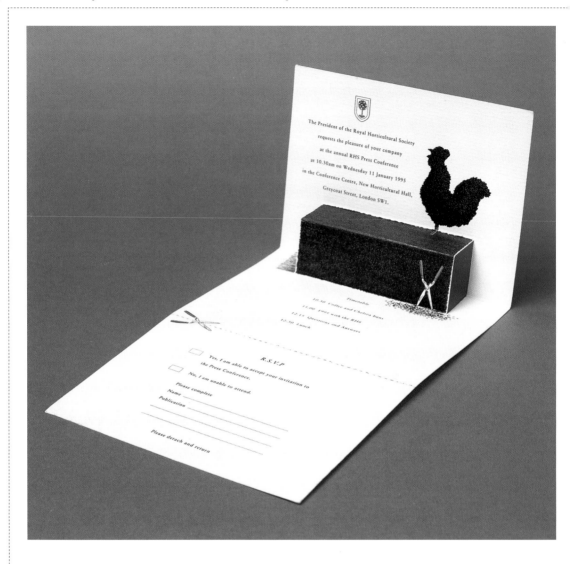

DESIGN	→	Carter Wong Tomlin
PROJECT	→	Invitation
DESCRIPTION	→	The parallel fold on this press conference invitation for the Royal Horticultural Society creates a topiary hedge on which a cockerel sits.

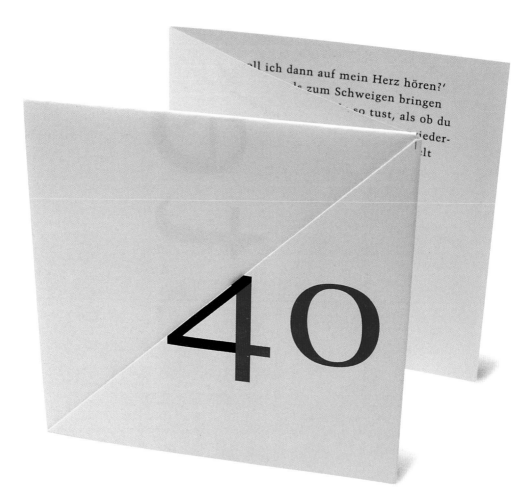

DESIGN	→	Peter Felder
PROJECT	→	Birthday party invitation
DESCRIPTION	→	The invitation gatefolds out conventionally to its center, and then a single diagonal fold causes the design to turn the corner.

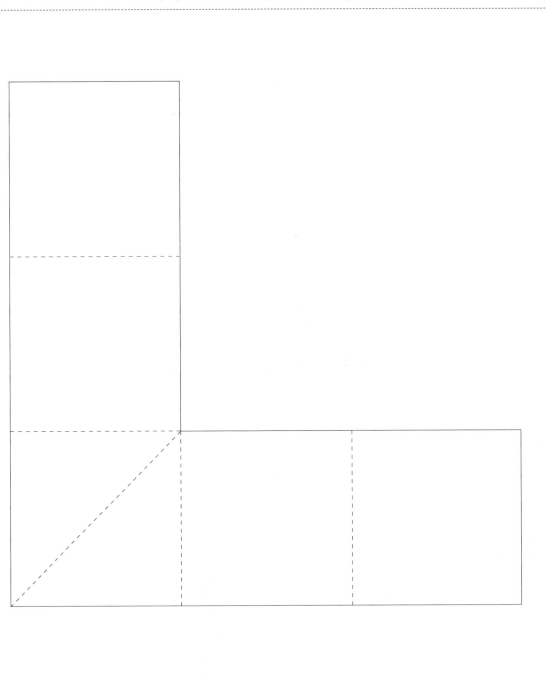

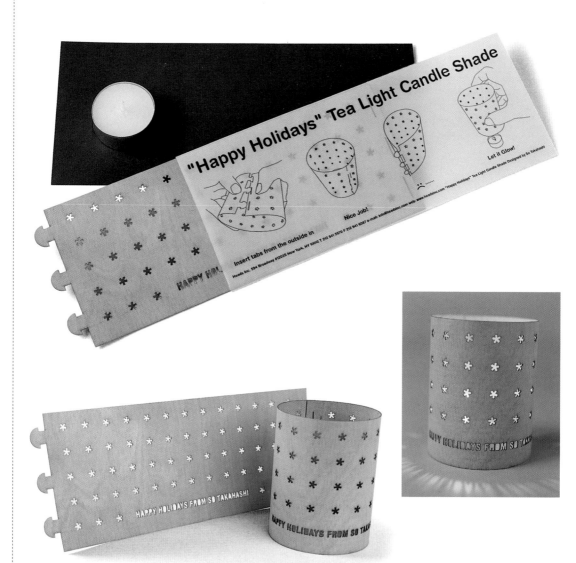

DESIGN	→	Heads, Inc.
PROJECT	→	Greetings card
DESCRIPTION	→	Thin birch plywood has been laser-cut with a geometric pattern to create this candle lantern.

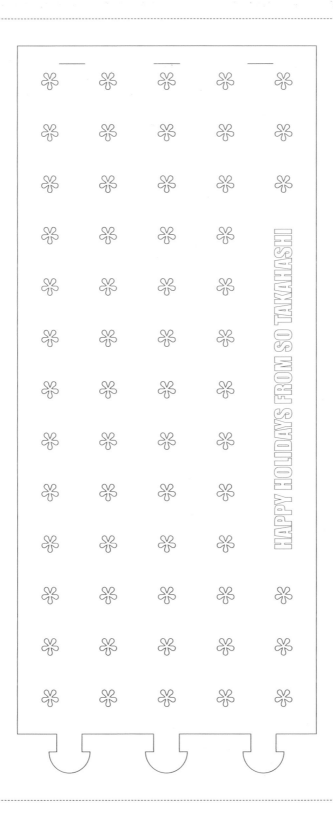

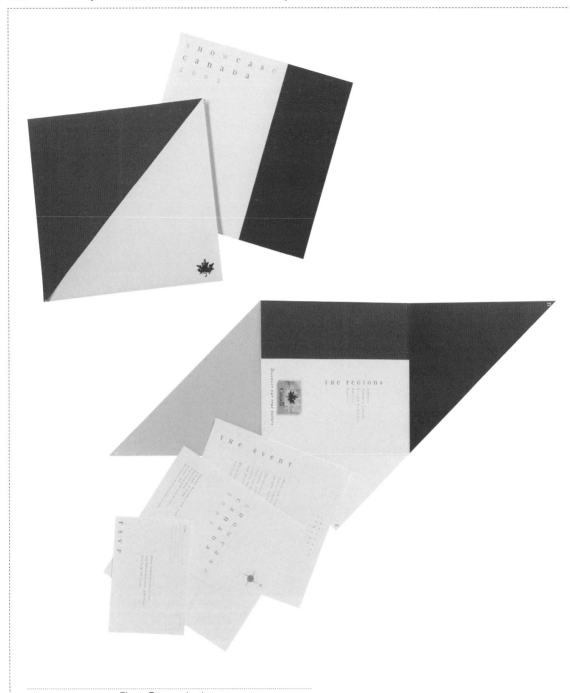

DESIGN	→	Sharp Communications
PROJECT	→	Invitation
DESCRIPTION	→	This folder opens on all four sides and unfurls into a compass shape with a red flap, pointing due north.

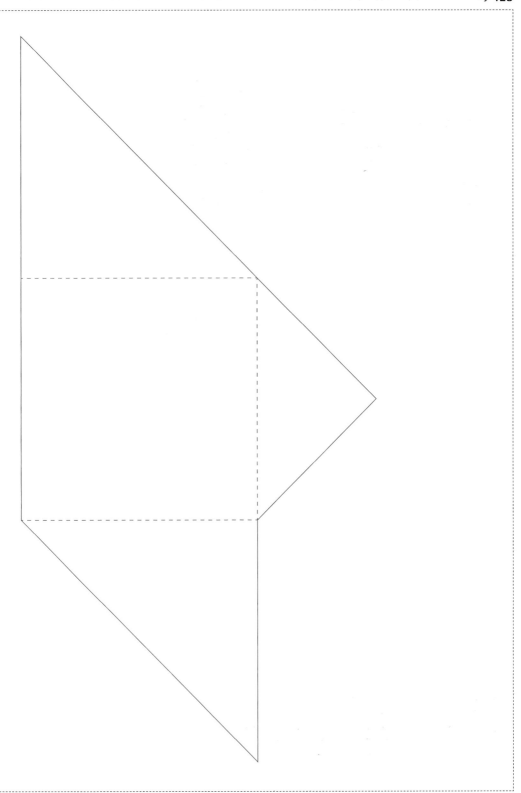

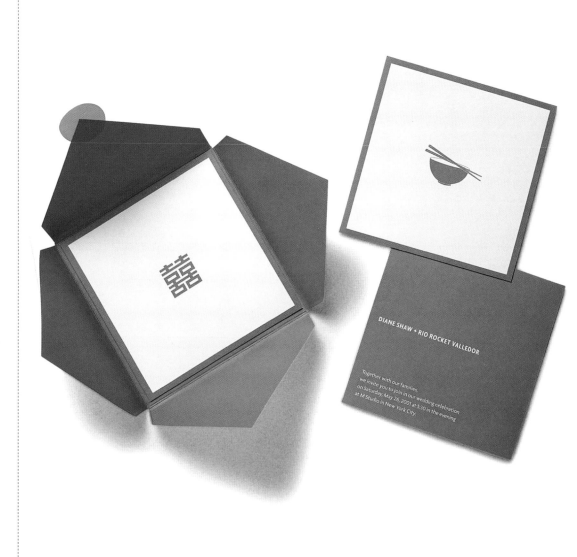

DIANE SHAW + RIO ROCKET VALLEDOR

Together with our families,
we invite you to join in our wedding celebration
on Saturday, May 26, 2001 at 5:30 in the evening
at M Studio in New York City.

DESIGN	→	Goodesign
PROJECT	→	Wedding invitation
DESCRIPTION	→	Four-fold card folder that holds two invitation inserts. This neat folder is sealed shut with a circular sticker.

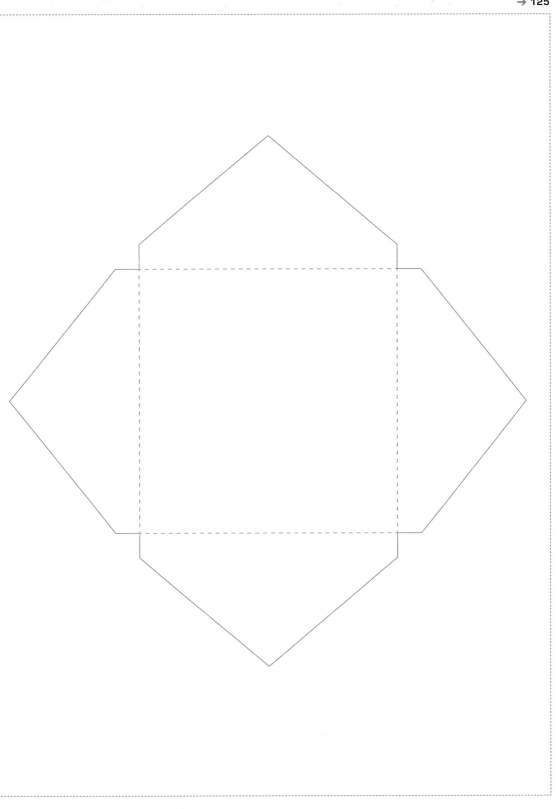

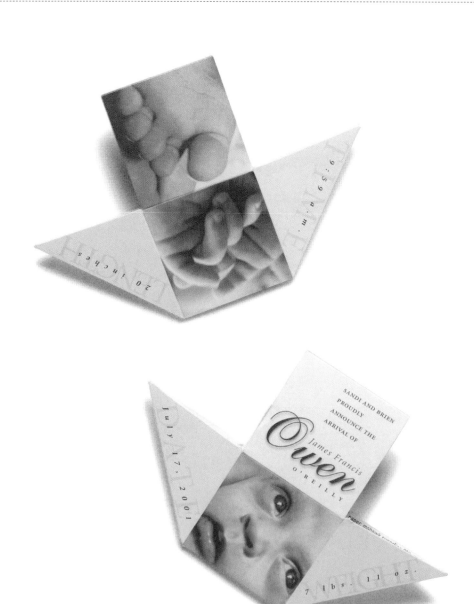

DESIGN	→	Tom Fowler, Inc.
PROJECT	→	Announcement card
DESCRIPTION	→	This flat-packed card pops up into a three-dimensional cube.

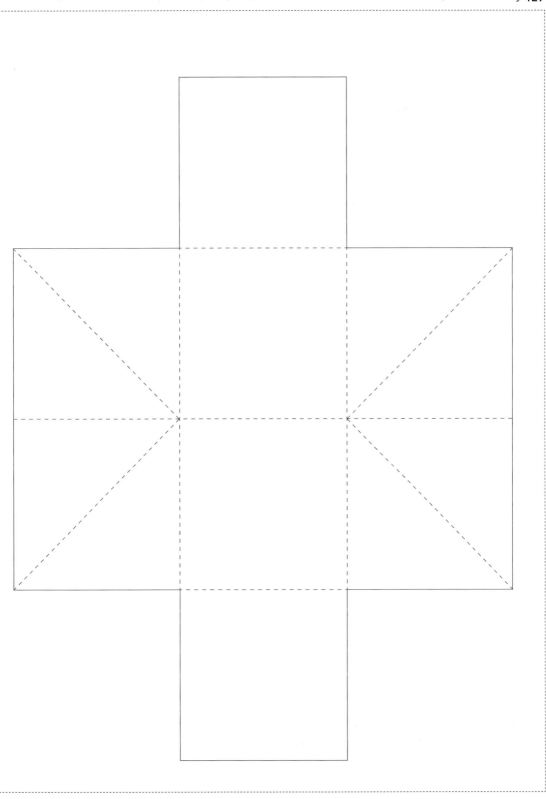

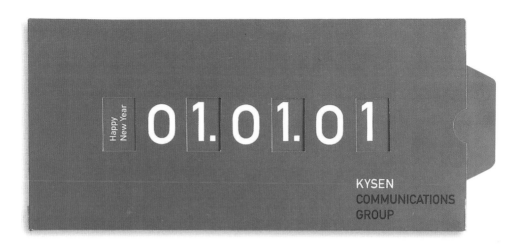

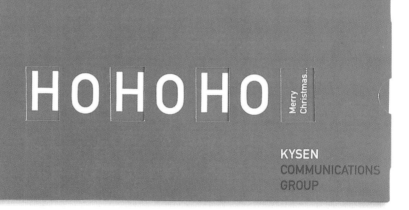

DESIGN	→	Kysen Communications Group
PROJECT	→	Greetings card
DESCRIPTION	→	Slide card that reveals a set of dates when moved.

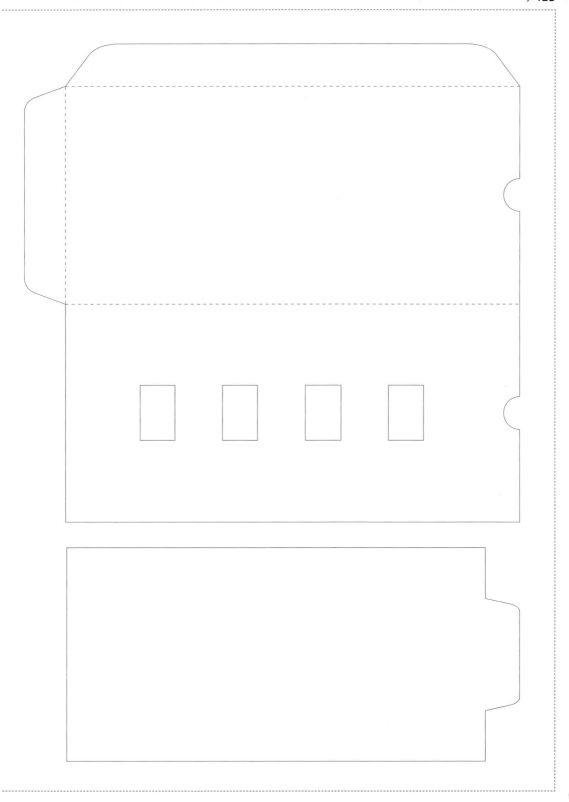

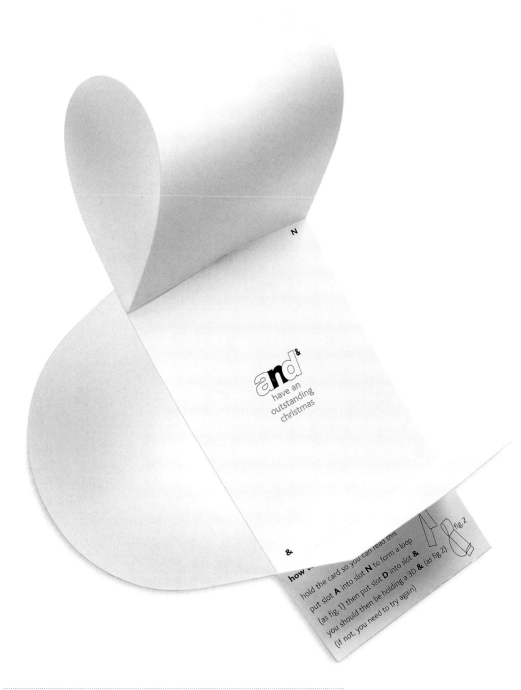

and&
have an
outstanding
christmas

N

&

how to...
hold the card so you can read this
put slot **A** into slot **N** to form a loop
(as fig.1) then put slot **D** into slot **&**
you should then be holding a 3D **&** (as fig.2)
(if not, you need to try again)

fig.2

DESIGN	→	And Advertising
PROJECT	→	Greetings card
DESCRIPTION	→	This card folds to make a three-dimensional ampersand.

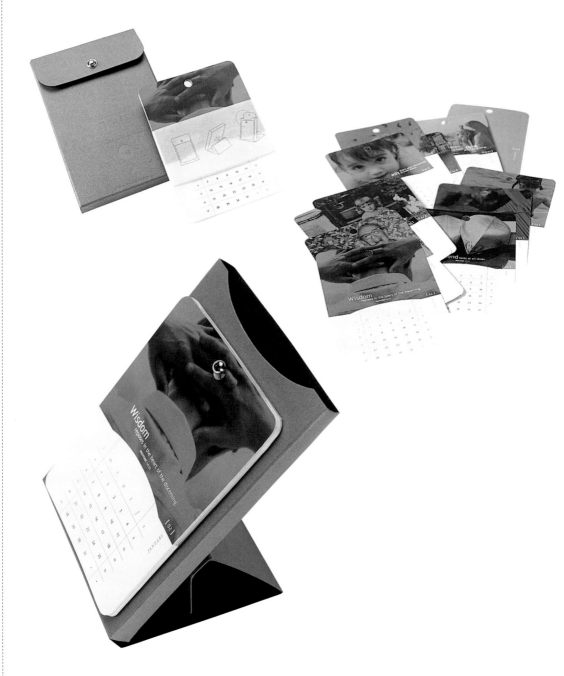

DESIGN	→	Riordon Design
PROJECT	→	Promotional calendar
DESCRIPTION	→	This dual-functioning package serves as an outer container as well as a desk stand. The closure mechanism, made from a purse clasp, also serves as a hanging device for the calendar.

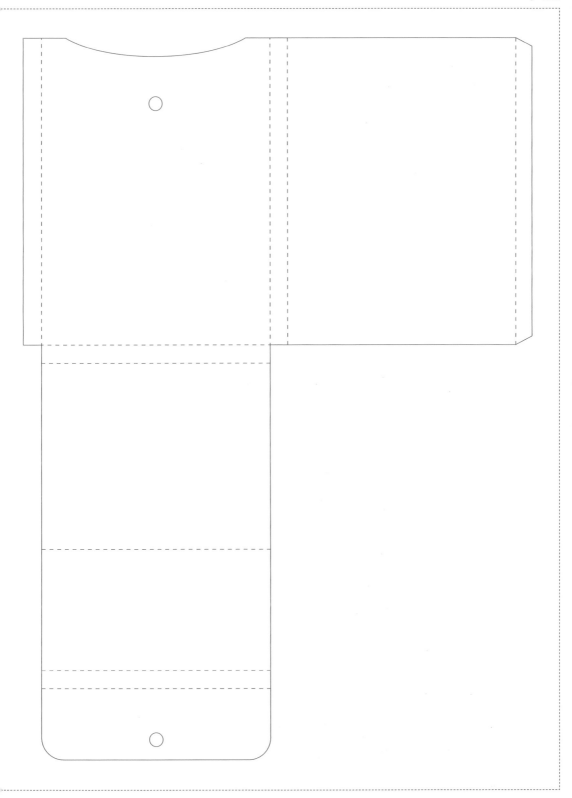

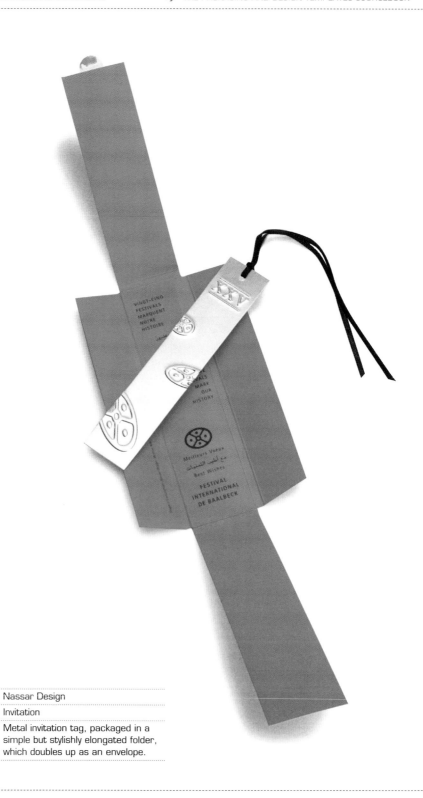

DESIGN	→	Nassar Design
PROJECT	→	Invitation
DESCRIPTION	→	Metal invitation tag, packaged in a simple but stylishly elongated folder, which doubles up as an envelope.

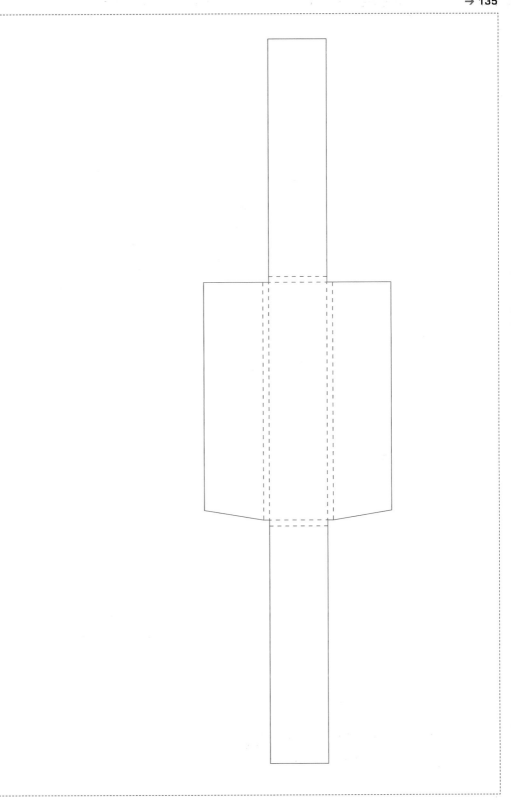

FLYERS AND
MAILERS

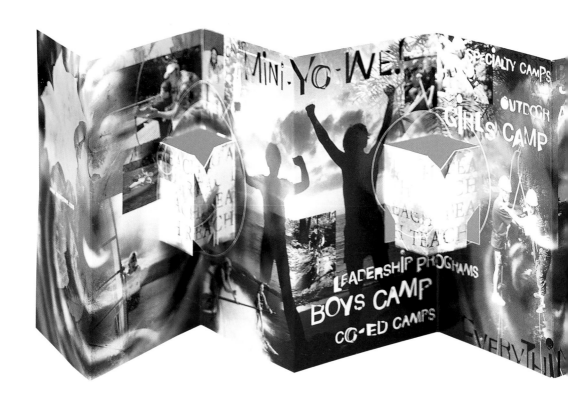

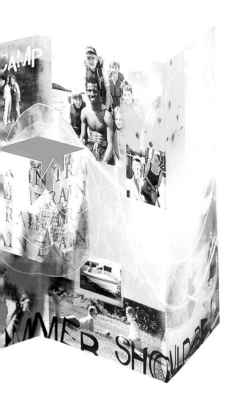

DESIGN	→	Riordon Design
PROJECT	→	Promotional leaflet
DESCRIPTION	→	This example shows how further effects can be applied to the parallel fold. Cuts have been introduced to create truly three-dimensional letters.

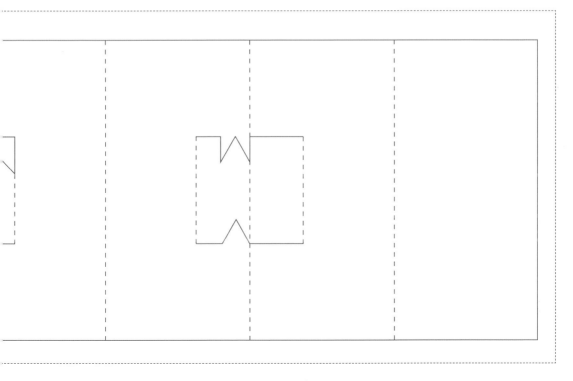

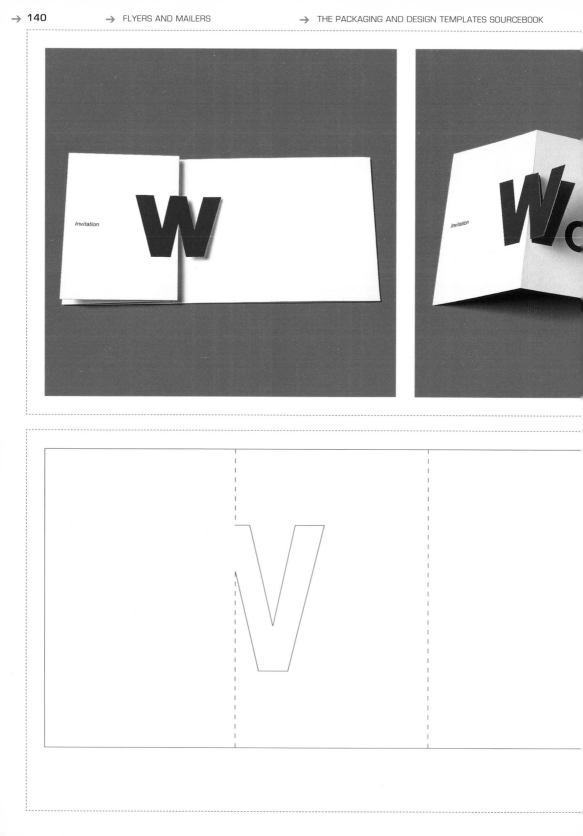

DESIGN	→	Zuan Club
PROJECT	→	Leaflet
DESCRIPTION	→	Part of a letter printed on a page has been cut around its edges. When the page is folded, the cut-out piece of the "W" pops out and lies on top of another panel created by the fold. This is a very clever but simple use of cutting and folding that could be applied to a number of different letter forms or shapes.

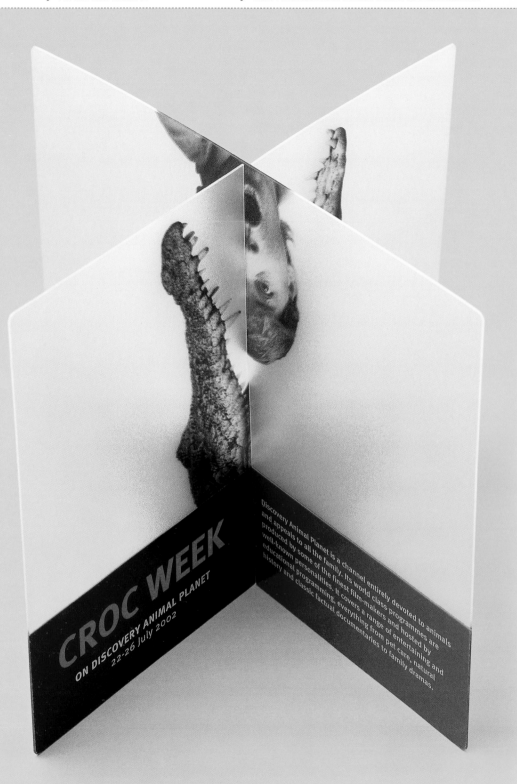

CROC WEEK
ON DISCOVERY ANIMAL PLANET
22-26 July 2002

Discovery Animal Planet is a channel entirely devoted to animals and appeals to all the family. Its world class programmes are produced by some of the finest film-makers and hosted by well-known personalities. It covers a range of entertaining and educational programming, everything from pet care, natural history and classic factual documentaries to family dramas.

DESIGN	→	Salterbaxter
PROJECT	→	Mailer
DESCRIPTION	→	This clever mailer is made from an opaque plastic-like product called Plasma Polycoat 350 Micron. It is supplied by GF Smith and is a popular material with graphic designers. The two halves have been cut to slot neatly together.

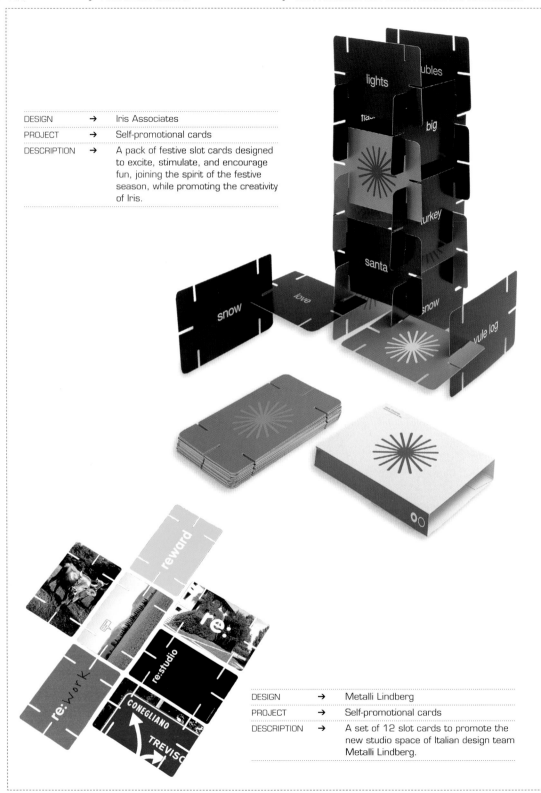

DESIGN	→	Iris Associates
PROJECT	→	Self-promotional cards
DESCRIPTION	→	A pack of festive slot cards designed to excite, stimulate, and encourage fun, joining the spirit of the festive season, while promoting the creativity of Iris.

DESIGN	→	Metalli Lindberg
PROJECT	→	Self-promotional cards
DESCRIPTION	→	A set of 12 slot cards to promote the new studio space of Italian design team Metalli Lindberg.

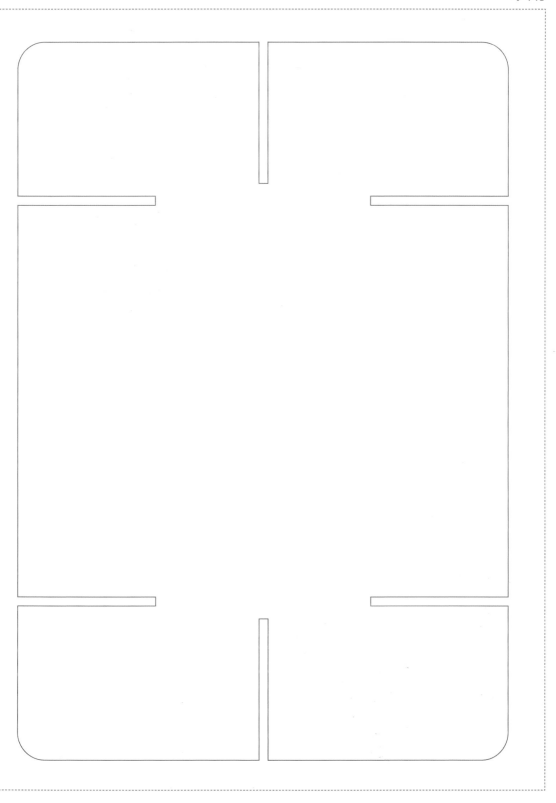

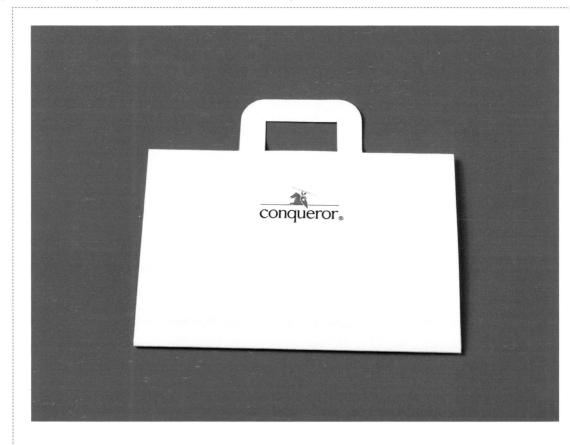

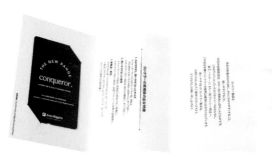

DESIGN	→	Zuan Club
PROJECT	→	Promotional sample for paper company
DESCRIPTION	→	One piece of paper has been die-cut and folded into the shape of a suitcase. The suitcase works as a pocket to hold a pay phone card. The suitcase itself is a sample of Arjo Wiggins paper, showing how strong and agile the stock is and therefore how ideal it is for cutting and folding projects.

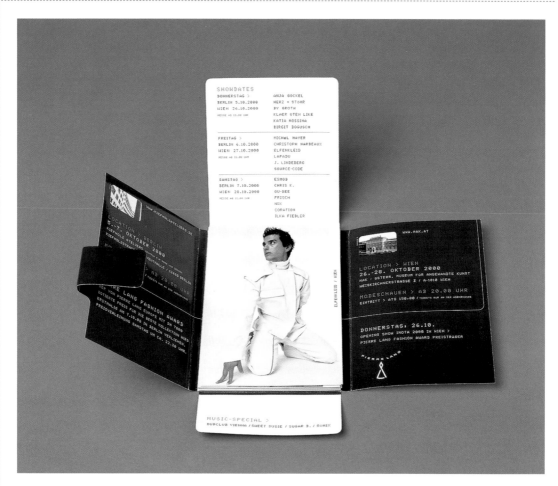

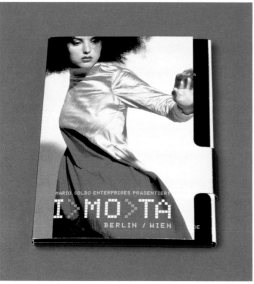

DESIGN	→	Eggers + Diaper
PROJECT	→	Postcards in folder
DESCRIPTION	→	This collection of postcards, used to promote a fashion show, was held together by a die-cut cover, which includes a tongue-in-cheek reference to a belt.

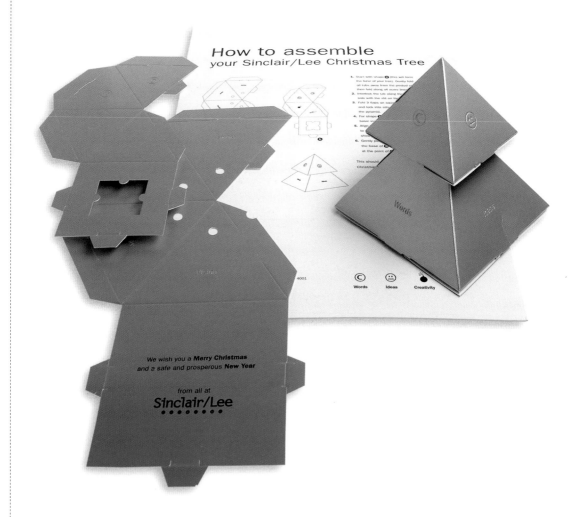

How to assemble
your Sinclair/Lee Christmas Tree

We wish you a **Merry Christmas**
and a safe and prosperous **New Year**

from all at
Sinclair/Lee

DESIGN	→	Sinclair/Lee
PROJECT	→	Promotional mailer
DESCRIPTION	→	Three-dimensional self-promotional card that is assembled by the recipient.

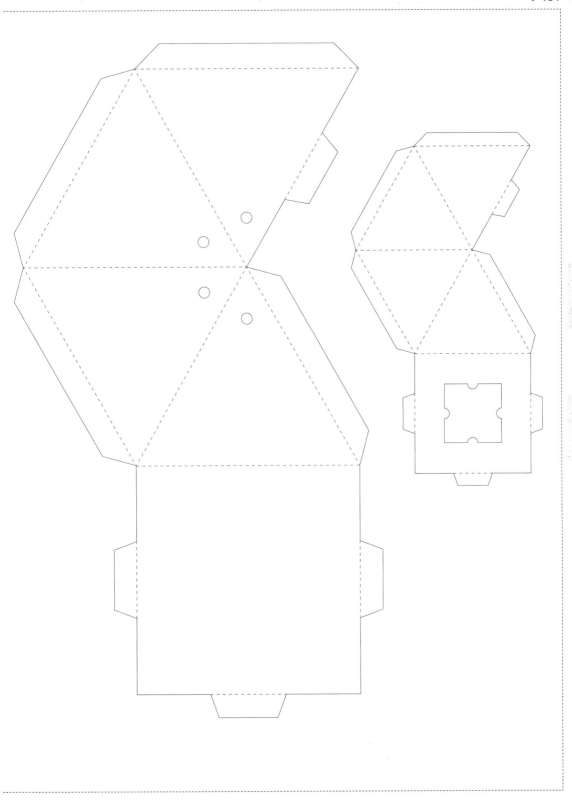

DESIGN	→	Secondary Modern
PROJECT	→	Pamphlet
DESCRIPTION	→	This pamphlet opens up to form a full poster. The cardboard cover is in the top right-hand corner and bottom left-hand corner, hence the title "Sandwich." The other side contains an essay. This is a very simple but very effective way to present information.

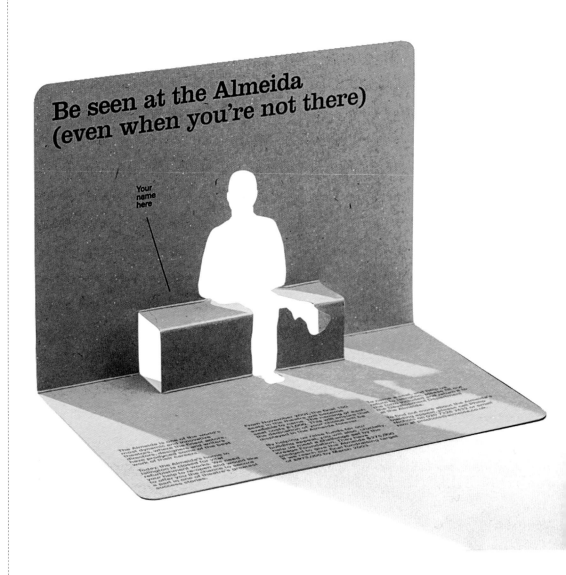

DESIGN	→	NB: Studio
PROJECT	→	Mailer
DESCRIPTION	→	Die-cut card mailer for the Almeida Theatre, London. This witty mailer features a cut-out figure of a person that sits on a bench. The production of this mailer was "lo-fi," due to the theater's budget, and thus fairly cheap to produce.

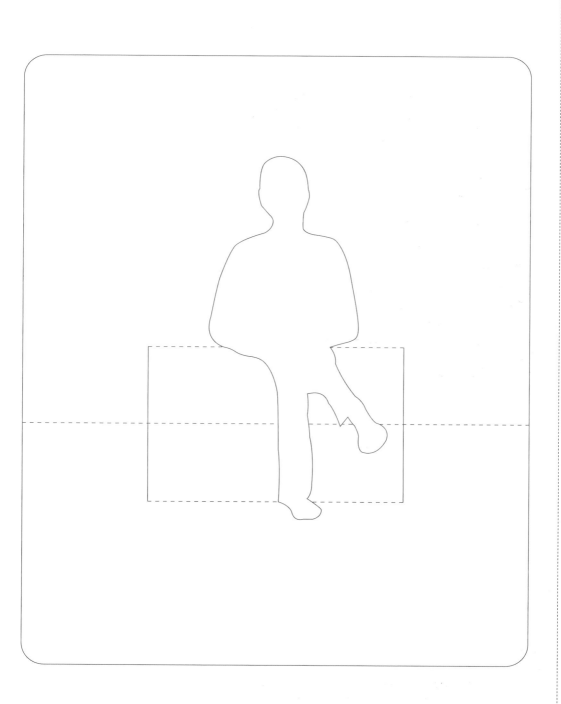

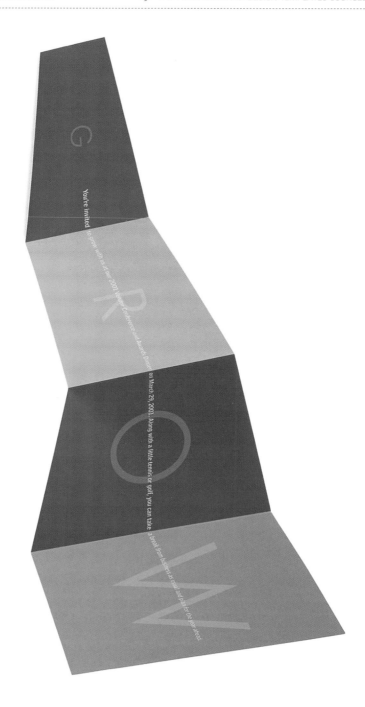

DESIGN	→	Design 5
PROJECT	→	Card mailer
DESCRIPTION	→	Simple die-cut, concertina-folded card mailer.

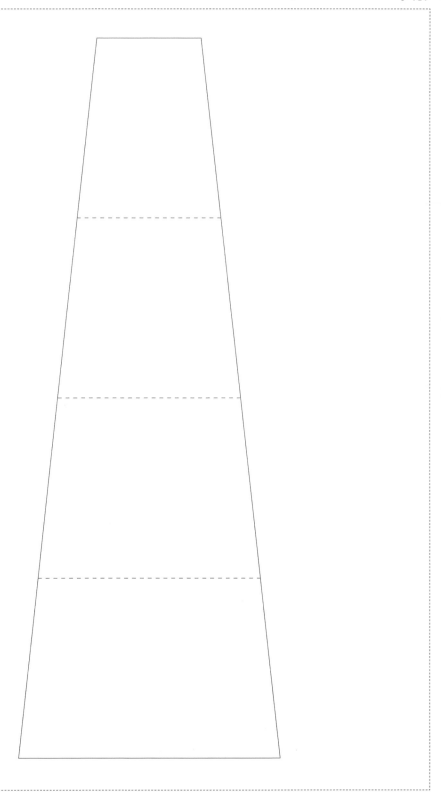

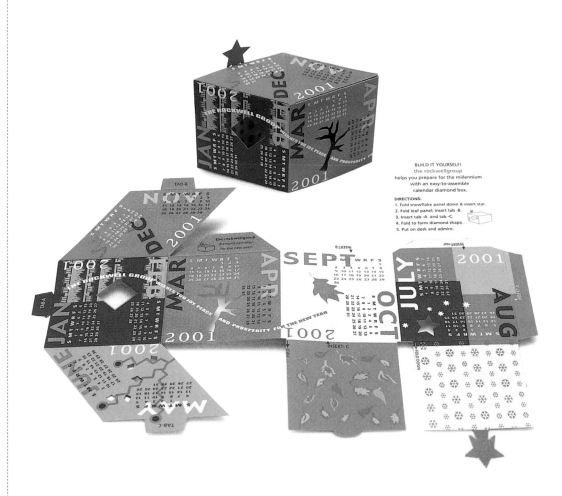

BUILD IT YOURSELF!
the rockwellgroup
helps you prepare for the millennium
with an easy-to-assemble
calendar diamond box.

DIRECTIONS:
1. Fold snowflake panel down & insert star.
2. Fold leaf panel; insert tab -B.
3. Insert tab -A and tab -C.
4. Fold to form diamond shape.
5. Put on desk and admire.

DESIGN	→	Artistic Announcements
PROJECT	→	Calendar mailer
DESCRIPTION	→	This flat-packed mailer folds neatly into a cube, becoming both a festive greetings card and a desk calendar.

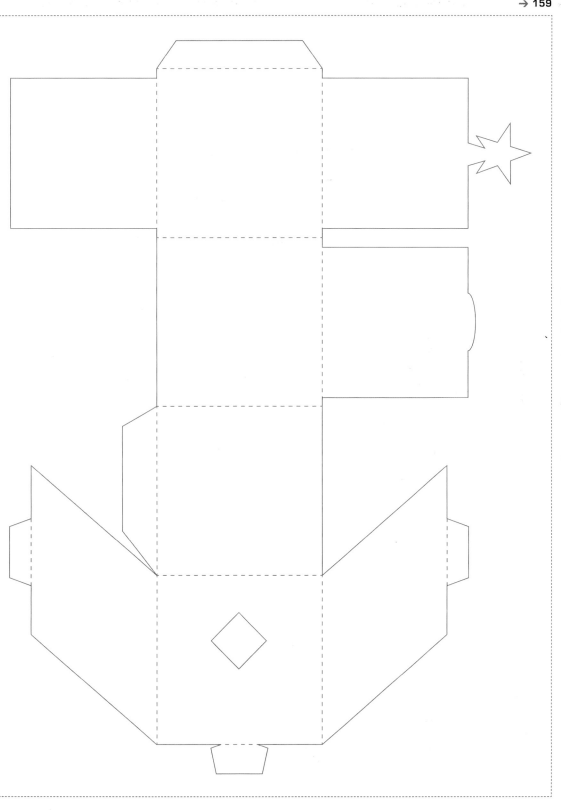

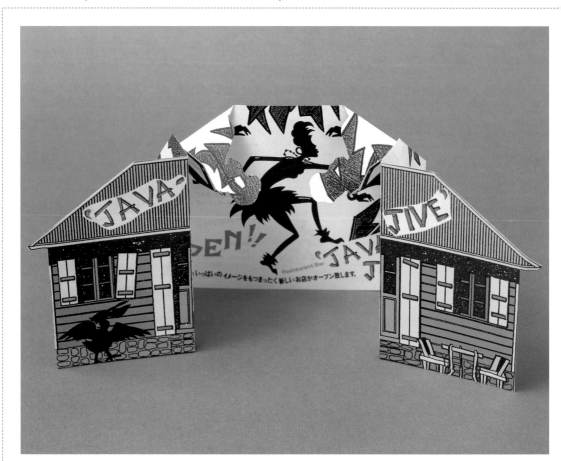

DESIGN	→	Zuan Club
PROJECT	→	Club flyer
DESCRIPTION	→	Flyer and invitation to a Japanese nightclub. As you open the card, dancing figures pop up giving the invitation a sense of excitement. The energy of the paper and the folds really make the page come alive and convey the party vibe of the club.

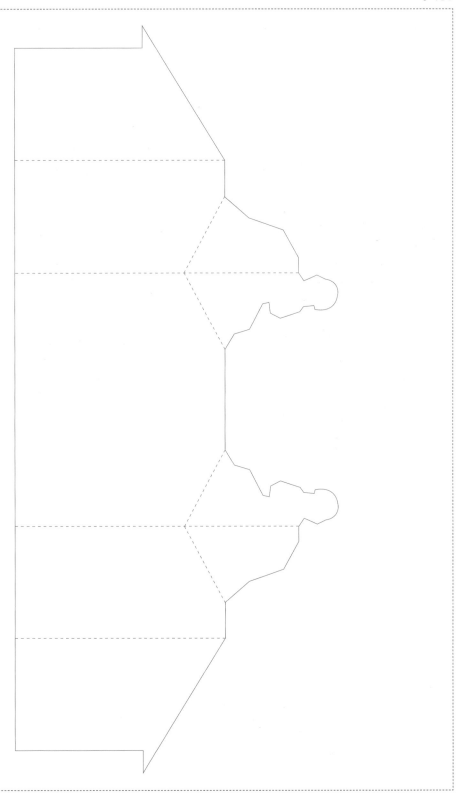

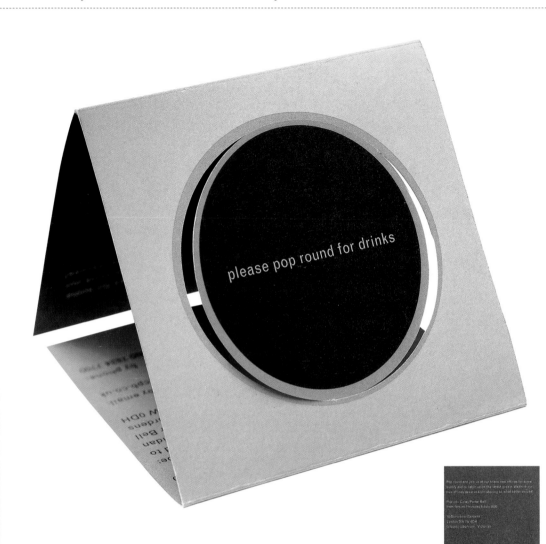

please pop round for drinks

DESIGN	→	Coley Porter Bell
PROJECT	→	Relocation card
DESCRIPTION	→	The RSVP message is a play on the meaning of "pop." It is a call to action—"Please pop round for drinks"—but it also requires the invitee to pop out a disc. The RSVP section is a pop-up part die-cut window, cut into 300gsm Dutchman Smooth paper. This was cut, form-creased and roll-folded to create an opening mechanism. The reply mechanism requires guests to fill in the options, spelled out in a witty style, and send it off in a prepaid envelope.

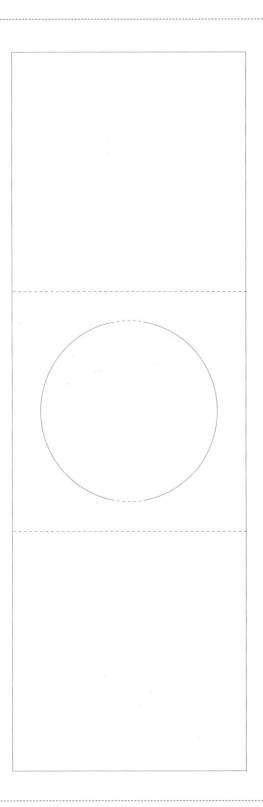

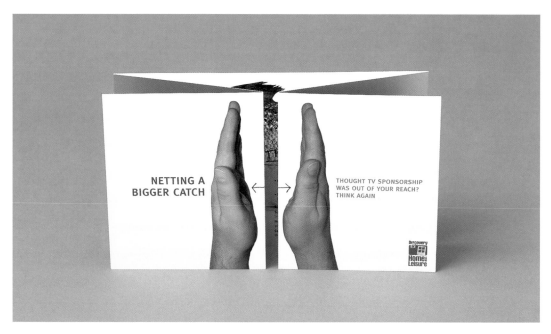

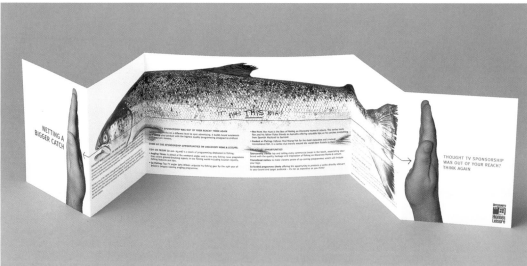

DESIGN	→	Salterbaxter
PROJECT	→	Mailer
DESCRIPTION	→	Double gatefold mailer, whereby two folded panels on either side of one longer central panel fold in symmetrically to meet at the middle of this longer panel.

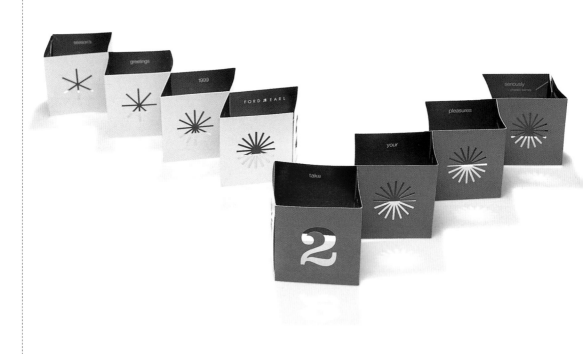

DESIGN	→	Ford & Earl Associates
PROJECT	→	Self-promotional mailer
DESCRIPTION	→	Concertina interlocking card. This card mails flat and doesn't require assembly.

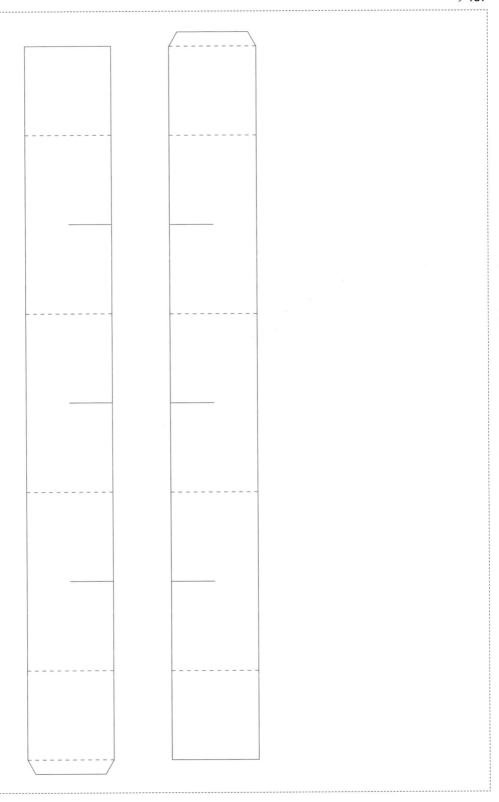

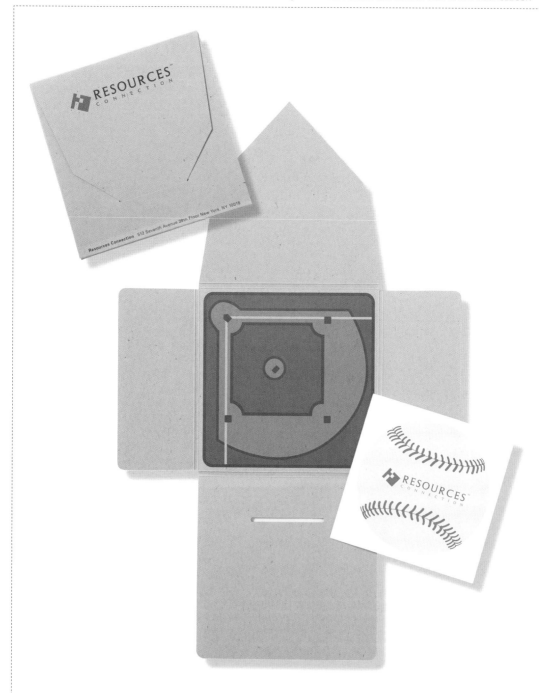

DESIGN	→	General Public
PROJECT	→	Promotional mailer
DESCRIPTION	→	This envelope, constructed of uncoated, cover weight, flecked stock, unfolds to reveal the company's small brochure.

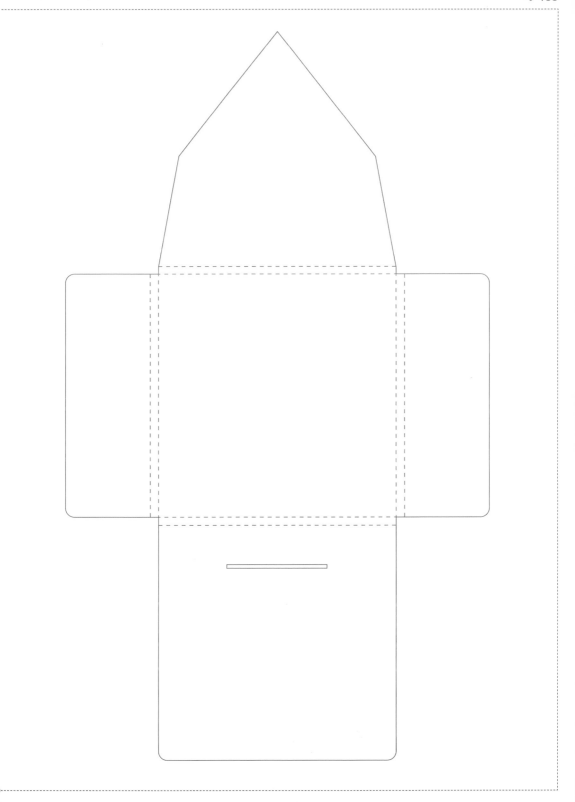

CDS AND DVDS

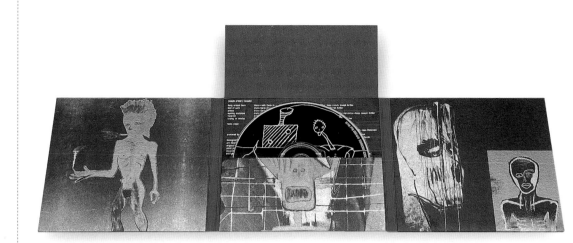

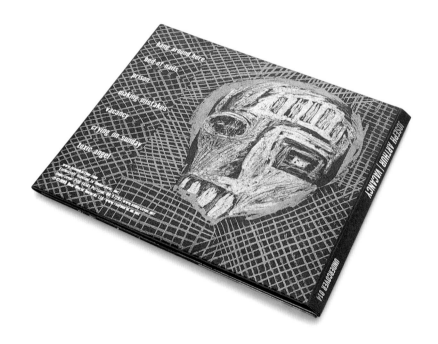

DESIGN	→	Bombshelter Design
PROJECT	→	Joseph Arthur CD sleeve for Virgin Records
DESCRIPTION	→	Six-panel gatefold sleeve, printed with metallic inks and letterpressed onto uncoated card.

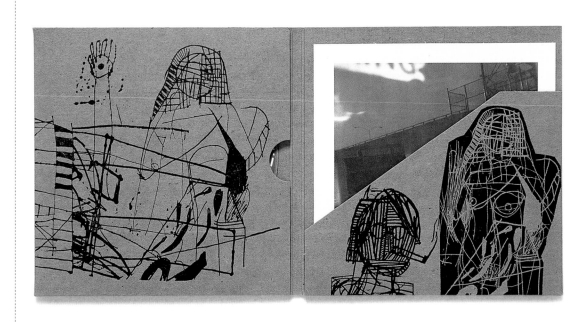

DESIGN	→	Stephen Byram
PROJECT	→	Tim Berne, Tom Rainey, and Drew Gress CD cover
DESCRIPTION	→	Natural-card sleeve with pocket.

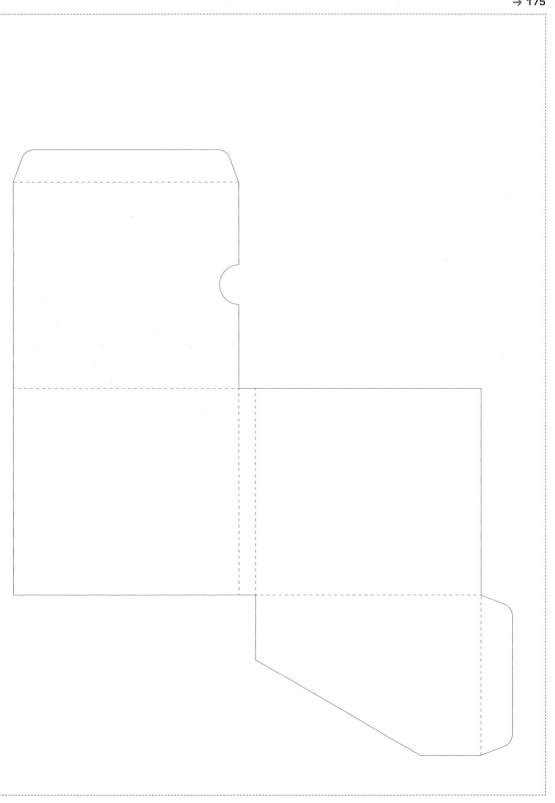

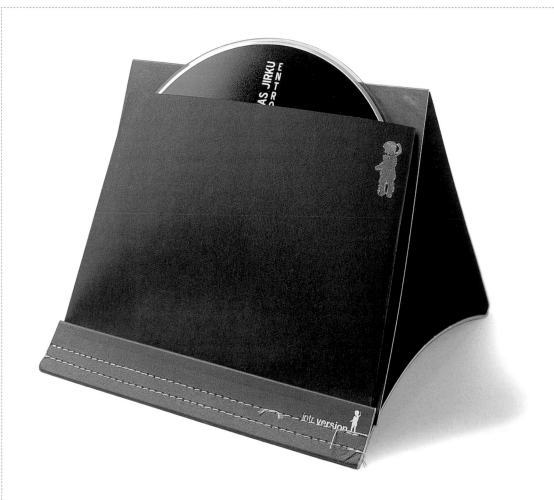

DESIGN	→	Aaron McConomy
PROJECT	→	CD sleeve for Tomas Jirku, intr_version records
DESCRIPTION	→	This CD cover is based on a matchbook using the same opening and stitching principles.

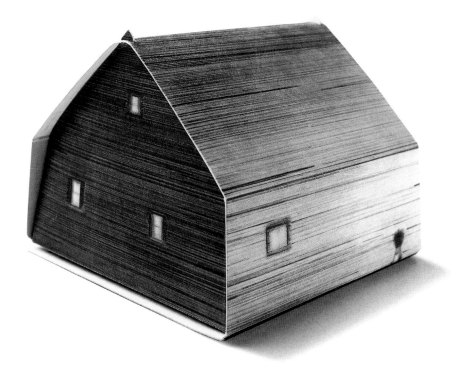

DESIGN	→	John Shachter with Hans Seeger
PROJECT	→	Pulseprogramming CD packaging
DESCRIPTION	→	Tyvek® model house kit. This flat-packed piece opens up and assembles into a three-dimensional building.

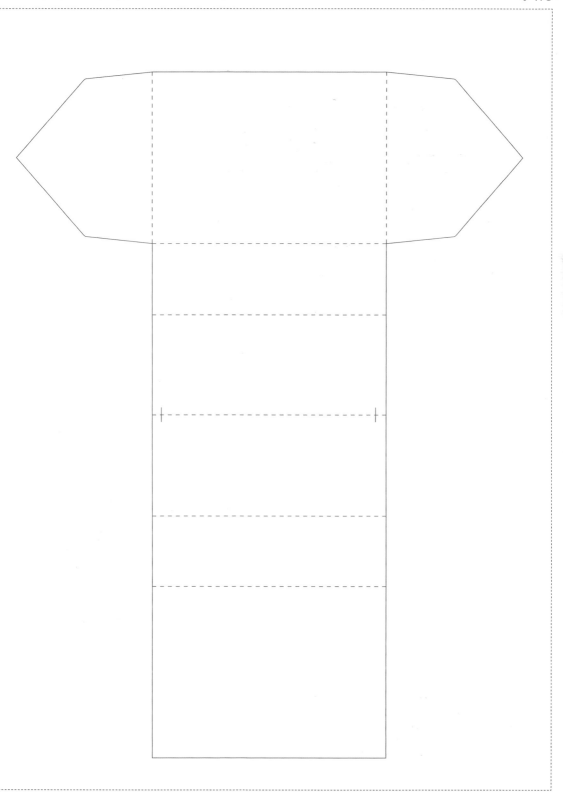

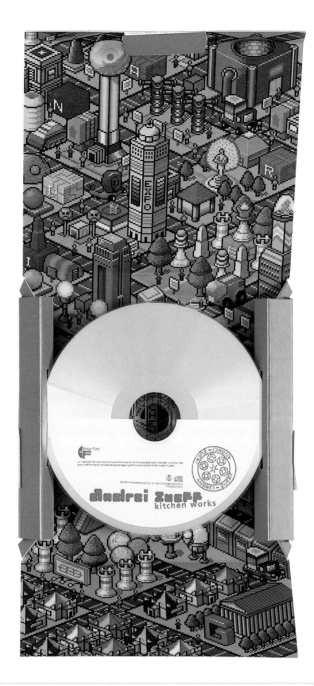

DESIGN	→	TGB Design
PROJECT	→	CD Packaging for Andrei Zueff
DESCRIPTION	→	Card only presentation pack. This packaging is a great example of an alternative to the jewel case. It is solid, sturdy, and because of the way the disc is held, also protects it from scratch damage.

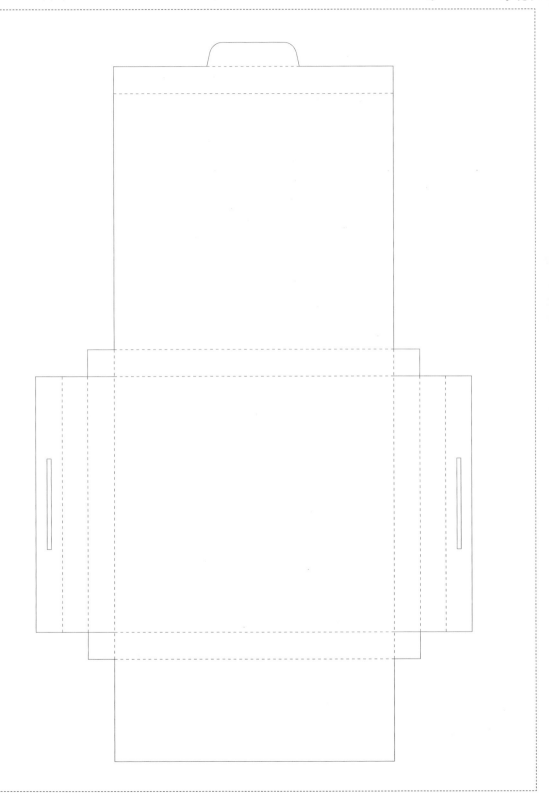

DESIGN	→	Laurent Seroussi
PROJECT	→	No One is Innocent CD cover
DESCRIPTION	→	Four-fold CD case.

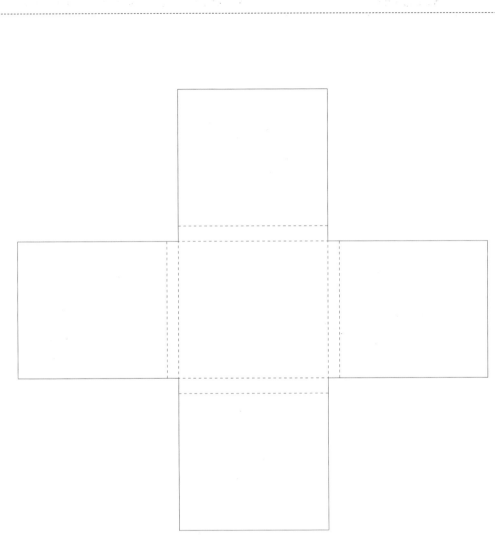

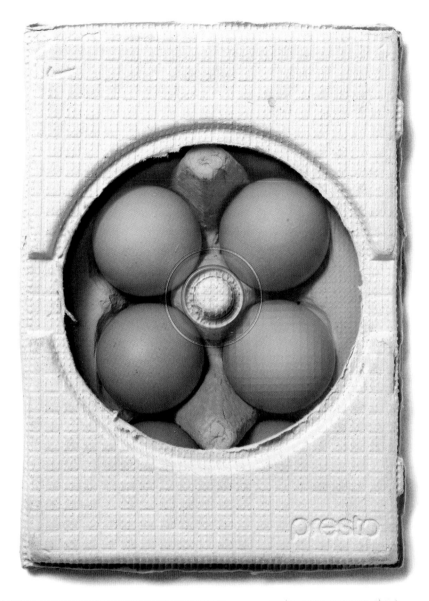

DESIGN	→	Nike/Neverstop/C505
PROJECT	→	Promotional DVD for Nike
DESCRIPTION	→	Box packaging made from egg carton material. The DVD is printed with an egg print to complete the look.

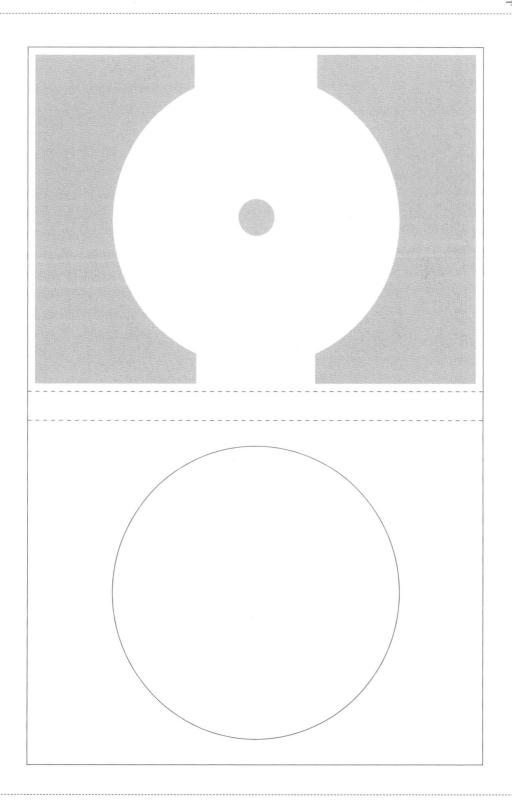

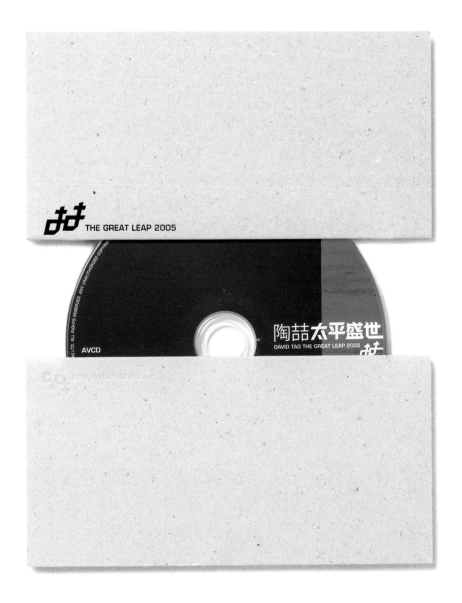

THE GREAT LEAP 2005

AVCD

陶喆太平盛世
DAVID TAO THE GREAT LEAP 2005

DESIGN	→	Pao & Paws
PROJECT	→	David Tao DVD packaging
DESCRIPTION	→	The natural-card insert neatly splits into two parts to reveal the DVD.

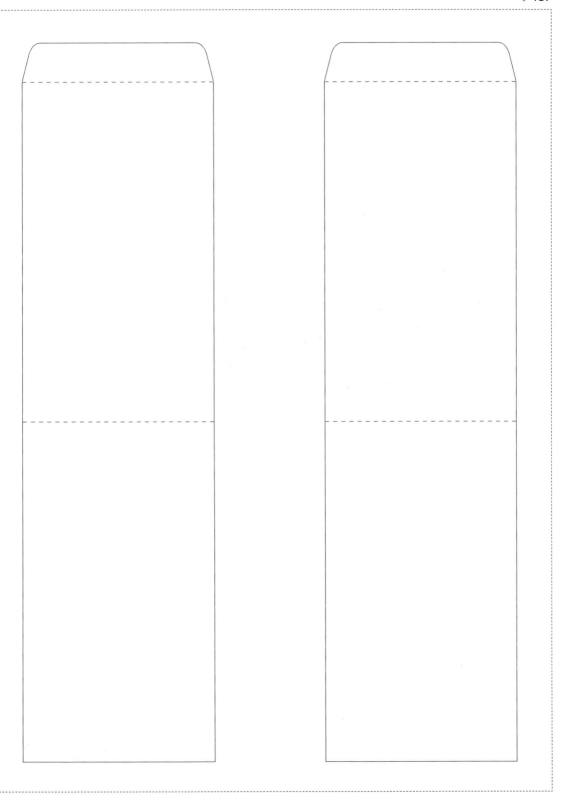

DESIGN	→	Pandarosa
PROJECT	→	Håkan Lidbo CD/DVD packaging
DESCRIPTION	→	Package made from recyclable and durable cardboard, with a die-cut insertion to hold the CD/DVD.

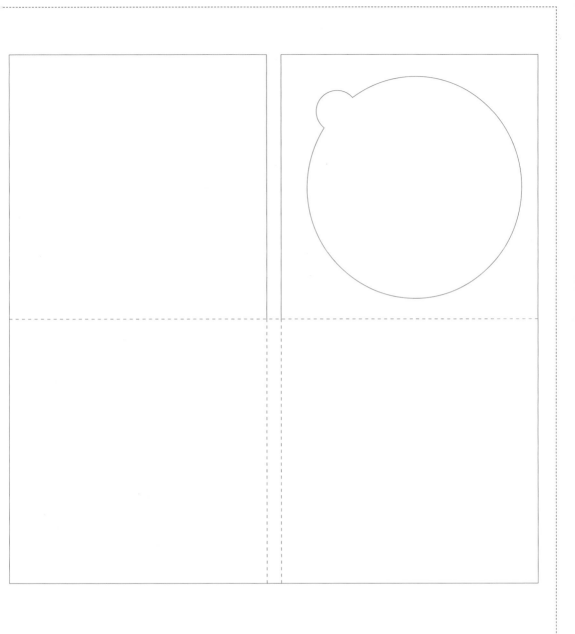

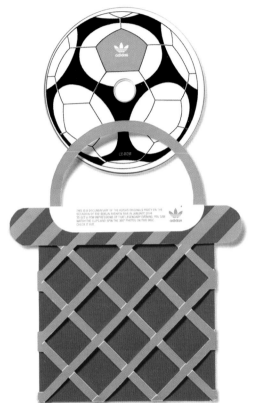

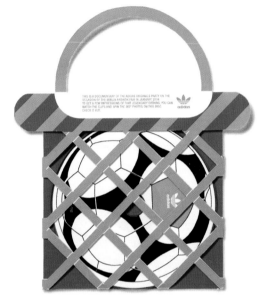

DESIGN	→	Pfadfinderei/Florian
PROJECT	→	Promotional DVDs for Adidas
DESCRIPTION	→	Made from one piece of paper, this package for Adidas is designed to look like a ball in a net.

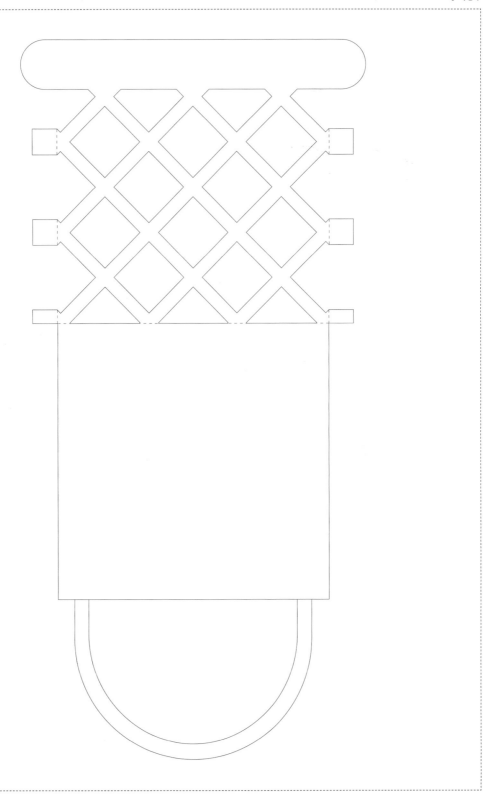

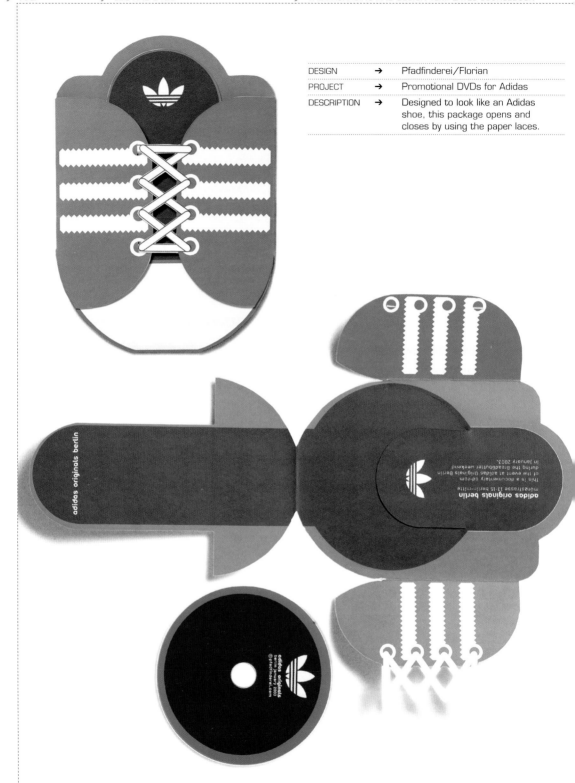

DESIGN → Pfadfinderei/Florian

PROJECT → Promotional DVDs for Adidas

DESCRIPTION → Designed to look like an Adidas shoe, this package opens and closes by using the paper laces.

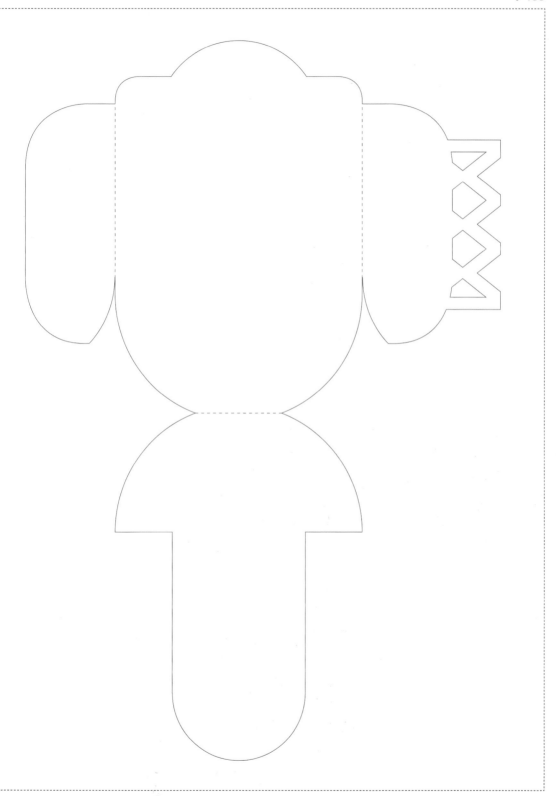

DESIGN	→	Pfadfinderei/Florian
PROJECT	→	Self-promotional piece for Pfadfinderei
DESCRIPTION	→	Low cost, easy to produce, and economical to post handmade DVD package. The cable pattern is printed single color onto matte paper.

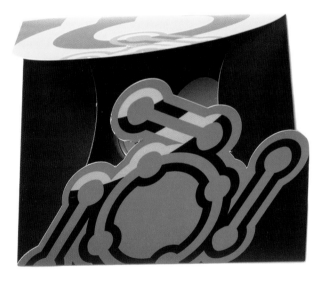

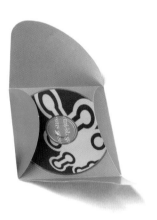

DESIGN	→	Likovni Studio
PROJECT	→	Verso CD/DVD packages
DESCRIPTION	→	Simple die-cut DVD packages.

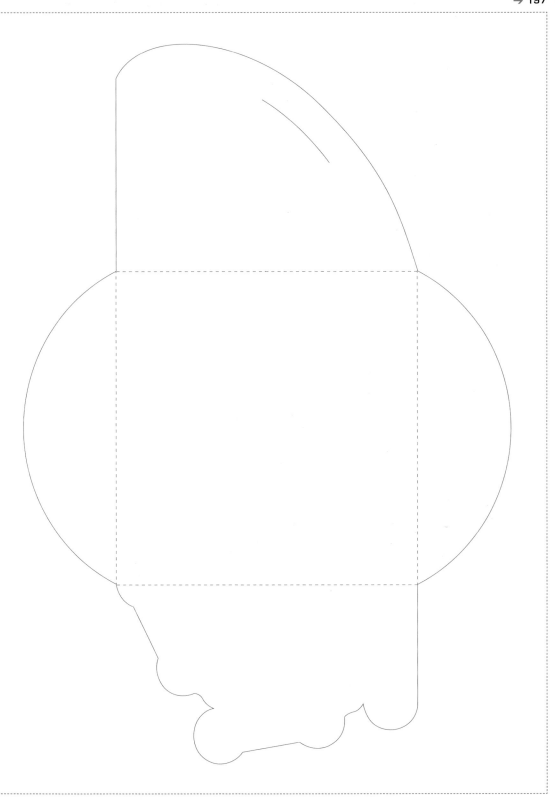

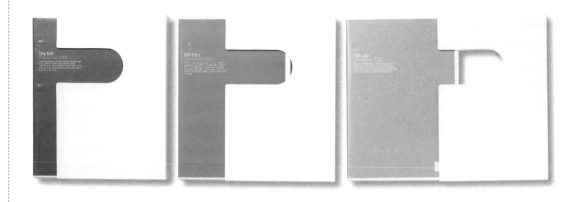

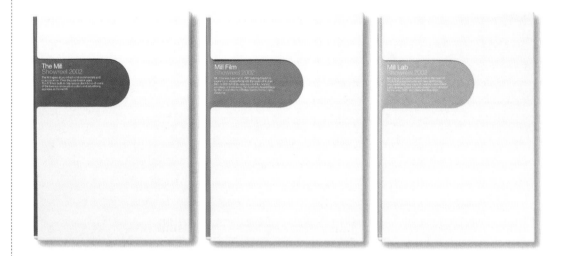

DESIGN	→	Made Thought
PROJECT	→	Showreel DVDs for The Mill, The Mill Film, and Mill Lab
DESCRIPTION	→	These standard DVD cases are housed in card slipcases, which give them a sense of individuality and create a neat visual set. The slipcases are produced in high gloss white Chromolux, and die-cut with an elliptical shape to the left to allow the text and color of each DVD to be visible.

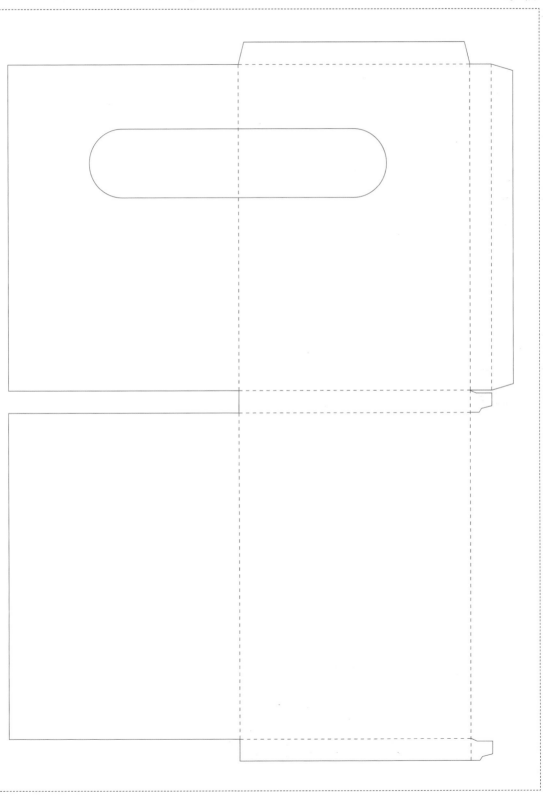

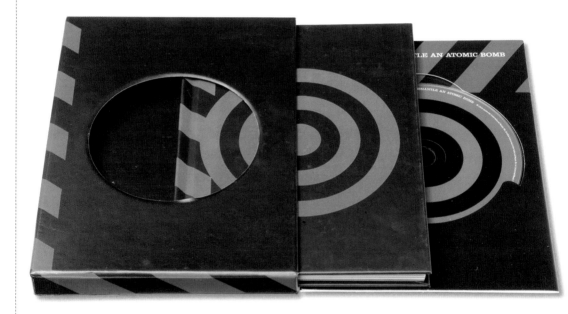

DESIGN	→	Four5one
PROJECT	→	U2 DVD packaging
DESCRIPTION	→	Die-cut card slipcase housing a book and DVD. The die-cut outer cover reveals the disc inside, which is housed in a separate folder.

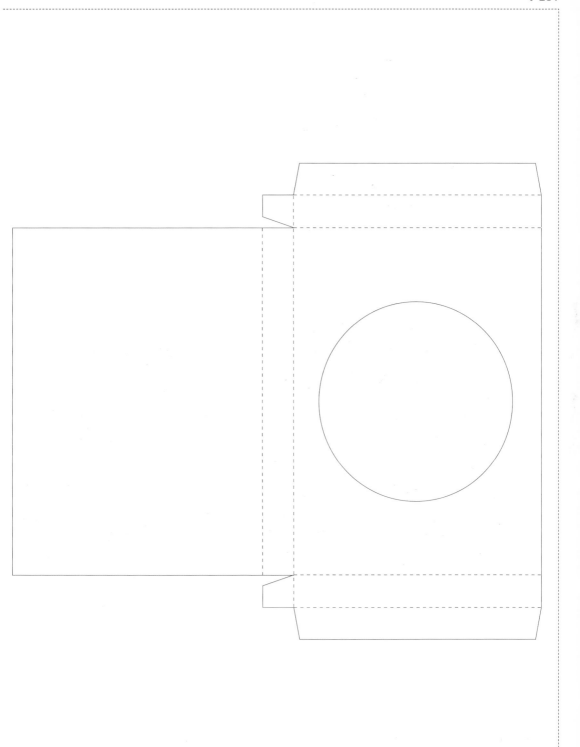

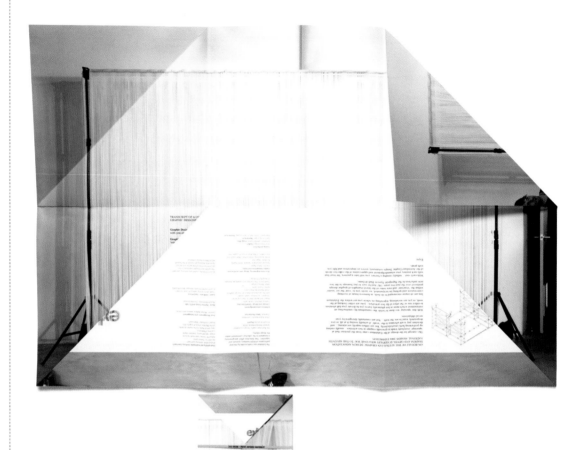

DESIGN	→	Gentil Eckersley
PROJECT	→	DVD packaging
DESCRIPTION	→	This "enveloped" poster folds to create a neat case for the DVD.

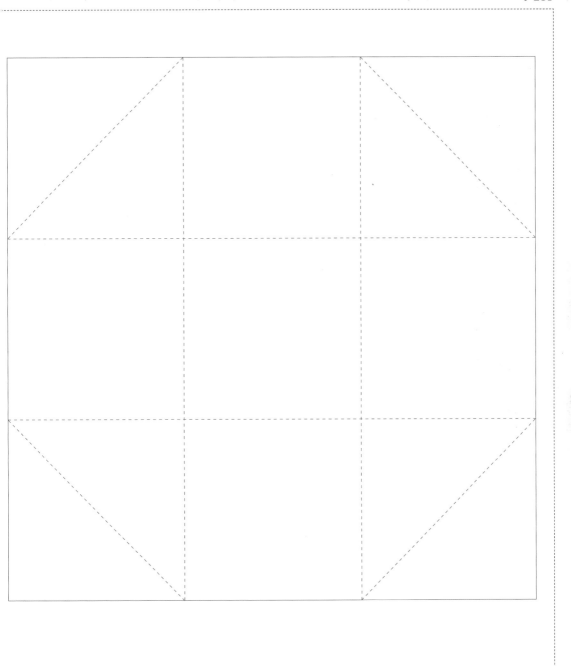

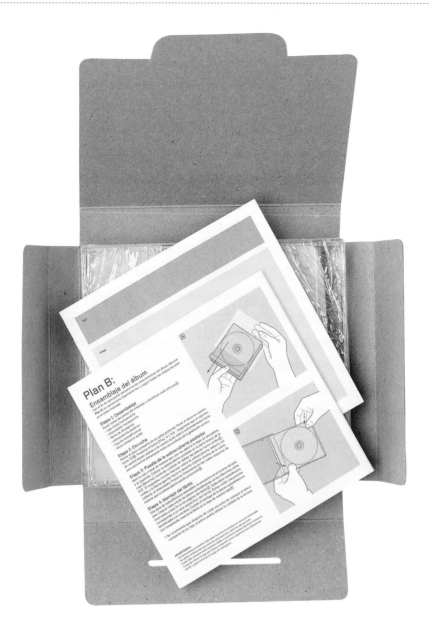

DESIGN	→	Plan B
PROJECT	→	CD packaging
DESCRIPTION	→	Natural-card brown box that holds a kit of parts necessary to build your own CD. In this case, the plastic dual case, card inserts, CD, cover stickers, etc., come as separate elements to be assembled.

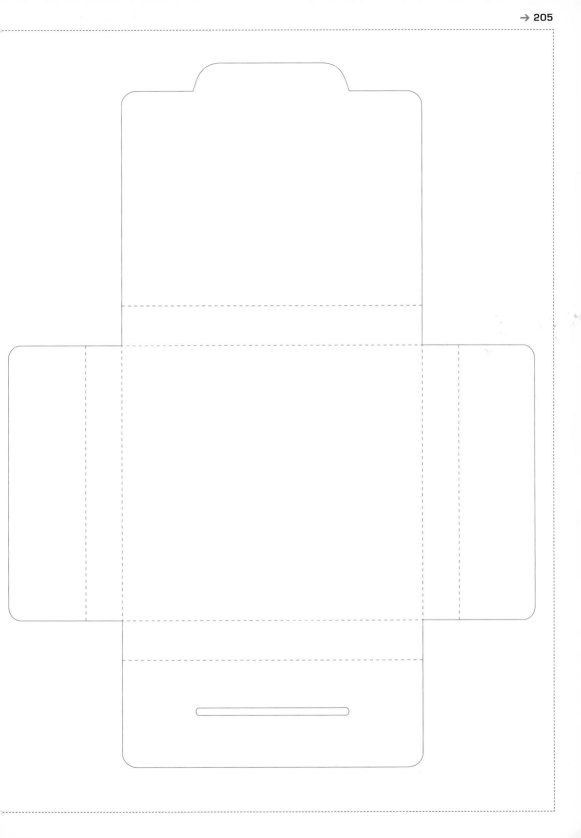

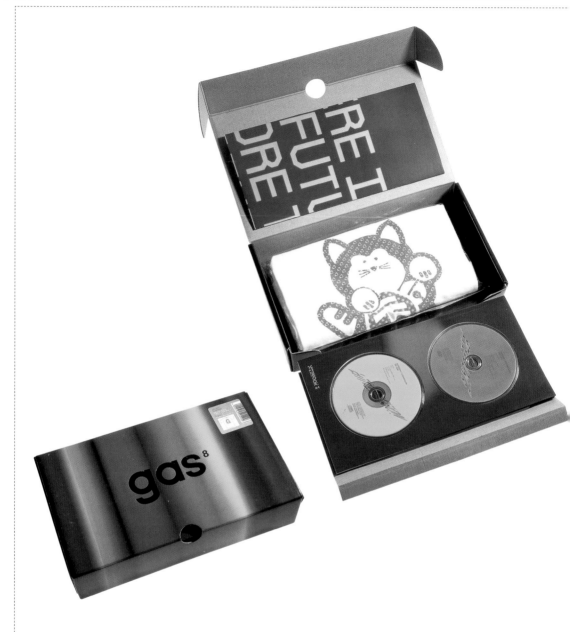

DESIGN	→	Hideki Inaba
PROJECT	→	Magazine and CD packaging
DESCRIPTION	→	The outer packaging is a hinged-lid transit box, a nondescript box requiring no glues to create its form. This exterior has been clad with a brightly colored litho sheet and is gloss-laminated to give a high level of finish.

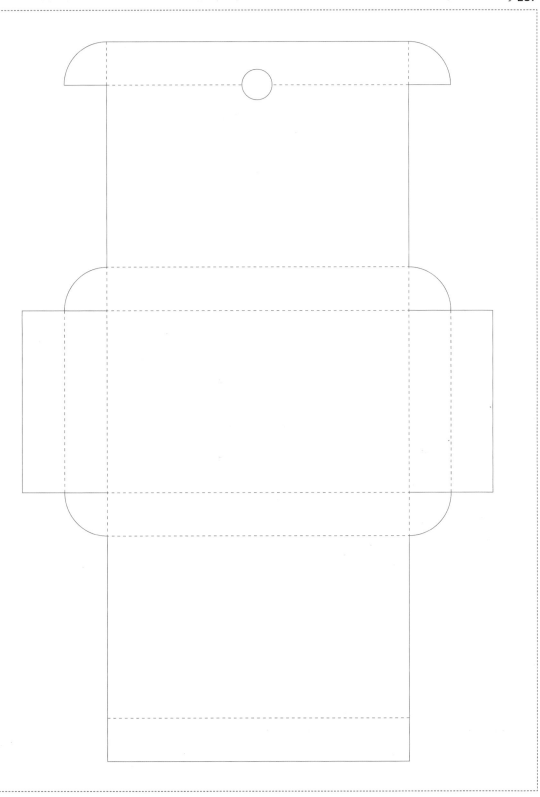

PRODUCT
PACKAGING

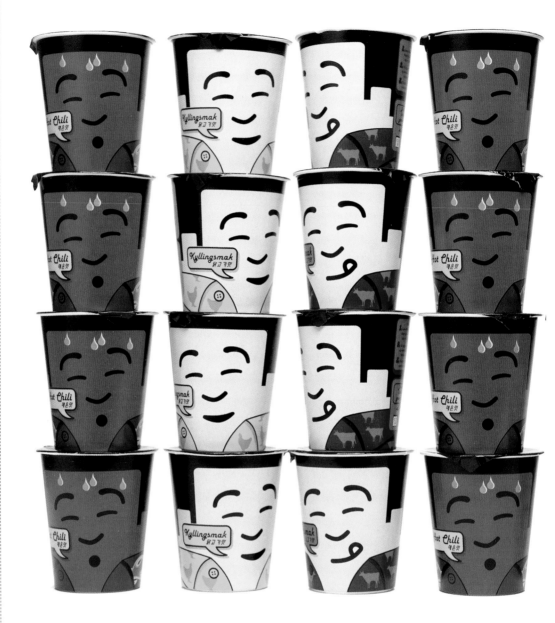

DESIGN	→	Design Bridge
PROJECT	→	Mr Lee food packaging
DESCRIPTION	→	Simple carton packaging for a noodle snack.

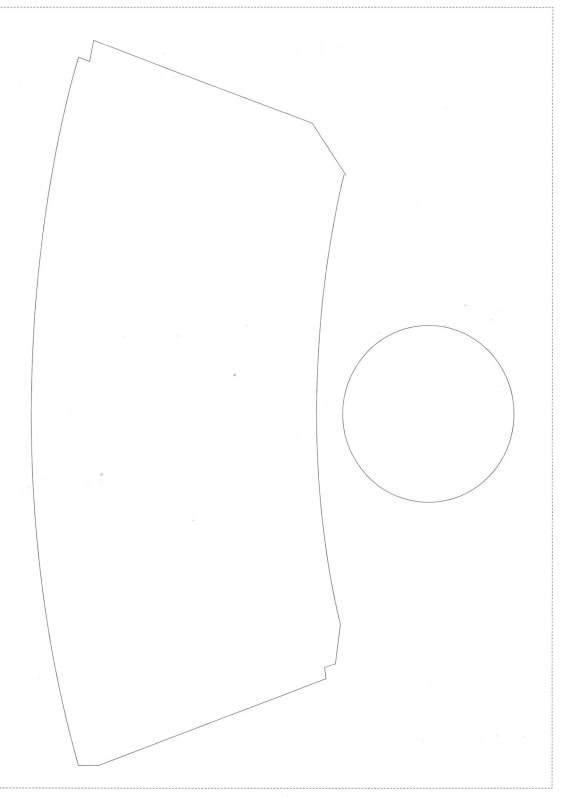

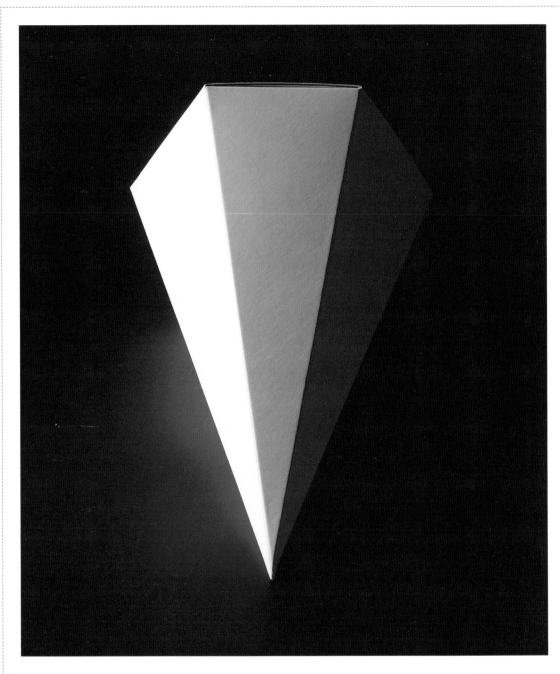

DESIGN	→	M.M. Packaging
PROJECT	→	Pyramidal carton
DESCRIPTION	→	The tapered sides and glued tuck flaps create a pyramid-shaped carton, and the intermediate slip and lid is optional depending on product requirements. The designer also has the option of increasing or decreasing the number of sides of this carton by altering the side sections and, as such, the shape of the base.

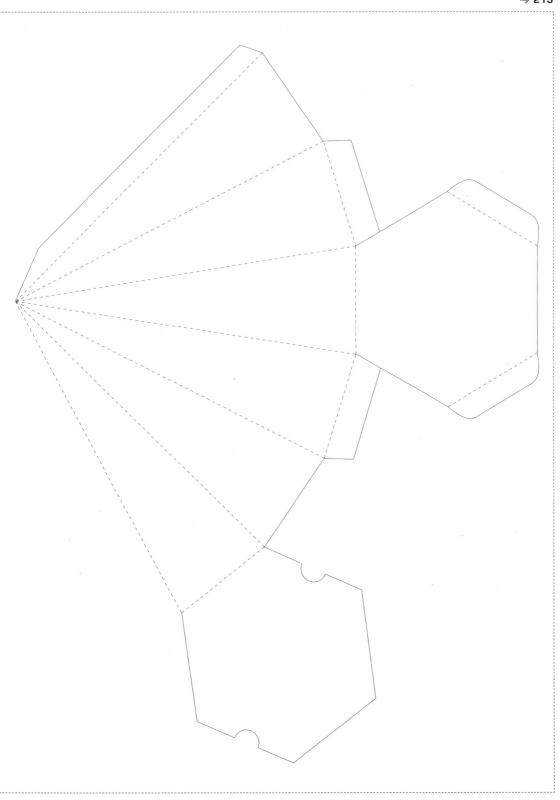

IT'S MORE THAN A SOAP,
IT'S A PHILOSOPHY.

UNAVAILABLE ™

7.25

15 PROVEN PRINCIPLES FOR APPLYING UNAVAILABLE, THE PHILOSOPHY:

If you've ever felt as if you were wearing a "KICK ME!" sign on your heart, you are not alone. Thankfully, there is a solution for finding that ever-elusive, seemingly exclusive, happily ever-after love you've been craving. And that solution is called Unavailable. Time and again, a woman who makes herself Unavailable (socially, emotionally, sexually, intellectually, geographically, or any combination there-of) finds herself reeling in men from virtually all over the planet. It's as if she were emitting a powerful sixth scent that men can smell from miles away – even from another coast... especially from another coast. Now, for the first time, you can enjoy the satisfying, magnetic affects of being Unavailable in both soap and philosophy form. Once you start applying this synergistic combination, you will quickly find yourself surrounded by nice men... or (even better) that cooler, more dangerous kind you really want!

Good Luck,
KAREN SALMANSOHN

author of HOW TO SUCCEED IN BUSINESS WITHOUT A PENIS and THE 30-DAY PLAN TO WHIP YOUR CAREER INTO SUBMISSION

CLASSIC SUCCESS STORIES

A. ROMEO AND JULIET
B. CINDERELLA

Unavailable is an irresistible scent that has helped women lure men since, well, since the beginning of time. If you need a celebrity endorsement, they abound. Just ask Romeo about Juliet. Juliet had that enviable Unavailable family lineage working in her favor. "Oh no, Romeo, I can't meet you tonight!" Juliet told her man. When she finally agreed to a date, she stood him up. Guess what? Romeo still thought Juliet was to die for.

Then there's Cinderella. With a dead-end career and an embarrassing home life, she still knew how to snag a prince. How?
1. She flirted profusely.
2. She excused herself to go to the powder room.
3. She never once told the Prince she loved him.
And just who did the Prince (a popular guy who could go for Chinese food and a movie with any woman in the kingdom) want? Exactly. The one woman he could not find. The woman who was (duh!) Unavailable.

01
Don't fake orgasm, but do fake call waiting. Multiple call waiting. Let him know you're a woman in demand – not a demanding woman.

02
Viva Le Indifference.

03
Never, never (ever) call the man. The more challenging you are to catch, the greater the pride he'll take in catching you. Remember, a man's primal instinct is to hunt; he enjoys the thrill of the kill. You'll be glad you resisted, and so will he. It's an opportunity to tap into his primal hunting urge.

04
Women take longer than men to get ready for parties. Men take longer to get ready for relationships. Neither like to be rushed. Don't be in a hurry to unpack your emotional baggage. Always travel light into a relationship.

08
Consider dating someone with whom you don't share a native language. The less vocabulary you share, the more you can remain a mysterious, alluring babe (and the less you'll be able to piss each other off).

09
Consider dating someone in a distant city. Or, if you already desire a man in your local tri-state area, simply try using some of the most seductive words a woman can ever use on a man: "I may be moving to Siberia in November." Casually mention your future departure plans and watch the magic unfold.

10
If you ever wanna hear "I do," you have to say a few "I don'ts." The harder you are to win sexually, the bigger your estimated prize value. Yes, unfortunately, even in this modern age, no man wants to belong to a club

sex. And keep in mind that men have a three-date maximum.
NOTE: To enhance sexual willpower, don't shave armpits or legs for a few days before a date with a hunky guy...unless he's European.

11
Never tell a man how many men you've slept with. And never show off your sexual acrobatics too soon. Basically, men want a woman who knows what she's doing, without ever having done it before. So, in the beginning, fake being less fabulous in bed than you really are. note: Mysteriously, men don't seem to mind hearing about all the women you've slept with. (Go figure.)

12
As an Unavailable woman you are different than the typical woman that John Bray describes as being from the planet you...

in the same way a bank robber first gathers crucial information about a potential crime scene, you can determine how best to steal his heart.

14
When in doubt about how much and what to say, always keep in mind: It's walaaaly more important to be aloof than alert. Unfortunately, although many men claim they want a woman who's smart and funny, what they truly want is a woman who's smart and funny – as long as she's not more smart and funny than themselves.

15
As an Unavailable woman, you must always remain a bit out of reach, leaving him wanting more. This means:
1. leaving parties while your belle-of-the-ball curve is on the upswing.
2. ending all phone conversations before they've reached their full-throttle fun. In fact, consider getting off the phone before you've even finished your...

7.25

DESIGN	→	Sagmeister, Inc.
PROJECT	→	Unavailable soap packaging
DESCRIPTION	→	Simple box packaging for a soap bar. This box is printed inside with the company's 15 principles.

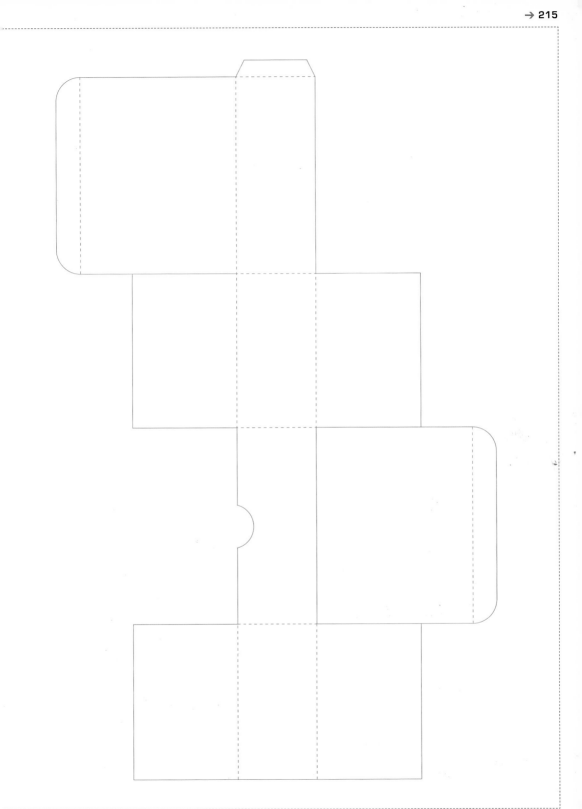

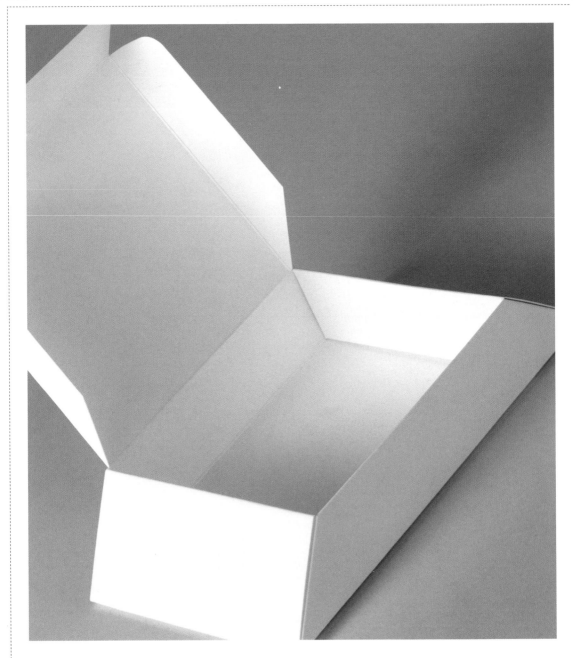

DESIGN	→	Unknown
PROJECT	→	Angle-sided tray with tuck top
DESCRIPTION	→	A tray that creates an image of thickness and rigidity by using tapered hollow sides, this tends to be used as a container for confectionery and gift items. Special locks clip together on the sides of the corners to support the structure. The lid with dust flaps is optional, but if removed, this fourth side should be adapted to replicate the remaining sides.

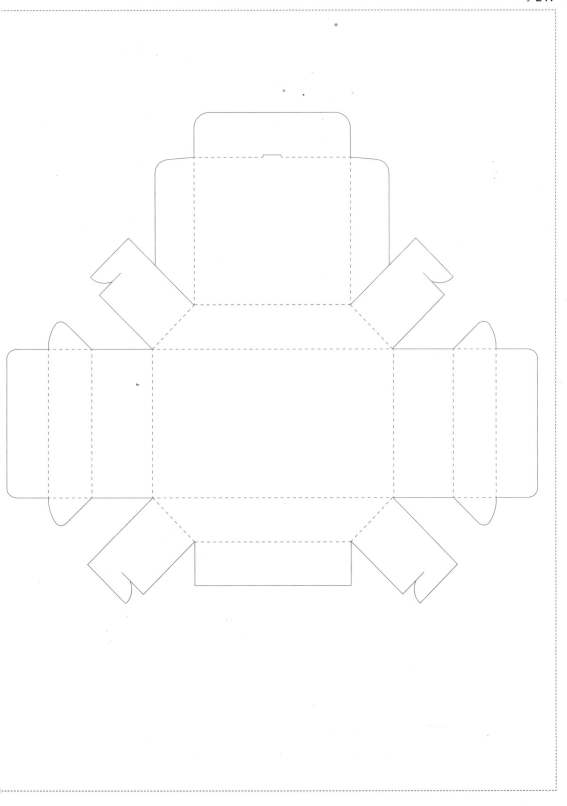

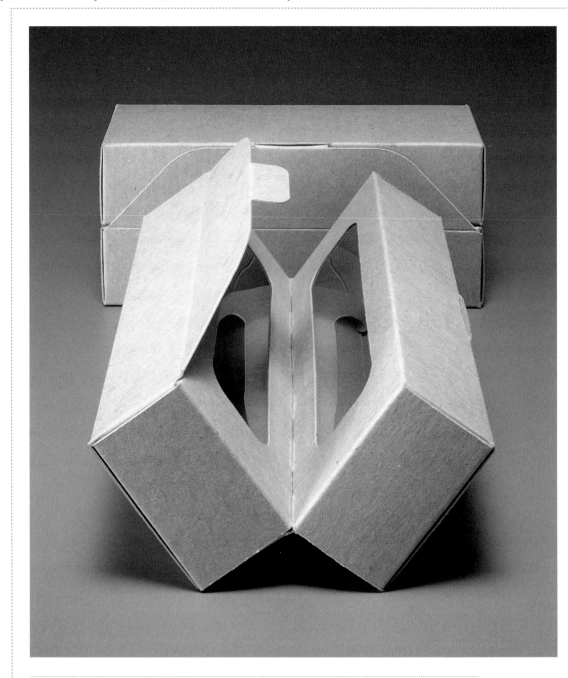

DESIGN	→	Unknown
PROJECT	→	Hinged double-closet carton
DESCRIPTION	→	As a sealed, closed container this carton initially appears to have a single compartment, but when opened up it displays two equal—yet separate— chambers. Made from a single piece of card, this carton is an ideal package for grouped or twinned items.

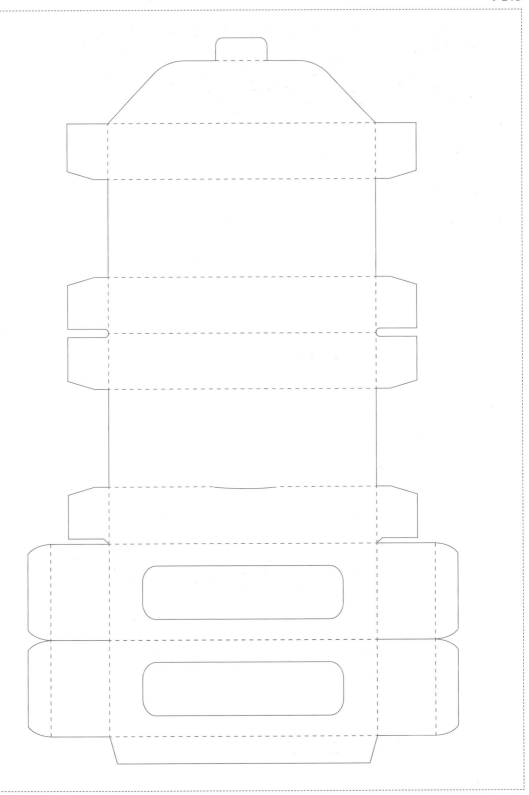

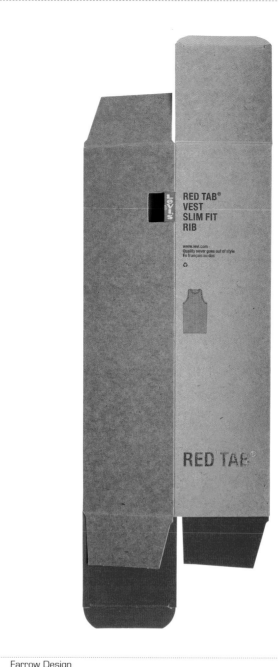

DESIGN	→	Farrow Design
PROJECT	→	Clothes packaging for Levi's®
DESCRIPTION	→	This box is for a Red Tab Levi's® vest. The red tag, printed onto the box, was die-cut so that it would stick out prominently when the box was folded into shape. The cut in the stock that this was made from was extended to create a bigger hole in the side of the box, to allow the shopper to see the color of the garment inside.

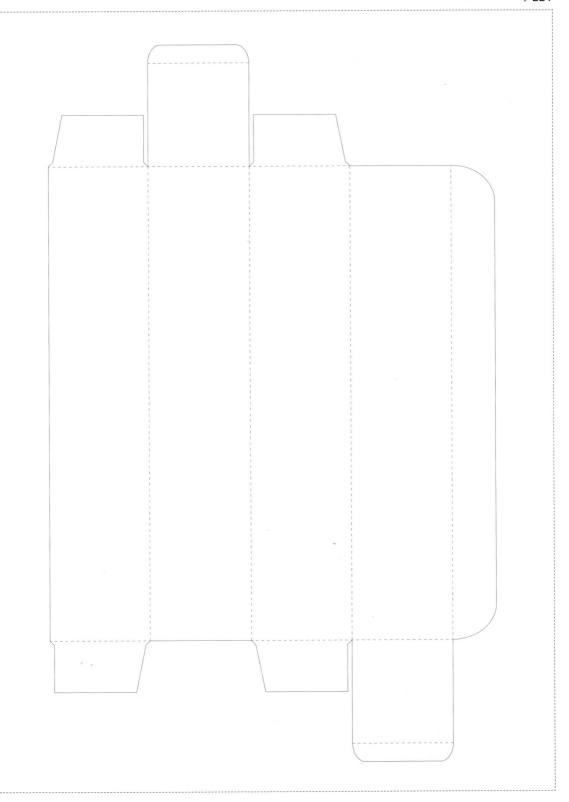

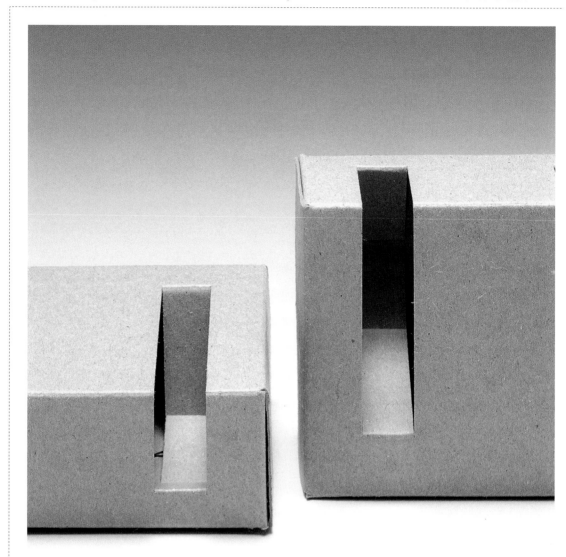

DESIGN	→	Parmjit Bhachu, Surrey Institute of Art and Design
PROJECT	→	Self-supporting carton
DESCRIPTION	→	The design of this carton uses the weight of the product to hold the structure together without needing any form of adhesive. The straps are cut from the same piece of card and used to contain the product while allowing the consumer to touch and feel it.

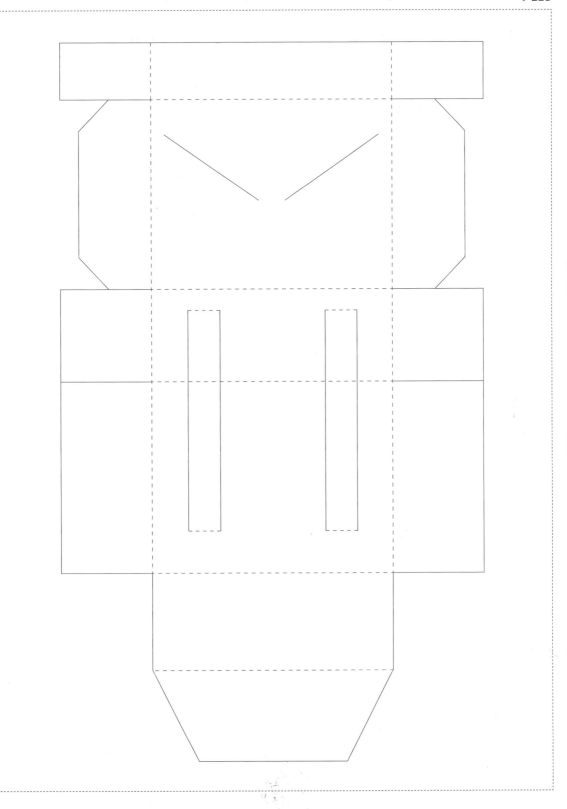

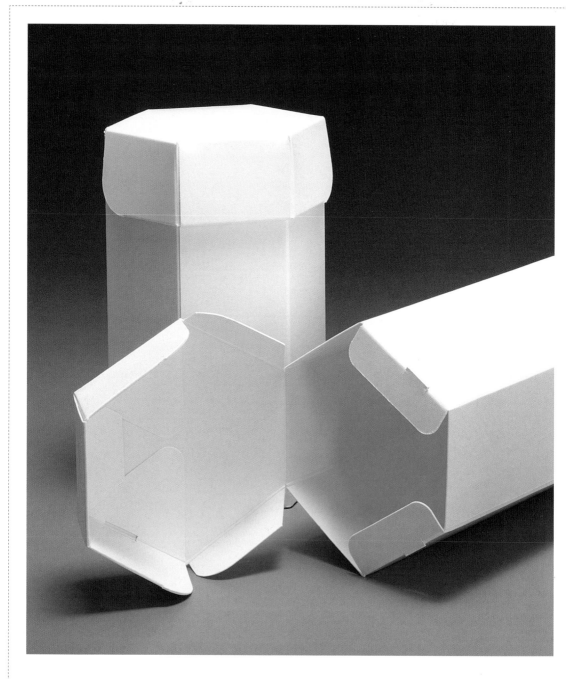

DESIGN	→	Robor Cartons
PROJECT	→	Hexagonal envelope-base carton with tab-locked lid
DESCRIPTION	→	This hexagonal carton displays an ingenious method of closure, whereby the walled lid locks into position using tab-locks on the lip of the body. The lid requires no glue in its construction as a series of folds create a strong and robust structure.

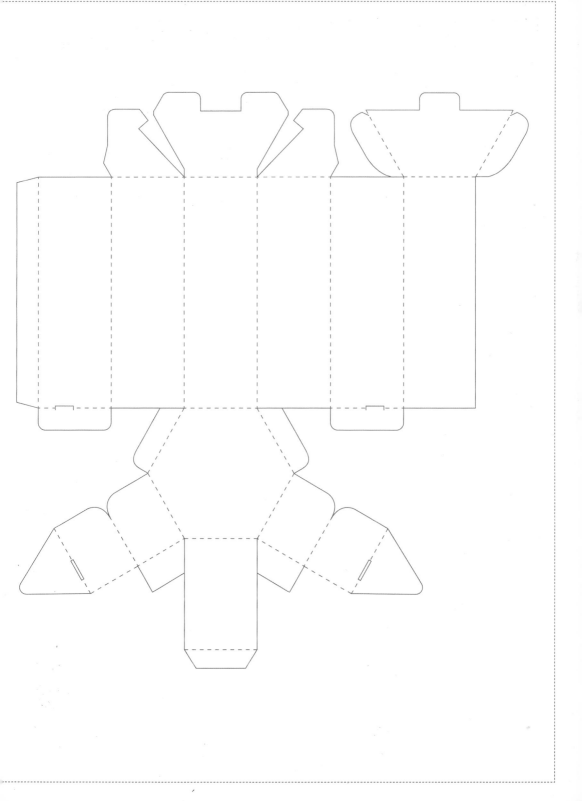

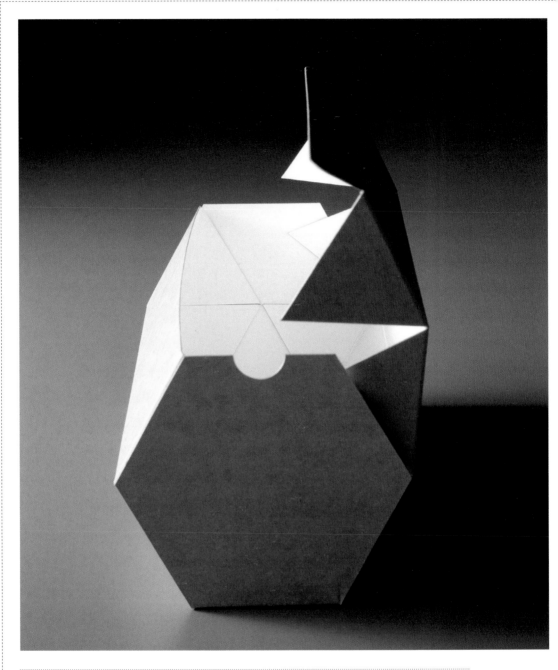

DESIGN	→	Unknown
PROJECT	→	Side-entry hexagonal carton
DESCRIPTION	→	This is a simple, yet effective, variation on the regular design of rectangular containers. The hexagonal shape makes the carton more eye-catching and provides a more interesting shape on the shelf. The orientation of this carton could be either vertical or horizontal.

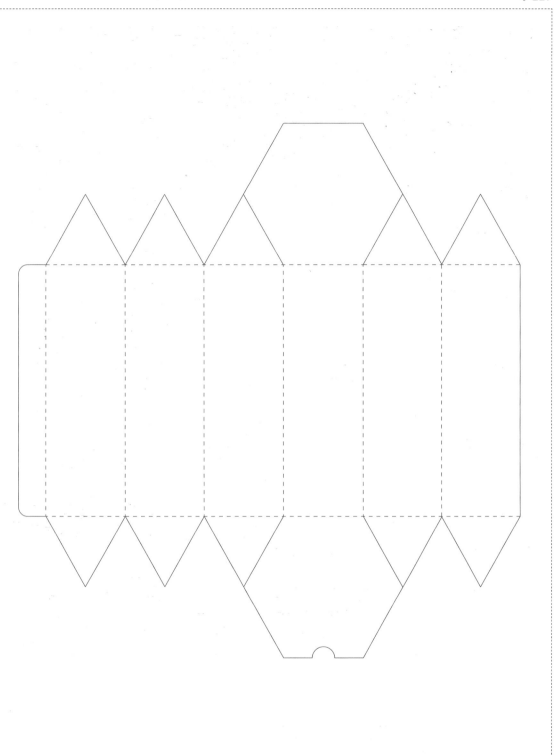

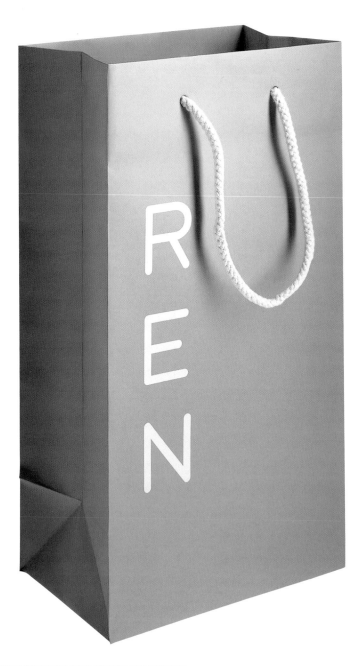

DESIGN	→	Ren
PROJECT	→	Gift bag
DESCRIPTION	→	Traditional boutique-style gift bag, designed to hold a range of Ren cosmetic products.

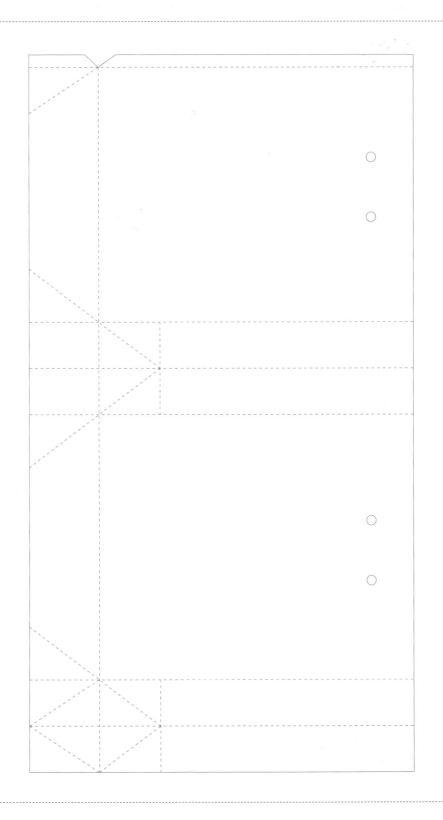

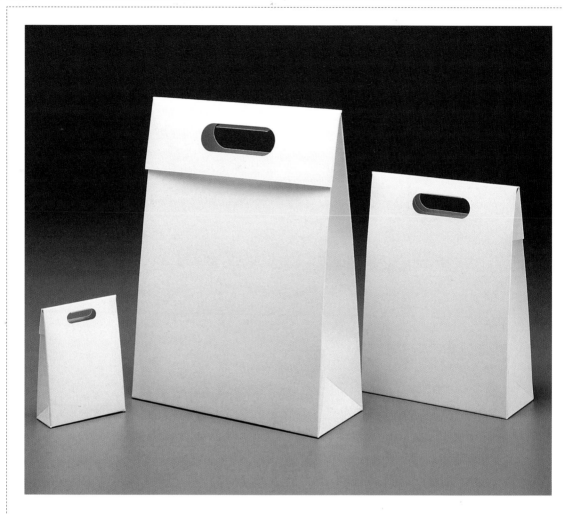

DESIGN	→	Robor Cartons
PROJECT	→	Gusset-sided carry carton
DESCRIPTION	→	A cardboard bag with a crash-lock base. The product determines the required strength of the bag and the strength will depend on the thickness of the card used. This could be used as primary or secondary packaging, with the material used greatly affecting the perceived quality of the product or retail outlet that provided the bag.

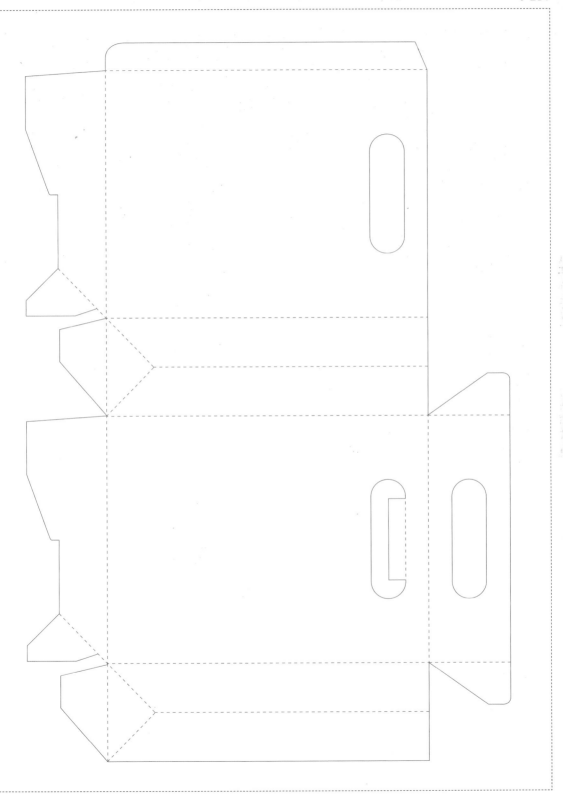

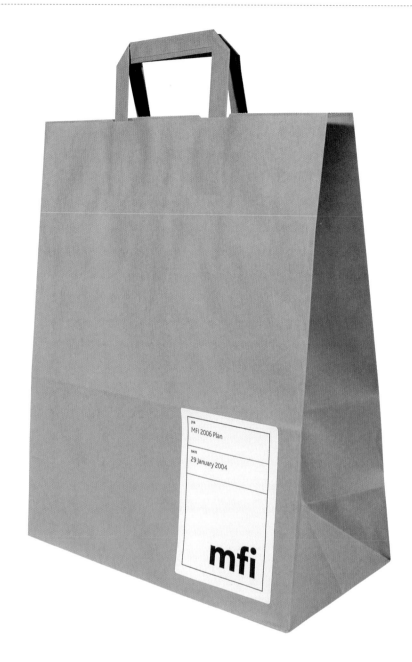

MFI 2006 Plan

29 January 2004

mfi

DESIGN	→	Rose Design
PROJECT	→	MFI sales report
DESCRIPTION	→	This anonymous brown paper bag is actually a sales report and contains a number of blueprint-style plans explaining the future ideas and development of the company.

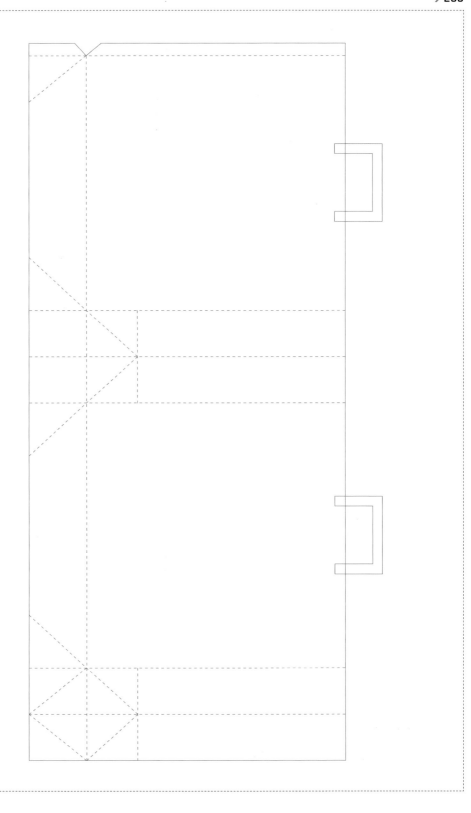

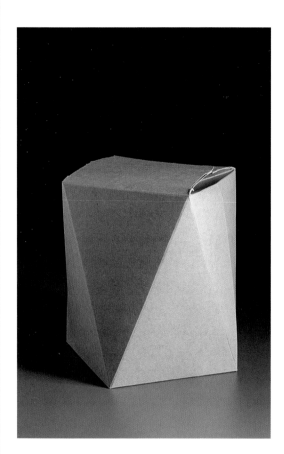
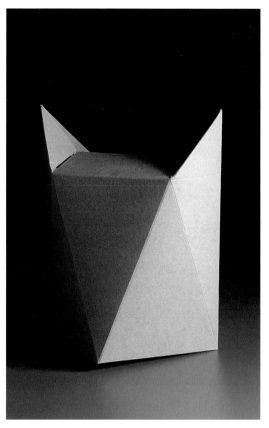

DESIGN	→	CGM Ltd.
PROJECT	→	Multisided tapered carton
DESCRIPTION	→	A scored carton with a crash-lock base which can provide three very different shapes. The first is a carton with folded-in sides and a pitched-top lid. The second has a flat top with "ears" on either side which can be folded down, and the third option is the primary design which has a flat top and reversed tapered triangular sides.

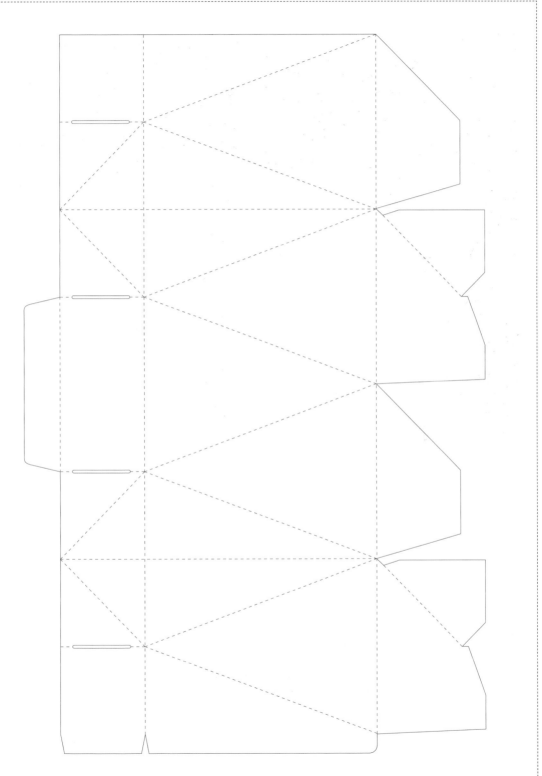

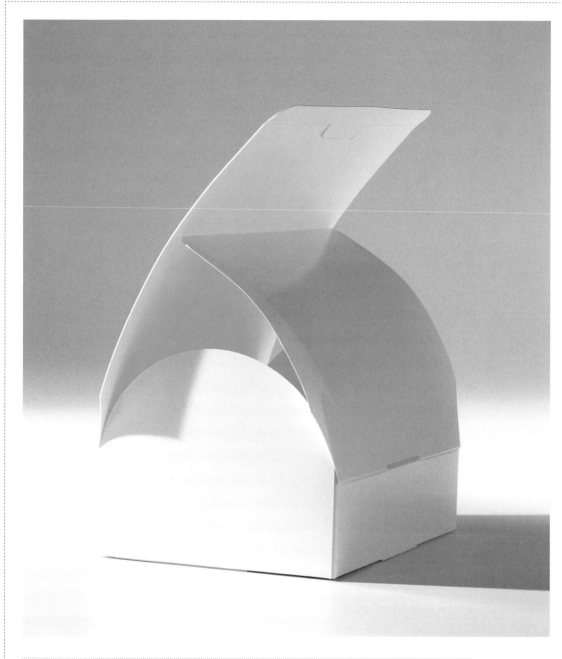

DESIGN	→	CGM Ltd.
PROJECT	→	Arc-top carton
DESCRIPTION	→	An example of how a standard four-sided carton can be given a more attractive appearance using a curved, semi-cylindrical lid. Flap "A" provides greater strength for the lid and protection for the product contained. Possible uses include take-away cartons for decorative food products, whereby the raised lid would provide additional space for the product inside.

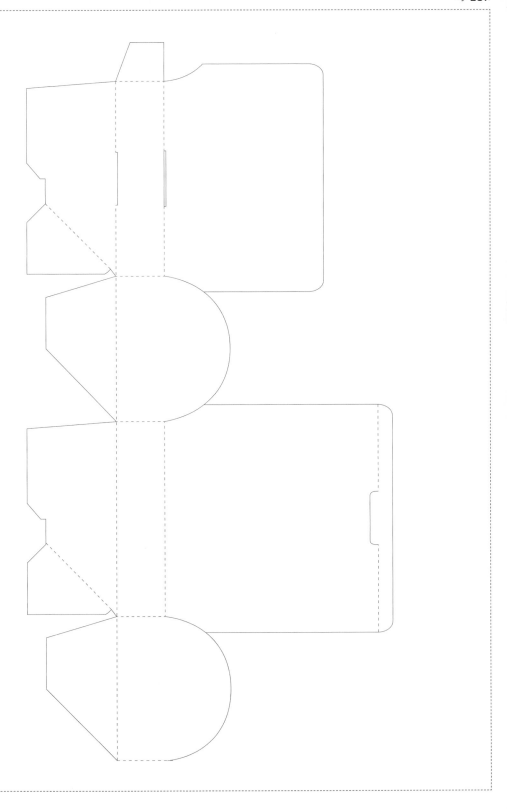

DESIGN	→	e-Types
PROJECT	→	Box packaging
DESCRIPTION	→	Standard box packaging for a range of cosmetic bottles. The proportions of this template can be easily adapted to create a variety of different shaped boxes.

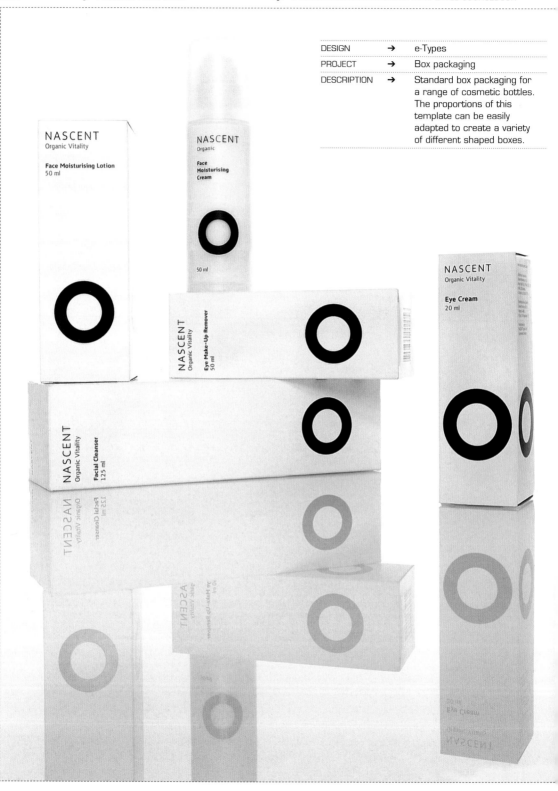

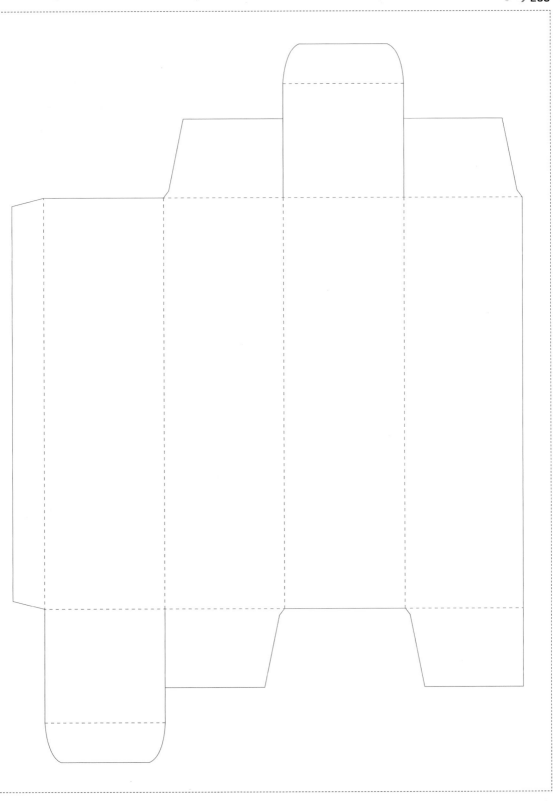

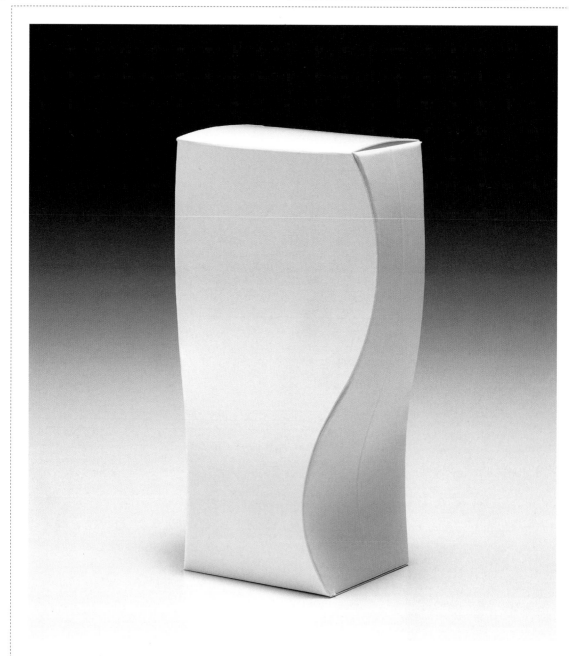

DESIGN	→	Robor Cartons
PROJECT	→	Multicurved carton
DESCRIPTION	→	This tuck-end carton makes good use of curved surfaces to create an attractive upright container. The curves and contours provide a visually appealing form that would be an ideal container for fabric, gift items, or confectionery. Glue is required in the construction of this container but it does flat-pack. The container is erected by pressing the sides.

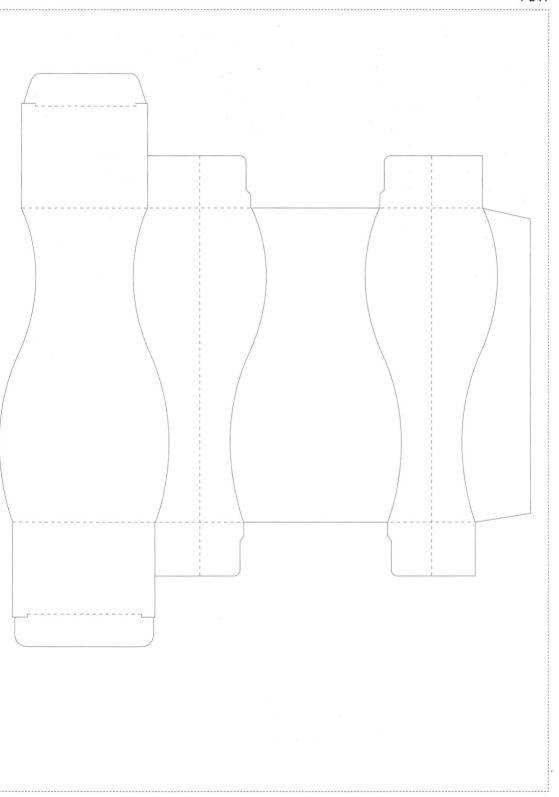

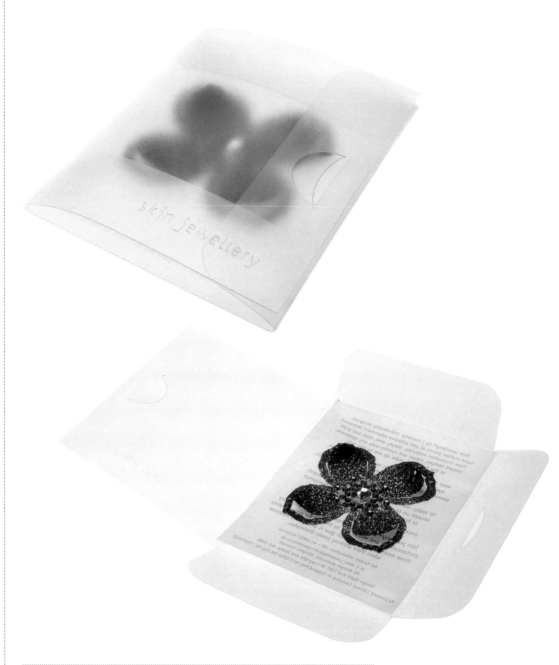

DESIGN	→	J. Maskrey/Artomatic
PROJECT	→	Skin Jewellery™ packaging
DESCRIPTION	→	Polypropylene jewelry wallet. The outer pack was debossed with the company logo. The construction was die-cut and scored out of the lightest weight of polypropylene, and kept shut with die-cut tabs.

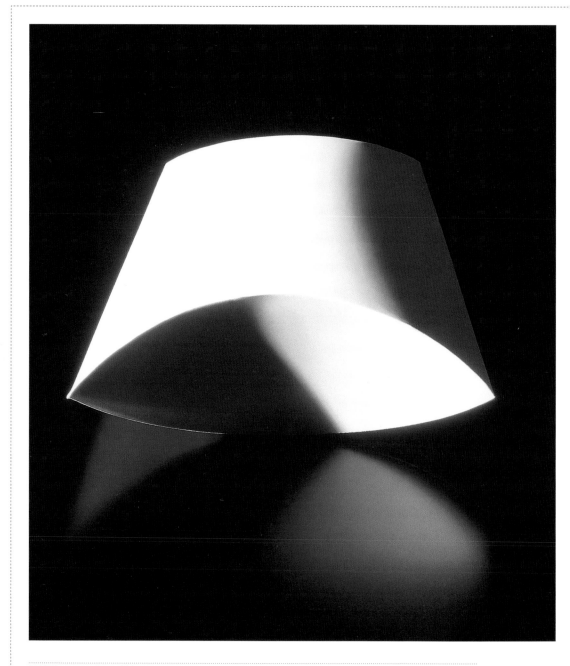

DESIGN	→	Unknown
PROJECT	→	Pillow pack
DESCRIPTION	→	Introducing contours to cartons produces interesting shapes which are visually inspiring, they can also be adapted to accommodate a Euroslot or pull-strips. This carton is good for the storage of soft items such as clothing or a number of small pieces such as confectionery or a jigsaw. It is easily erectable and can be stored in a flat-packed state.

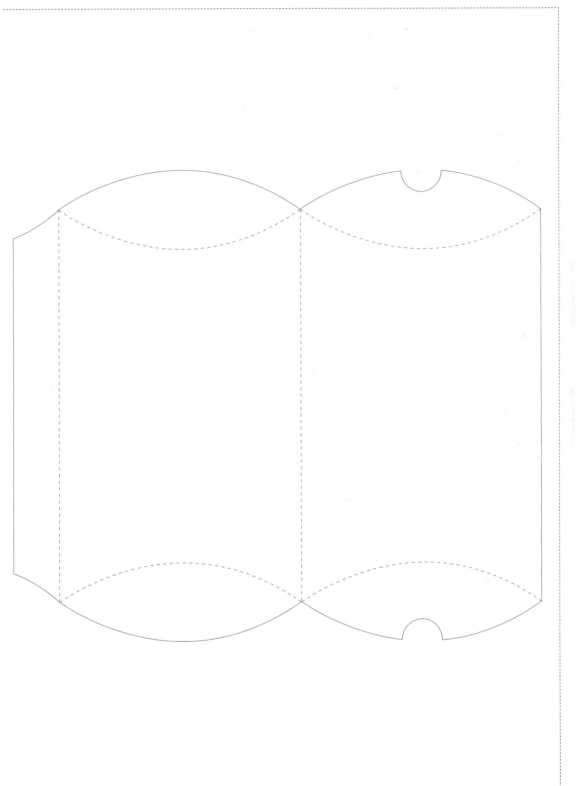

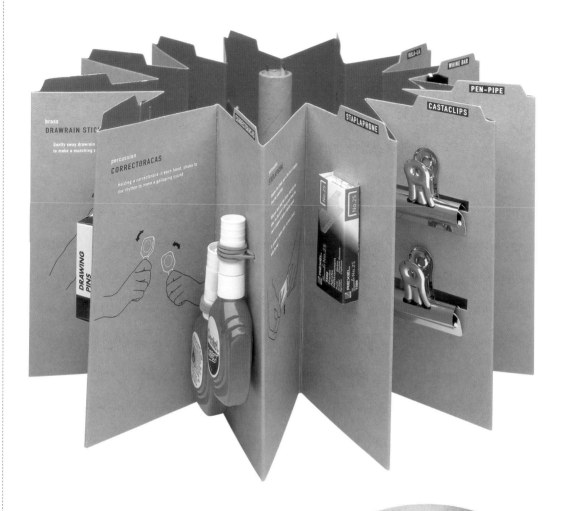

DESIGN	→	Andrea Chappell and Cherry Goddard
PROJECT	→	Office Orchestra stationery packaging
DESCRIPTION	→	Office stationery packaged in a circular concertina within a tubular, card box.

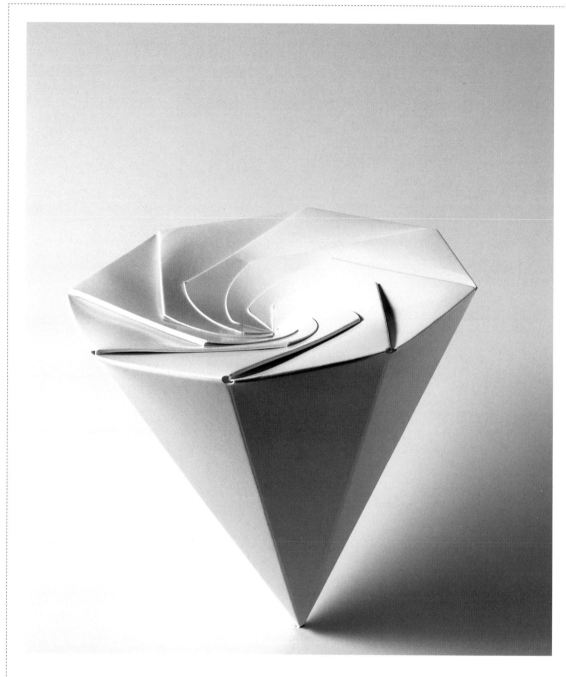

DESIGN	→	M.M. Packaging
PROJECT	→	Pyramidal carton with push-in closure
DESCRIPTION	→	Instead of a simple lid, this pyramidal carton includes a closing mechanism on each side section. This functions by pushing down one of the top tucks and then the others, in sequence, spiralling inward.

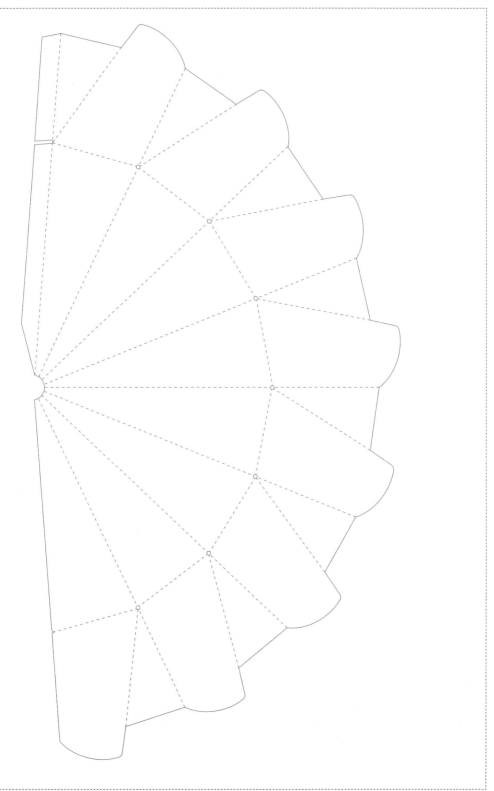

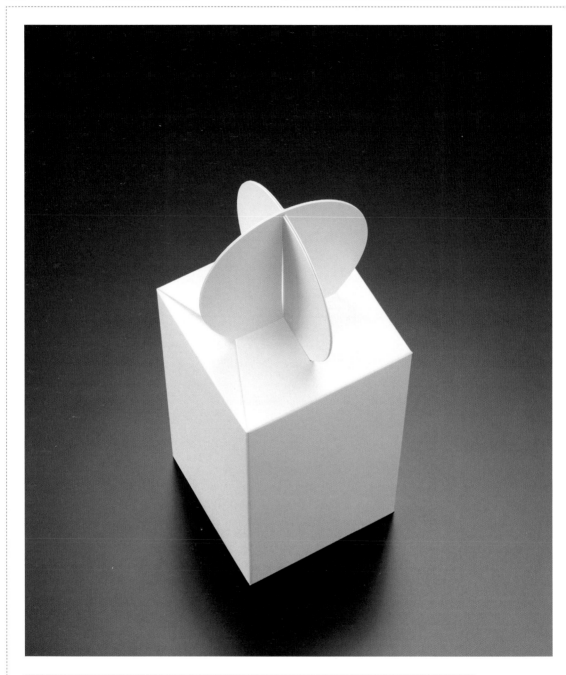

DESIGN	→	Unkown
PROJECT	→	Clover leaf closure carton
DESCRIPTION	→	A slotted disc-top closure carton with crash-lock base. The notched circle segments interlock with the slits to form a "clover leaf" design. This design is suitable for gift products where the process of opening the package is interesting and revealing.

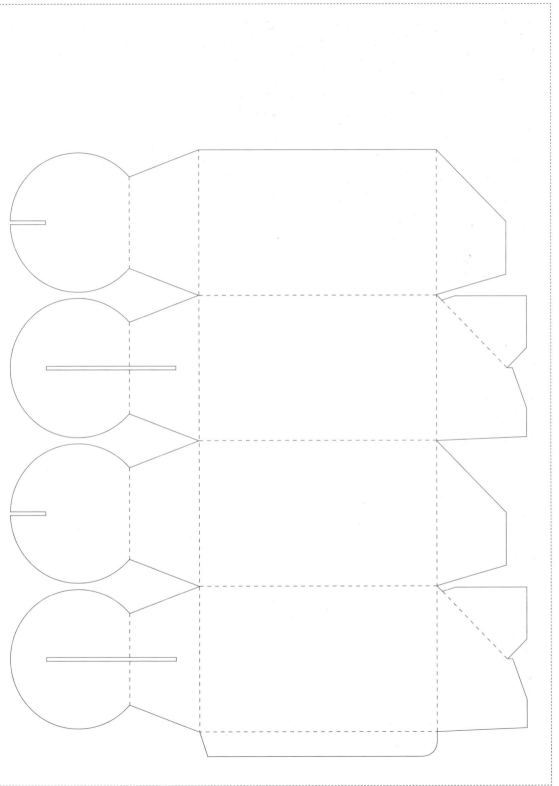

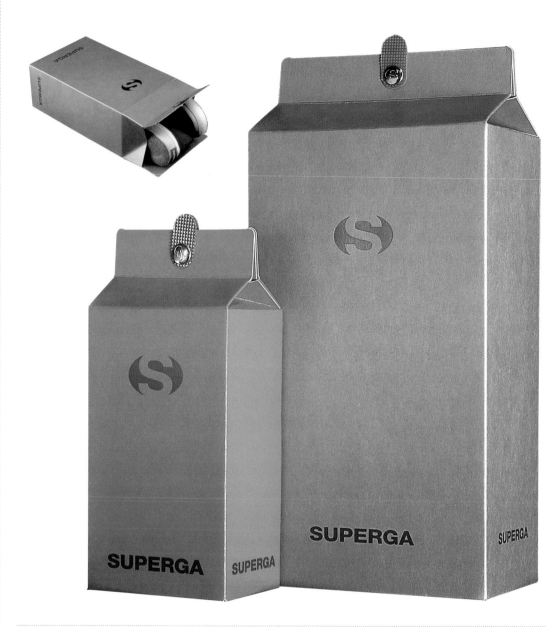

DESIGN	→	Pentagram
PROJECT	→	Shoe box
DESCRIPTION	→	This is a new patented shoe packaging system for Italian shoe company Superga. It is stackable in the conventional horizontal manner, yet it can be opened while stacked by a simple pulling action on the rubber tabs. The boxes can also be displayed vertically for point-of-sale purposes and, very importantly, are collapsible while allowing for easy and quick reassembly, indicating advantages in the stock room, for portability, and for domestic after-use.

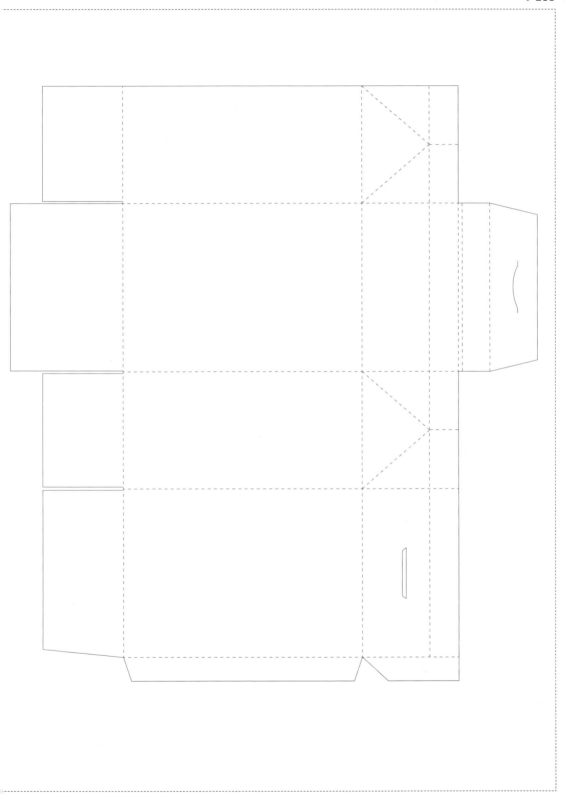

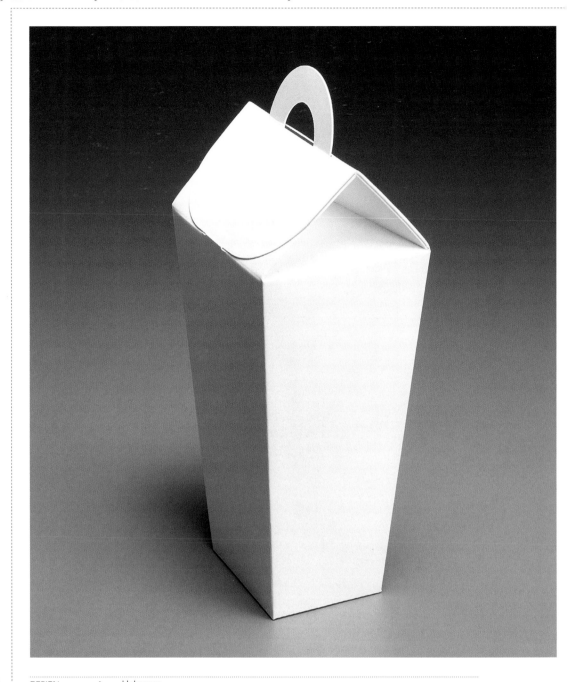

DESIGN	→	Unknown
PROJECT	→	Pitched lid and tapered sides
DESCRIPTION	→	This simple design is a basic container with tapered sides and a narrow base. Access to the product is through the pitched lid at the top of the carton, which in this case demonstrates how a handle can be incorporated into the design to enhance the performance of the package.

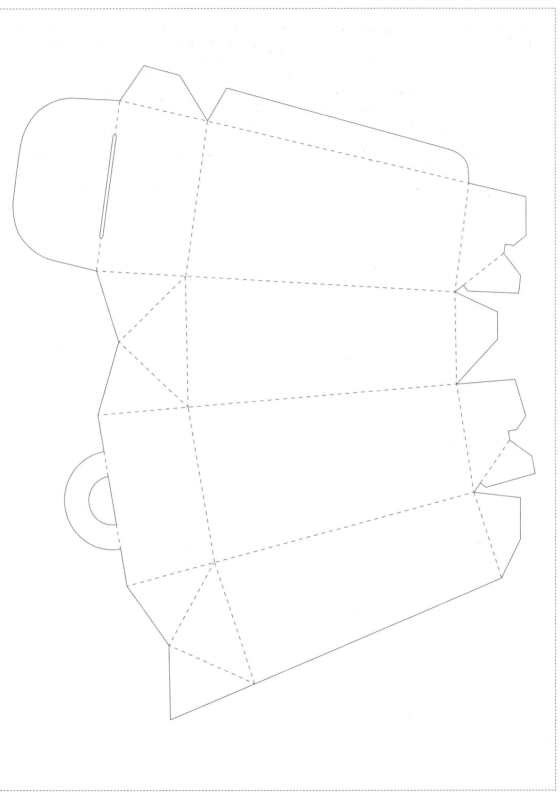

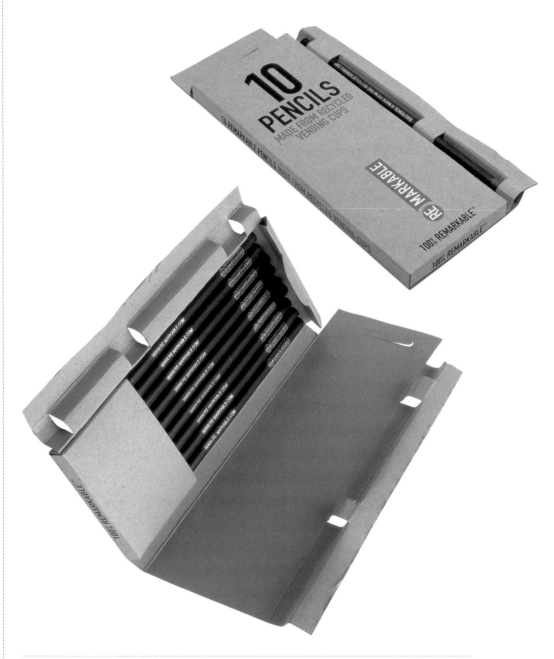

DESIGN	→	Frost Design
PROJECT	→	Remarkable pencil packaging
DESCRIPTION	→	This packaging is held together by one of the pencils, making it extremely energy efficient in terms of its manufacture. There is no glue required, plus there is the added bonus of seeing one of the pencils on display. The board used to make the packaging has been screen-printed on gray board, itself a recycled board material. It is very compact and can display in a variety of ways.

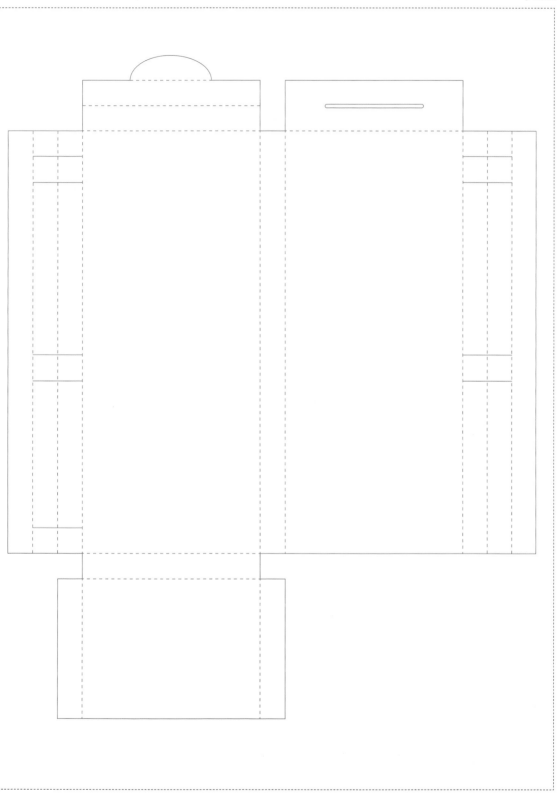

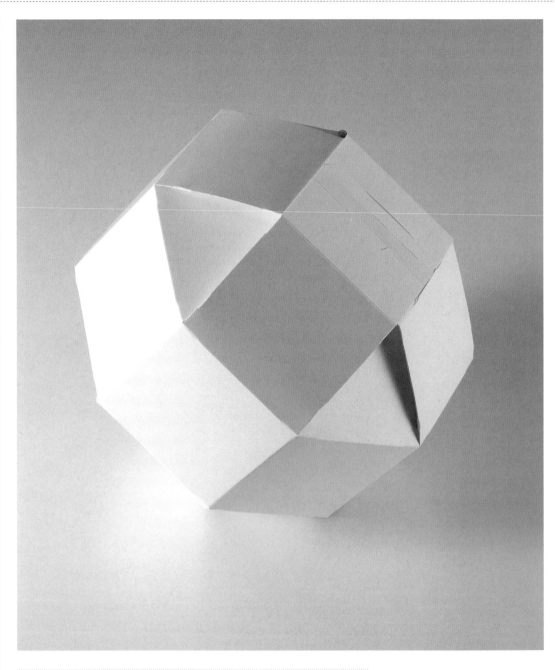

DESIGN	→	M.M. Packaging
PROJECT	→	Near spherical carton
DESCRIPTION	→	A multiformed and perforated carton. Through a series of semi-complex folds and tucks, this template takes on the rounded form that comes close to a sphere in carton board.

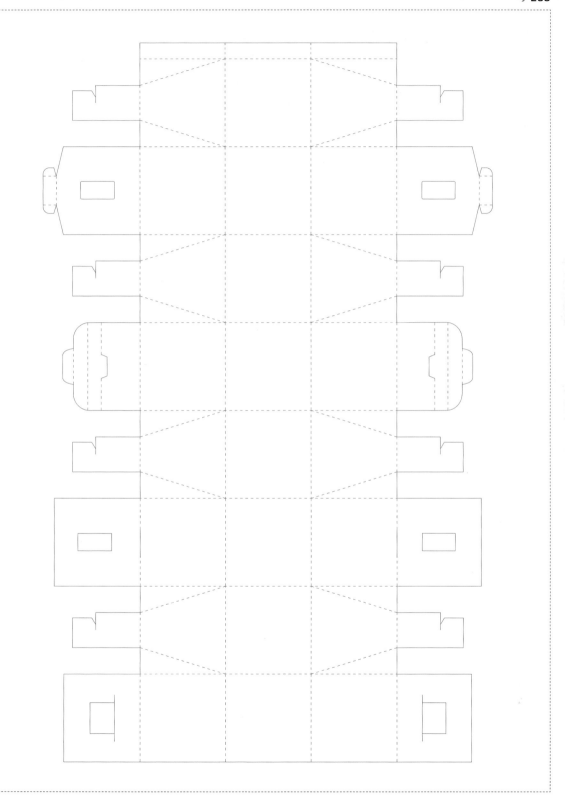

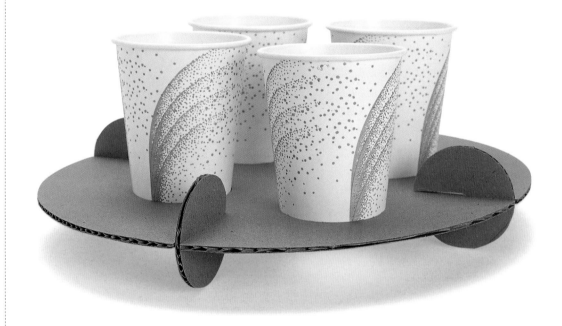

DESIGN	→	Burgeff Company
PROJECT	→	Cardboard coffee tray
DESCRIPTION	→	Four circles have been kiss-cut in the center of a piece of corrugated cardboard. Each punch-out has a slash cut into its edge. Once removed, the notched circles can be fitted into matching slits on the edge of the main board, creating legs for this take-away coffee tray.

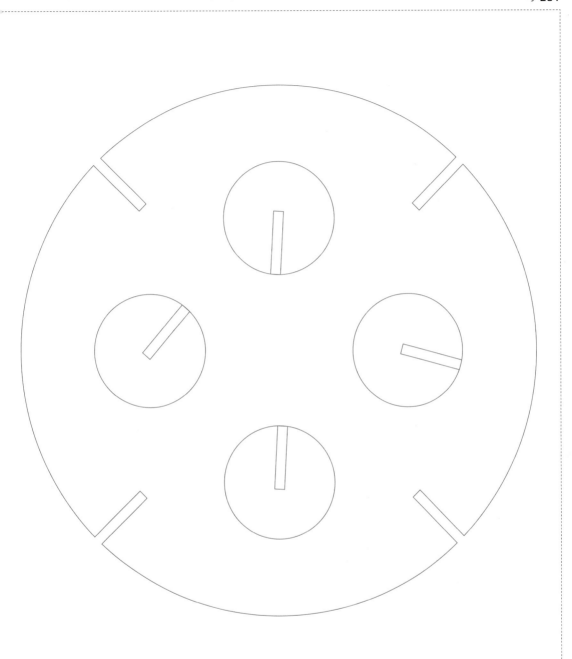

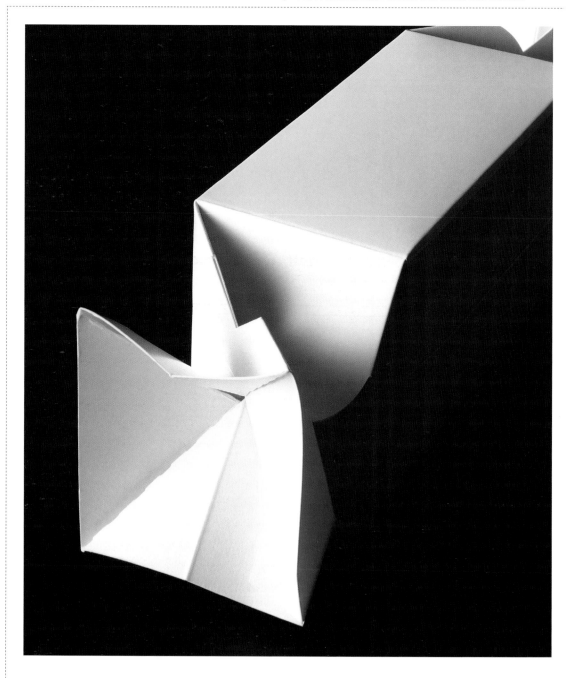

DESIGN	→	M.M. Packaging
PROJECT	→	Cracker-shaped carton
DESCRIPTION	→	This is glued along the main tuck flap and stapled together at the ends. With a few ingenious folds, the carton forms a cracker with a storage section in the middle.

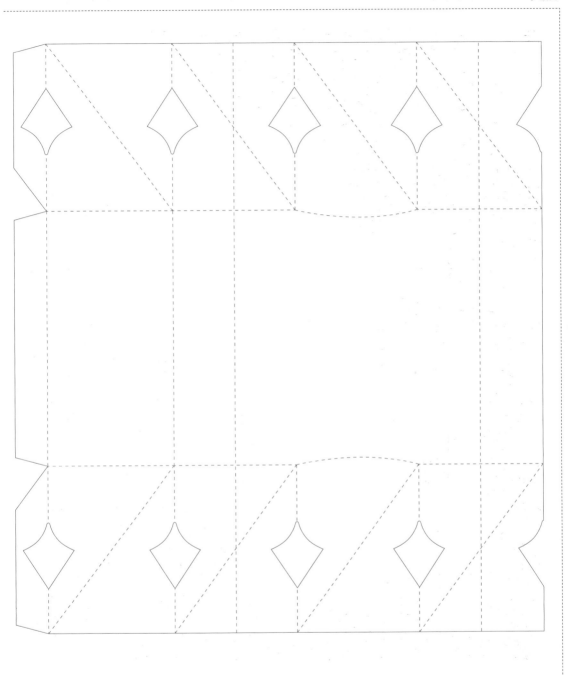

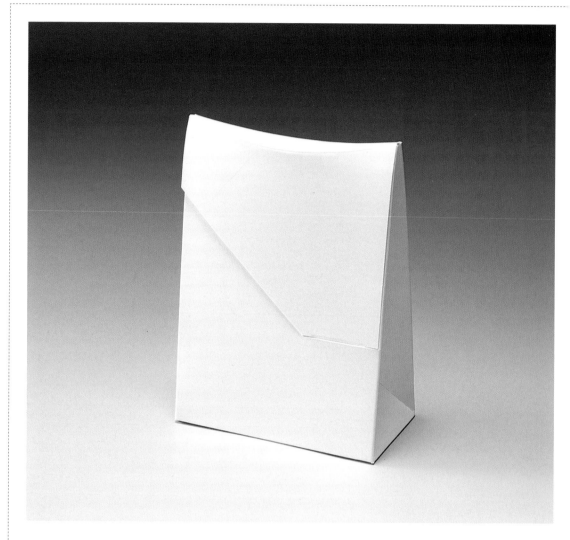

DESIGN	→	Robor Cartons
PROJECT	→	Cushion-top carry carton
DESCRIPTION	→	This carton, with a crash-lock base, cushion top, and tuck-flap closure, is designed for gift and luxury items. The use of cord creates a carry-handle and completes this stylish and sturdy carrier.

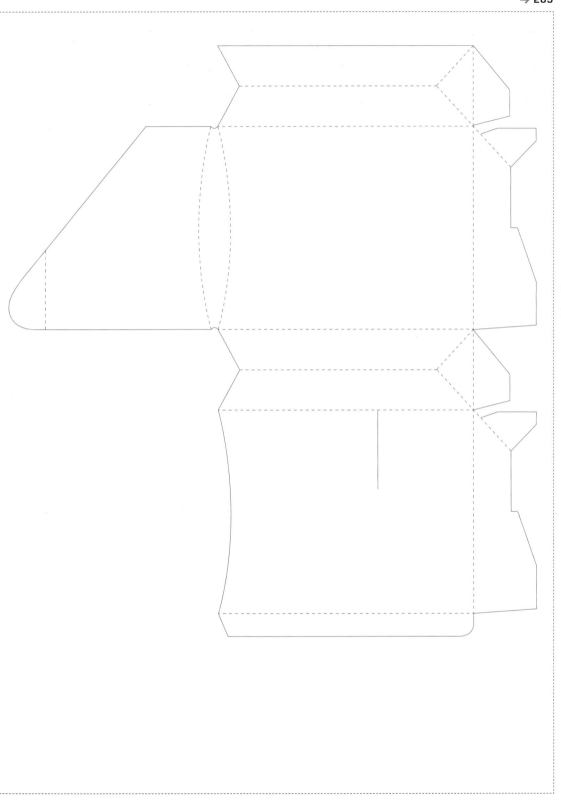

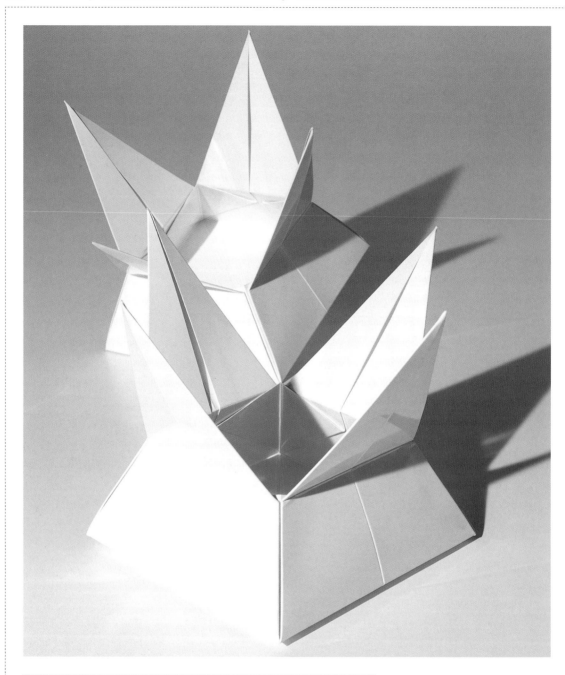

DESIGN	→	Claire Sheldon, Surrey Institute of Art and Design
PROJECT	→	Star-shaped carton
DESCRIPTION	→	An inspirational carton with a star-shaped opening that might provide a decorative container for food, confectionery, or luxury items. It would also be suitable for expensive limited edition products, or point-of-sale promotions.

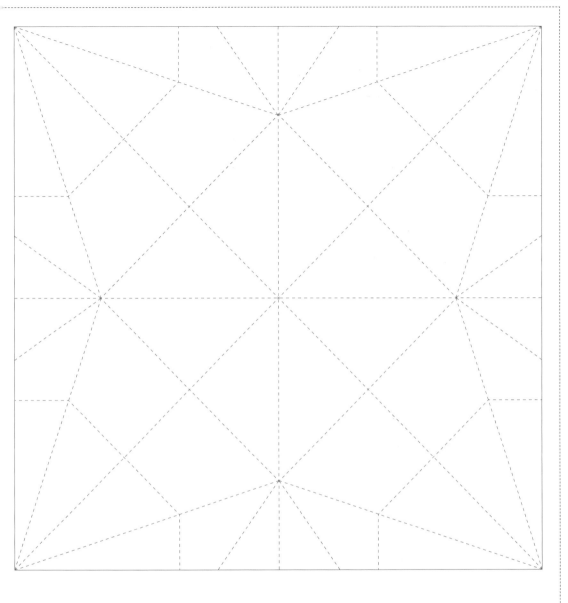

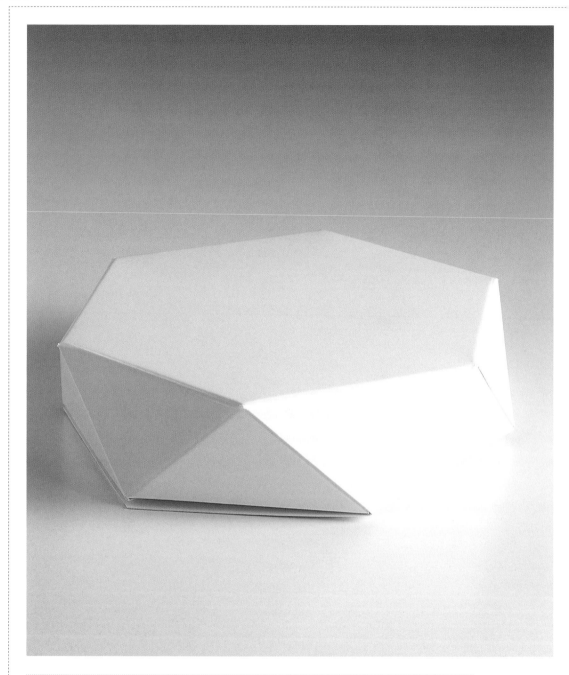

DESIGN	→	Claire Sheldon, Surrey Institute of Art and Design
PROJECT	→	Dodecagon carton
DESCRIPTION	→	This carton features a hexagonal lid and base, and erects by gluing each of the six tabs. The 12 sides of the carton fold in to form a crystal shape, while the hexagonal lid provides access to the contents. This is a good example of packaging for luxury items, such as quality confectionery or other gifts.

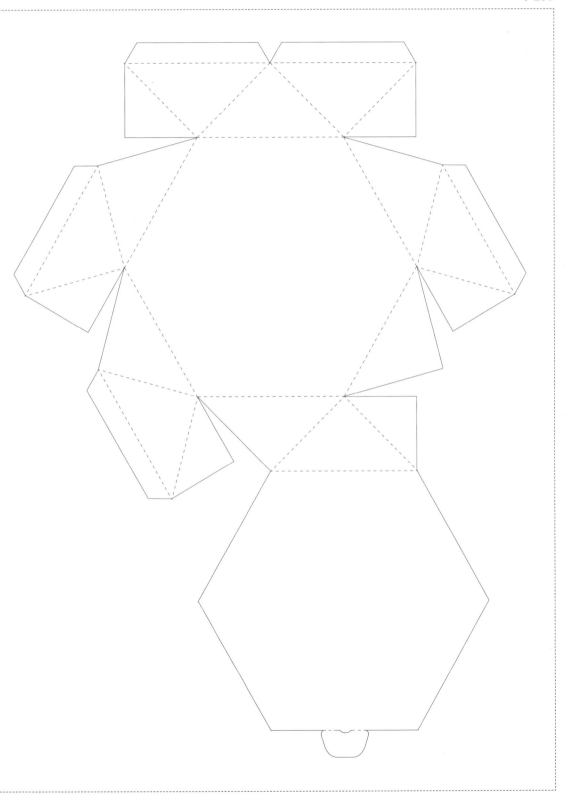

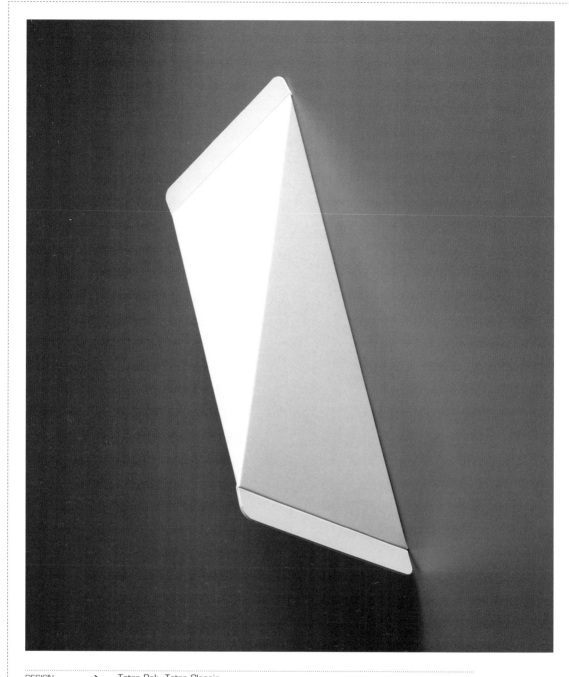

DESIGN	→	Tetra Pak, Tetra Classic
PROJECT	→	Tetrahedron carton
DESCRIPTION	→	A simple and classic example of early card containers designed to hold liquids. Laminated carton board is required for waterproof qualities, and design problems include the filling and dispensing of the liquid. This is a seemingly simple, yet quite complex, design classic.

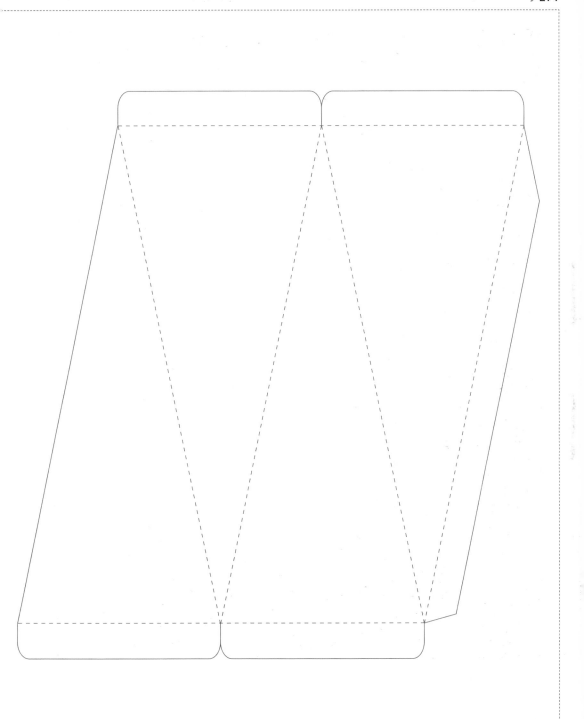

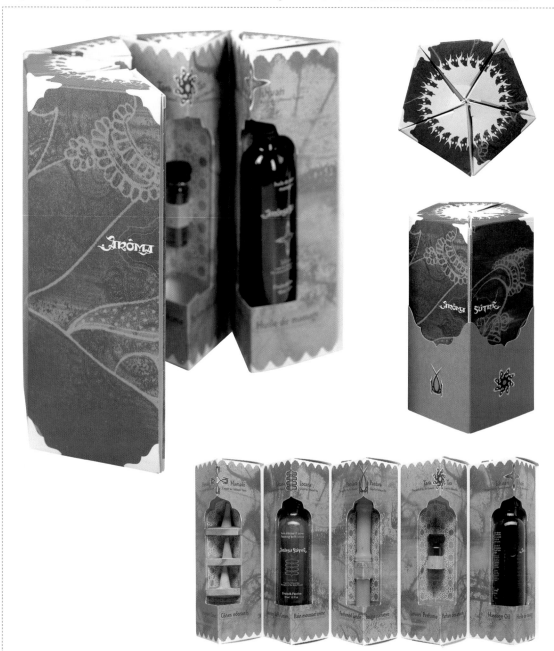

DESIGN	→	Époxy
PROJECT	→	Aroma Sutra gift packaging
DESCRIPTION	→	The construction consists of five triangular cylinders in a series that roll up to form a pentagonal cylinder package that will hold five products. The package is held together with an additional belly-band. Once opened, it can be used to display the contents.

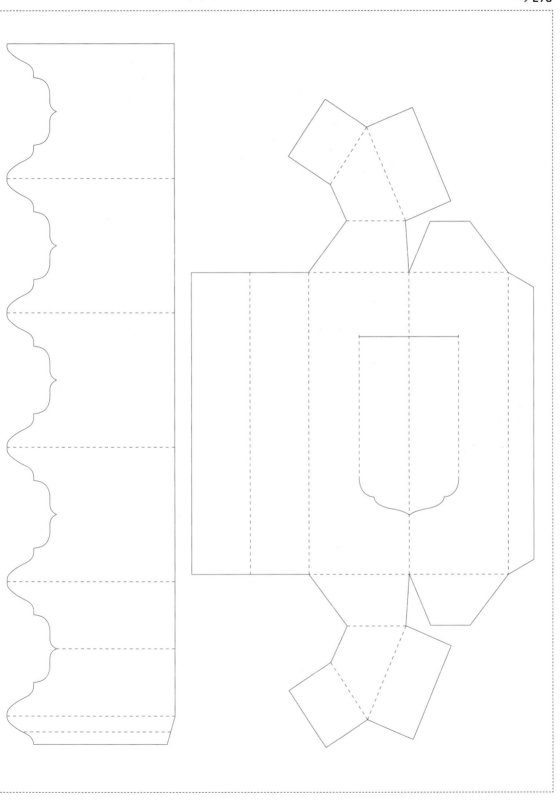

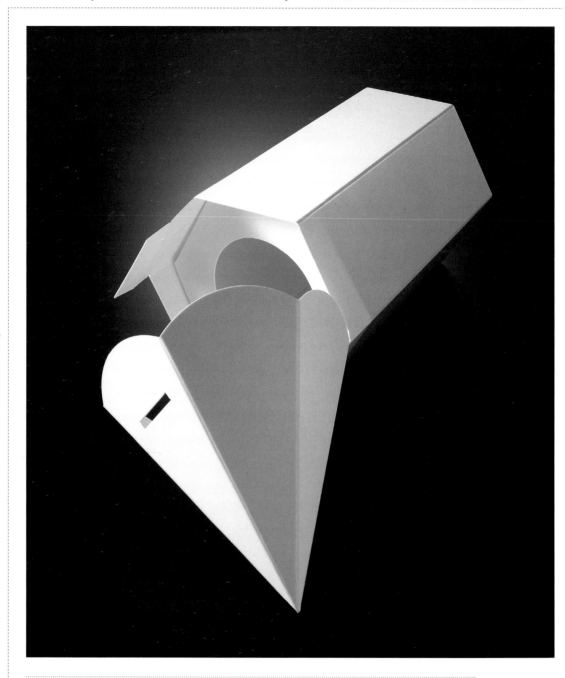

DESIGN	→	Danapak
PROJECT	→	Novelty pencil-shaped pack
DESCRIPTION	→	A novelty-shaped carton which may be used to display pencils. The two-part design is suited to promotions or advertising displays rather than large-batch production. The internal hexagonal insert provides rigidity and acts as a useful holder for the contents.

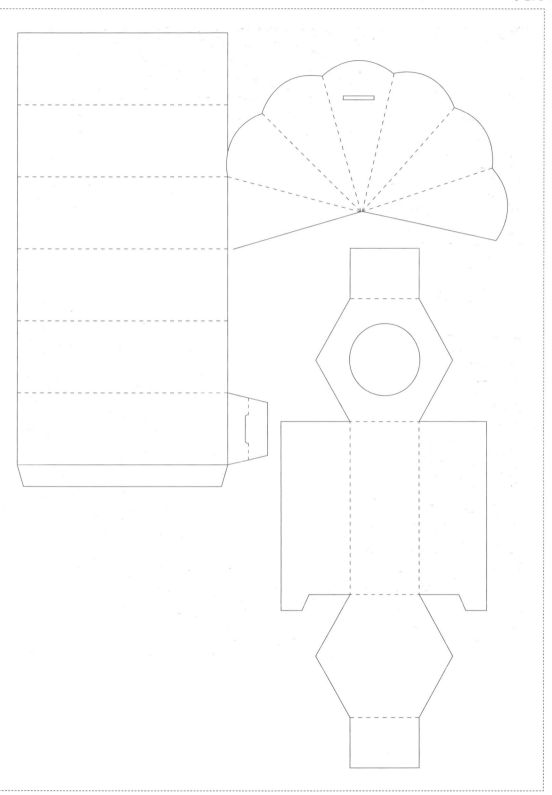

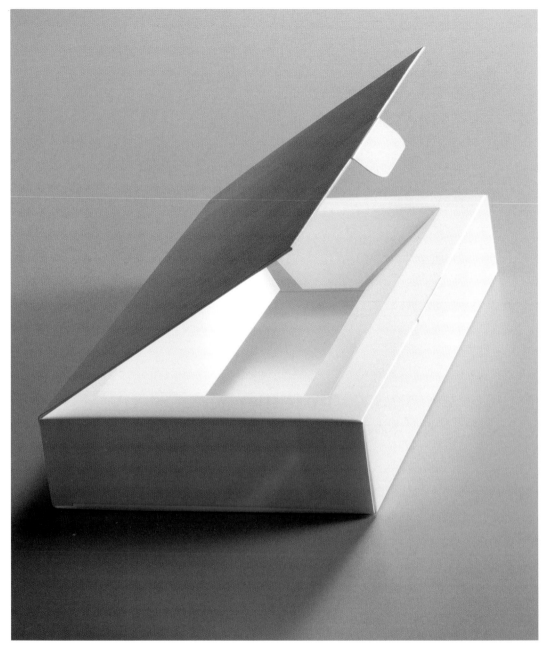

DESIGN	→	Unknown
PROJECT	→	Display carton
DESCRIPTION	→	This skillet carton has an extended lid-flap which opens to reveal a display recess. Die-cut from a single sheet, this tray provides a specific compartment for the product inside. The internal flaps that form the frame also add to the rigidity of the structure as well as helping to protect the product.

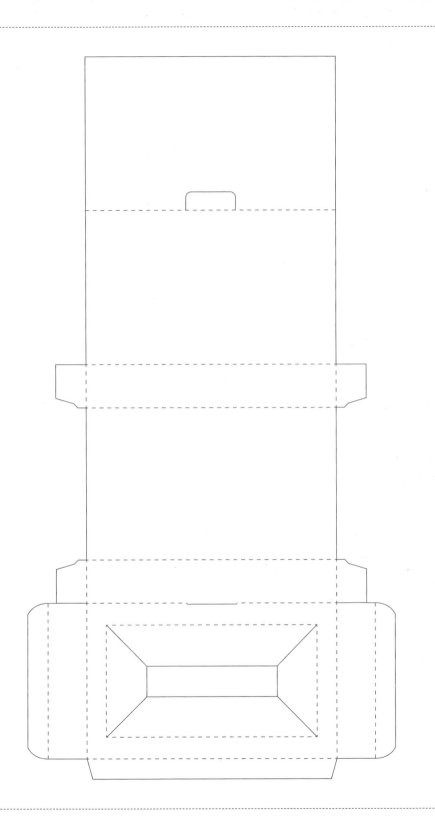

STATIONERY

City Academy

Capital City Academy
Doyle Gardens
London
NW10 3ST

T 020 8965 0409
F 020 8838 3680
E info@capitalcityacademy.org
www.capitalcityacademy.org

DESIGN	→	Carter Wong Tomlin
PROJECT	→	Stationery
DESCRIPTION	→	In this design for Capital City Academy's stationery, Carter Wong Tomlin uses the parallel fold to create the illusion of a brick wall.

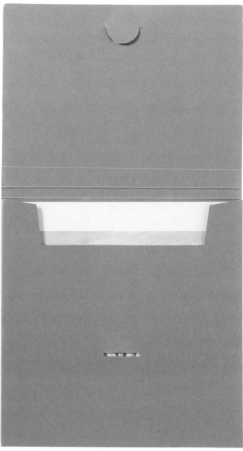

DESIGN	→	Blue River Design Ltd.
PROJECT	→	Stationery system for a contemporary art center
DESCRIPTION	→	A durable card stock forms the basis for a family of versatile folders and envelopes. The stationery is neutral in tone so as not to interfere with the content within. This square capacity folder with a die-cut slot closure makes a fine shell for glossy photo cards.

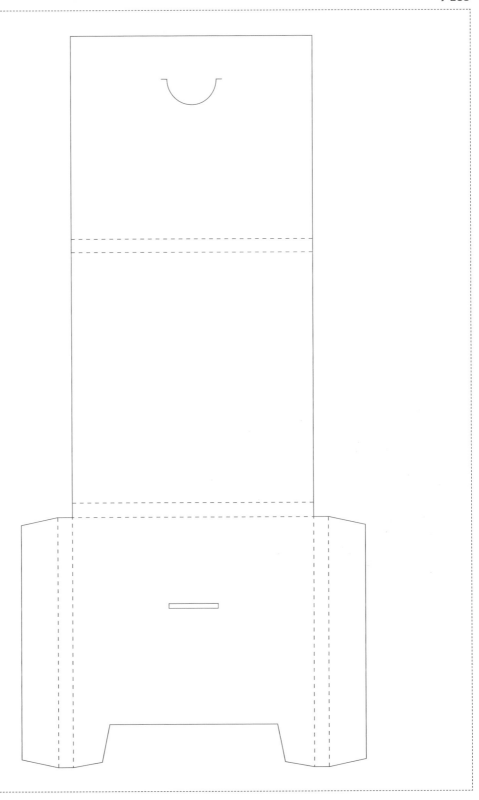

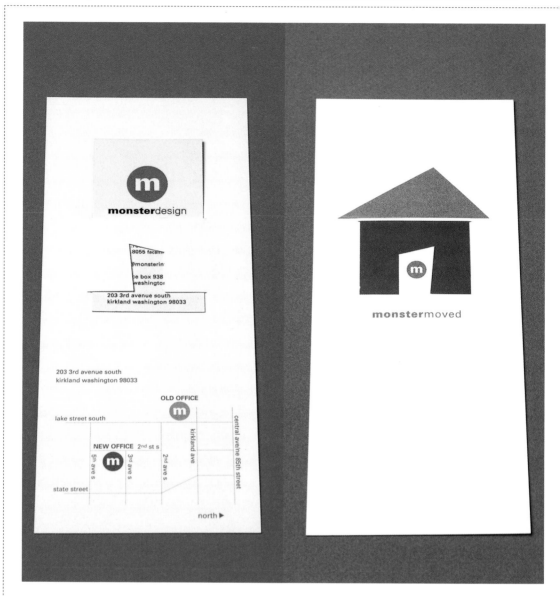

DESIGN	→	Monsterdesign
PROJECT	→	Card
DESCRIPTION	→	This card combines a business card, which can be detached and used, with a memorable presentation card, designed to fit into a standard-sized envelope.

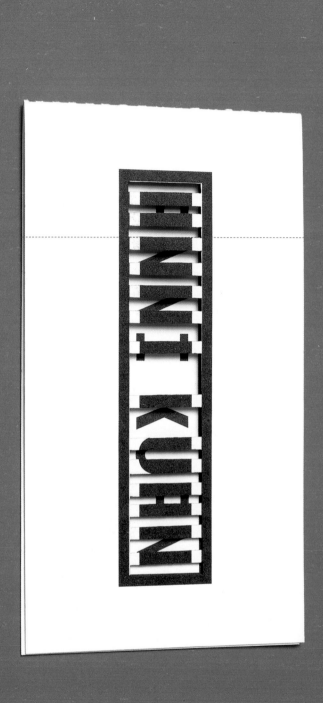

DESIGN	→	Sagmeister, Inc.
PROJECT	→	Business card for Anni Kuan
DESCRIPTION	→	Anni Kuan is an Asian fashion designer working in New York. This business card brings together different abstract elements to form her distinctive logo.

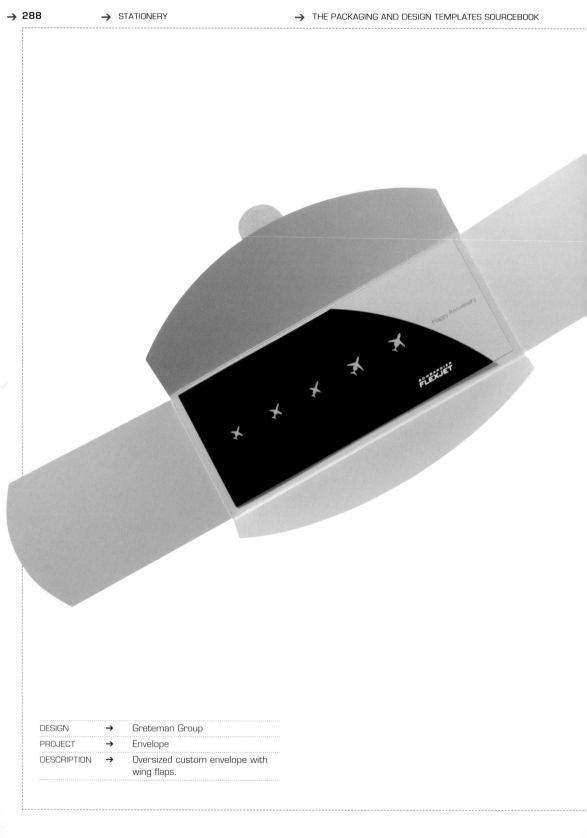

DESIGN → Greteman Group
PROJECT → Envelope
DESCRIPTION → Oversized custom envelope with
 wing flaps.

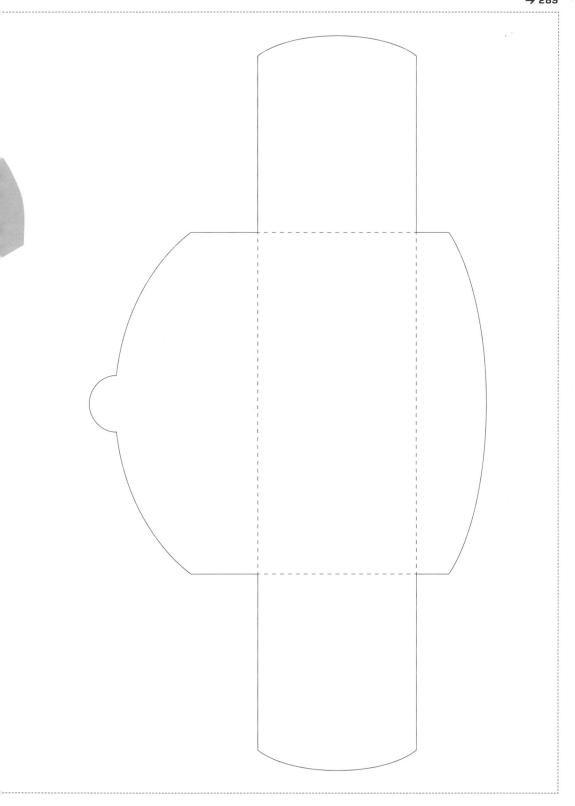

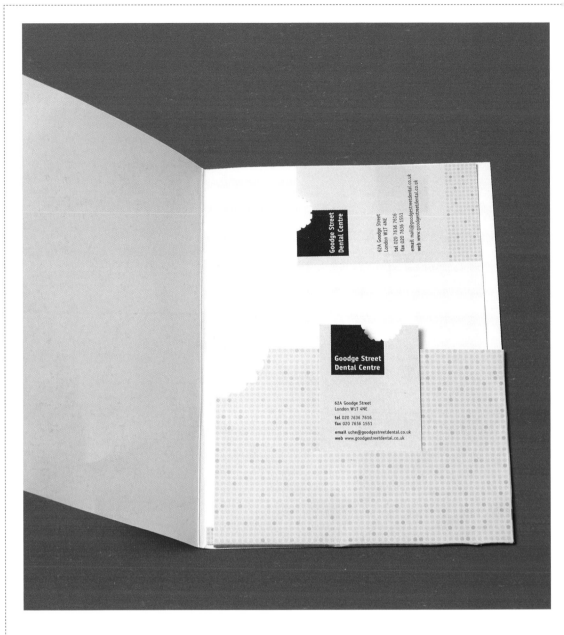

DESIGN	→	Etu Odi
PROJECT	→	Stationery for Goodge Street Dental Centre
DESCRIPTION	→	The corner of each piece of stationery has been die-cut with bite marks.

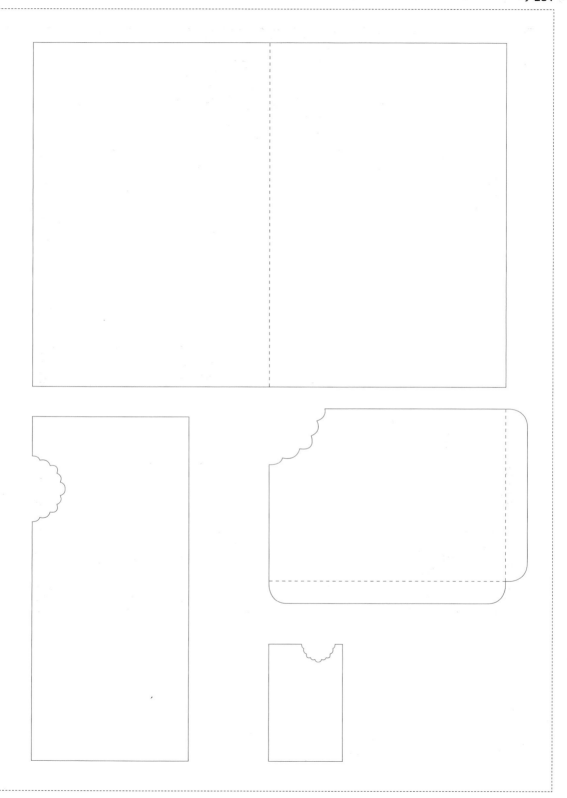

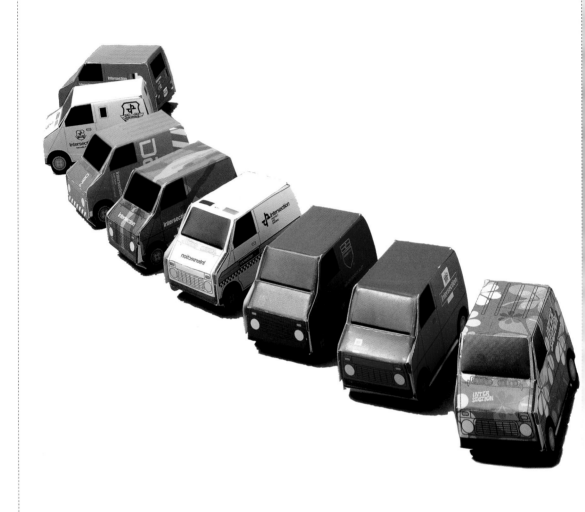

DESIGN	→	Yorgo Tloupas
PROJECT	→	Business cards
DESCRIPTION	→	These business cards are all based on the shape of a Honda minivan and were created by Yorgo Tloupas for the staff of his upbeat car magazine *Intersection*. They are given out flat and can be easily folded into a little model.

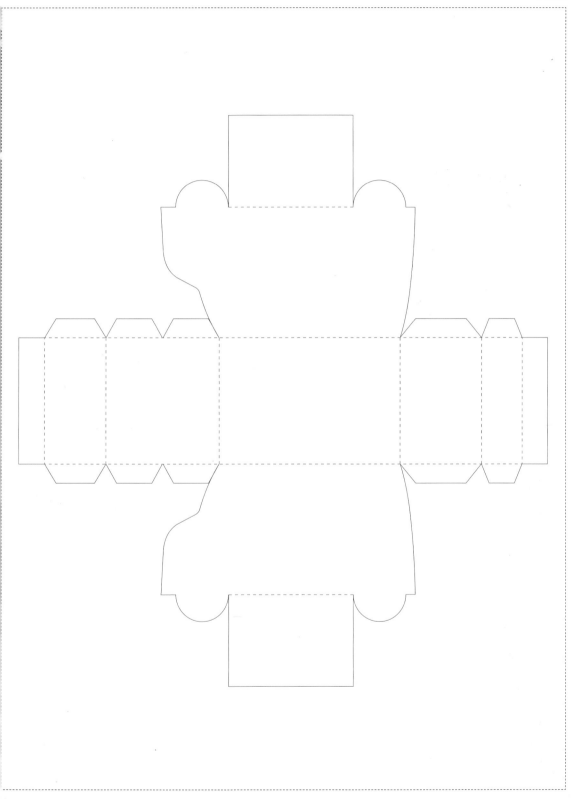

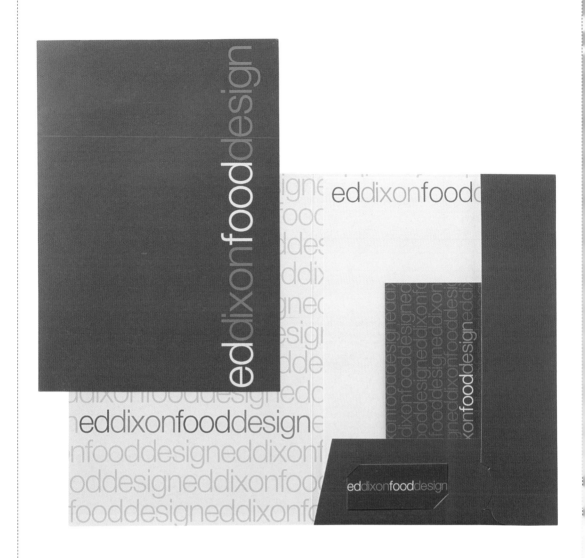

DESIGN	→	Flight Creative
PROJECT	→	Stationery folder
DESCRIPTION	→	Matte-laminated folder designed to hold A4 ($8^{1/8}$ x $5^{3/4}$ in) inserts. It has a non-glued, puzzle-piece pocket tab.

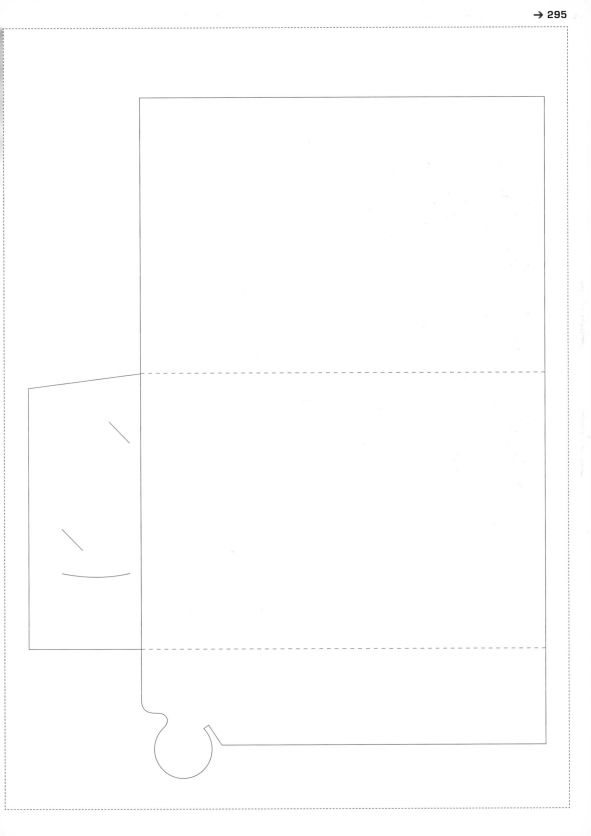

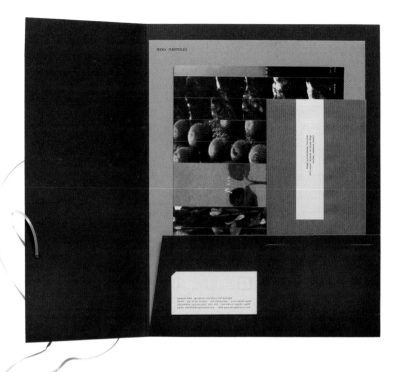

DESIGN	→	Noon
PROJECT	→	Folder
DESCRIPTION	→	This folder's revealing format is both interesting and economical in its paper use. A foreshortened cover allows the contents to serve as part of the face presentation.

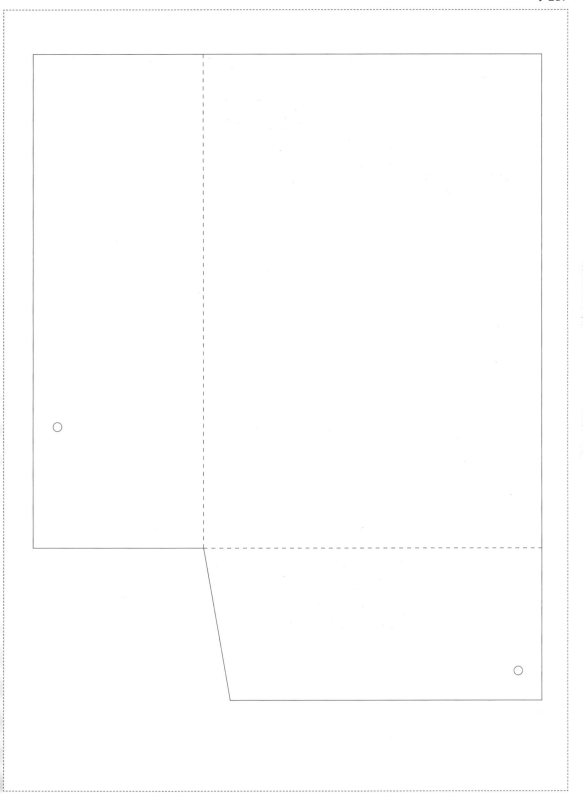

DESIGN	→	Belyea
PROJECT	→	Folder
DESCRIPTION	→	This folder delivers high impact on a low budget. To avoid gluing expenses, the two inside flaps were designed to lock together to create a holding area. A translucent stock allows the printing on the inside flap to show through the cover, adding a second dimension to the headline.

ENDMATTER